KANDINSKY

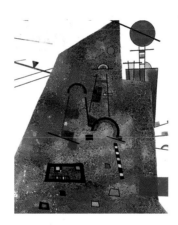

Publisher & Creative Director: Nick Wells
Senior Editor: Sarah Goulding
Picture Research & Development: Melinda Revesz
Designer: Cliff O'Dea

Special thanks to: Clare Lister, Hilary Bird, Helen Tovey and Elena Verrecchia

FLAME TREE PUBLISHING
Crabtree Hall, Crabtree Lane
Fulham, London, SW6 6TY
United Kingdom

www.flametreepublishing.com

Flame Tree is part of the Foundry Creative Media Company Limited

First published 2006

Every effort has been made to contact copyright holders. We apologize in advance for any omissions
and would be pleased to insert the appropriate acknowledgements in subsequent editions of this publication.

While every endeavour has been made to ensure the accuracy of the reproduction of the images in this book,
we would be grateful to receive any comments or suggestions for inclusion in future reprints.

Printed in China

KANDINSKY

Author: Michael Robinson Foreword: Elizabeth Keevill

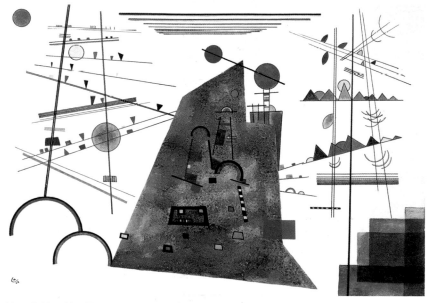

Schweres Zwischen Leichtem ('Between Heaviness and Lightness')

**FLAME TREE
PUBLISHING**

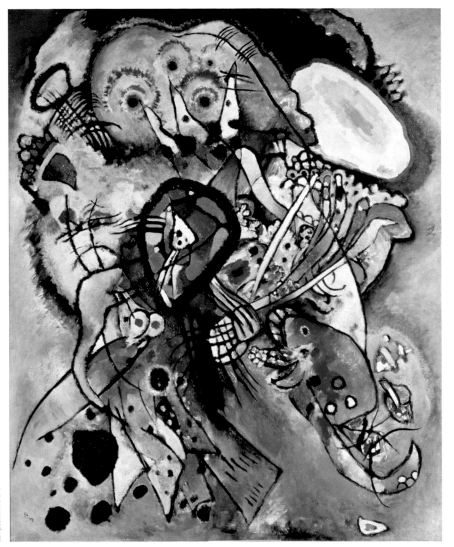

Contents

Song of the Volga; Saint Vladimir; Imatra

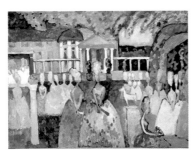 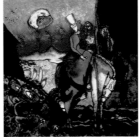 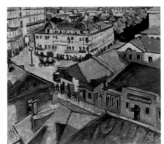

Women in Crinolines; Amazon; Zubowskaja Ploschad

Towards Abstraction

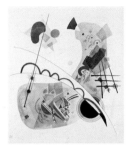 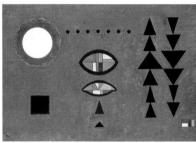 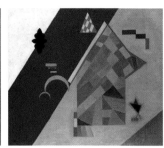

Grave Forme ('Engraved Shapes'); *Weiss-Weiss* ('White-White'); *Red Across*

Late Style

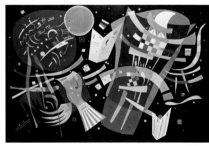 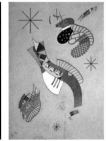 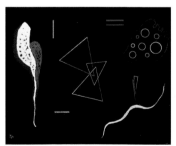

Composition X; *Trois Étoiles* ('Three Stars'); *Three Triangles*

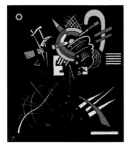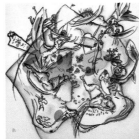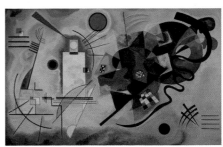

Kleine Welten VII ('Small Worlds VII'); *Afrika*; *Yellow, Red, Blue*

How To Use This Book

The reader is encouraged to use this book in a variety of ways, each of which caters for a range of interests, knowledge and uses.

- The book is organized into five sections: **Influences**, **Early Ideas**, **Towards Abstraction**, **Late Style** and **Techniques**.
- **Influences** looks broadly at Kandinsky's work, showing the many influences on him from Art Nouveau in his early career to Symbolism and Surrealism in his later years.
- **Early Ideas** covers the period from 1900–21 and shows how Kandinsky's work developed alongside his co-establishment of *Der Blaue Reiter* in 1911.
- **Towards Abstraction** covers the years 1922–33 and looks at his work at the Bauhaus.
- **Late Style** covers the period from 1934–44 when Surrealism was one of Kandinsky's major influences.
- **Techniques** delves into the myriad styles Kandinsky experimented with and the different media in which he worked, from watercolours and oils to chinaware and tapestry.
- The text provides the reader with a brief background to the work, and gives greater insight into how and why it was created.

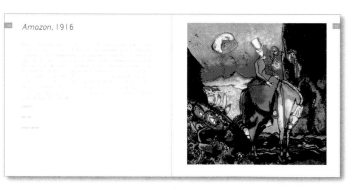

Amazon, 1916

1. Title of work

2. Date of work (if known)

9. Picture credit

3. Information about the work and the context within which it was created

8. Place in which the work was created (if known)

7. Medium in which the work was created (if known)

5. Related work to the one pictured

4. Artists name, date of birth and death, and place of birth features at the beginning of each chapter

Amazon, 1916

Foreword

Vasily Kandinsky's paintings have fascinated me ever since I was first introduced to them as a young art student. Since those days I have become just as intrigued by Kandinsky the man as by those astonishing paintings. He was, by all accounts, complex, highly educated and cultured. One of the most surprising aspects of his life was that, having trained as a lawyer and taught as professor of jurisprudence at Moscow University, he suddenly decided to become an artist at the age of 30. He never acted the part of the bohemian, always cutting a dash with his dapper appearance and smart suits. However, despite his sophisticated appearance, Kandinsky was deeply entrenched in the ancient traditions of his Russian ancestry, and had an enduring love for the folk art and fairy tales of his homeland.

Like his friend the Swiss painter Paul Klee (1879–1940), Kandinsky was a talented musician and his abstract paintings are often described as 'painted music'. However, Kandinsky was adamant that this was not true. In a lecture he gave in Cologne in 1914, he insisted that all he wanted to do was 'paint good, necessary, living pictures'.

Despite his complex nature and wide-ranging achievements, Kandinsky's work can be accessed on many levels, even the most basic. My nine year old daughter was recently involved in a Kandinsky project at school and thoroughly enjoyed producing her own 'version' of a Kandinsky painting with remarkable success. At the other extreme, issues raised by his work can often lead to complex philosophical discourses, not least about the nature of abstraction, a concept that he anguished over for years.

As well as his love of folk art, Kandinsky was always interested in the decorative arts and enjoyed producing designs for embroidery, even designing dresses for Gabriele Münter (1877–1962), his lover and companion during the early part of his artistic career. Sadly, Kandinsky never acknowledged the influence of Gabriele on his work. She shared his fascination with folk art, and her work as an accomplished painter in her own right had a significant influence on his own painting during the time they were together. But after their painful parting, Kandinsky never mentioned her again, whereas Gabriele championed his work for the rest of her life. An inspirational exhibition of Münter's work at the Courtauld Gallery, London in 2005 gave an all too rare opportunity to see something of the range of her highly individual paintings.

Although often referred to as the 'Father of Abstraction', Kandinsky was profoundly aware of the difference between the abstract nature of decorative designs and 'high art', and for a long time he felt unable to reconcile the two. He was concerned that in removing the representational aspects of an image he would arrive at something that was mere ornament or decoration. The result, he feared, would be patterns that were only suited to appear on 'neckties and carpets'.

Kandinsky anguished that if he was to attempt to produce an abstract painting, 'what should replace the missing object?', as he asked in *Reminiscences*, published in 1913. How could an image with no apparent subject matter be judged? And if a painting couldn't be valued for its ability to evoke the real world, how could it possibly be seen as worthy of hanging in an art gallery?

Of course, Kandinsky eventually put his concerns aside and wholeheartedly embraced abstraction, but in recent years his reputation as its sole originator has been called into question. Although he was keen to claim that he was the first artist to produce a non-objective painting, his early abstract images often had concealed figurative elements. He is also known to have changed the dates of certain works to enhance his standing in the avant-garde, and he was by no means the only artist who was engaged in the quest for abstraction at the time.

Father of Abstraction or not, Kandinsky had a more profound effect on the landscape of 20th century art than almost any other artist. What is not in question is the quality and originality of the vast body of work that he produced over his long and distinguished career.

Much of the development of art in the 20th century has been concerned with finding out how abstraction might replace 'the missing object'. You will find Kandinsky's solution in the pages of this book. I hope you find his work as enjoyable, challenging and thought provoking as I always have.

Elizabeth Keevill, *2005*

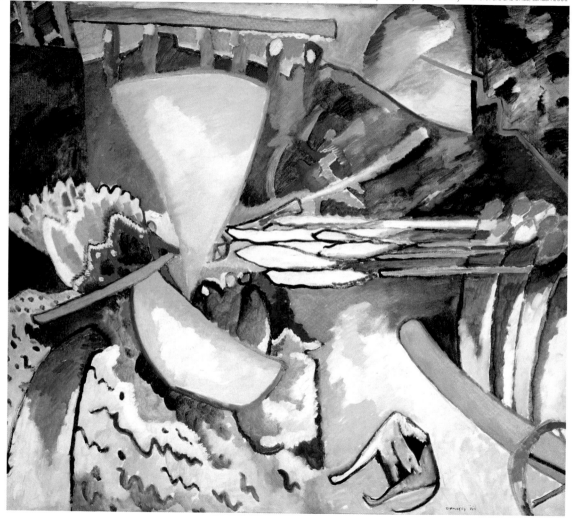

Introduction

'If I wanted to characterize myself, I would say: constantly, chronically restless. Yes, that is the possibly surprising but strict truth ... not a moment's rest you understand. Am always excited, my heart always feels different things simultaneously...There's plenty of joy in my heart. I love life so very much.'

Vasily Kandinsky, 1903

This statement by Kandinsky probably sums up his artistic approach much better than anything written by anyone else. It was written in a letter to his then-companion Gabriele Münter (1877–1962) at the beginning of what turned out to be an extraordinary artistic career. Kandinsky came to painting at a time when the old order was in rapid decline across Europe, and artists were seeking a new artistic language for a new epoch. His was Abstraction.

He was born Vasily Vasilievich Kandinsky, on 4 December 1866 in Moscow, the only son of a wealthy tea merchant. Within five years his parents were divorced and he lived with his father and aunt in Odessa. In 1886 he returned to Moscow to study law and economics at the city's university, finally submitting his doctoral thesis 'On the Legality of Labourers' Wages' in 1893. The year before, he had married his second cousin Anya Shemyakina, seven years his senior. Kandinsky initially settled into academic life as a teacher at Moscow University, but in 1896 decided to take up painting full time after seeing an exhibition of Claude Monet's (1840–1926) 'Haystacks' paintings, and attending a performance of Richard Wagner's (1813–83) *Lohengrin*, 'two events that stamped my whole life and shook me to the depths of my being'.

At 30 years of age, Kandinsky made a life-changing decision and moved to Munich, a city that was considered a progressive centre for art, particularly in its adoption of *Jugendstil*, a decorative-arts adaptation of Art Nouveau motifs. He enroled at the private academy of Anton Azbé (1862–1905), a Slovenian painter, where he met other like-minded painters such as Alexei Jawlensky (1864–1941). It was while subsequently studying with Franz von Stuck (1863–1928) at the Munich Academy of Art in 1900 that he met the artist Paul Klee (1879–1940). The following

year, Kandinsky and Jawlensky were instrumental in starting an artists' exhibiting society called Phalanx. The society grew in popularity and in the same year Kandinsky opened his own art school, also called Phalanx. The school was one of the few art schools open to women, and it was here that he met Gabriele Münter, one of his pupils, who from 1902 also became his companion.

Between 1903 and 1907, Kandinsky and Münter travelled extensively around Europe, making contact with many of its avant-garde artists, some of who had been included in the last of the Phalanx exhibitions in 1904. He travelled to Moscow and St Petersburg to exhibit with their respective Artists' Associations, thus developing his contacts in Russia, and held his first one-man exhibitions in Munich. During this period, he also exhibited at the *Salon d'Automne* and the *Salon des Indépendants* in Paris, with *Die Brücke* ('The Bridge') group in Dresden and the Secessionists in Berlin. Kandinsky had witnessed the burgeoning development of modern art across Europe, and wanted to be an integral part of it.

Kandinsky's paintings of the first decade of the twentieth century can best be described as Expressionist in temperament and style, but by 1910 he had begun to develop more abstract forms in his works, which he referred to as 'impressions', 'compositions' and 'improvisations'. Although Kandinsky had always had more than a passing interest in music, his meeting with the composer Arnold Schönberg (1874–1951) confirmed his belief in its relationship with painting. This development coincided with Kandinsky's first major theoretical work, *Concerning the Spiritual in Art*, in which he promulgated his ideas on colour and form, and philosophized about his artistic credo to paint from 'an inner necessity'. Apart from the publication of this influential book, the year 1911 also saw his divorce from Anya finalized and in December he held the first of *Der Blaue Reiter* ('The Blue Rider') exhibitions in Munich. *Der Blaue Reiter* consisted of a small group of artists around Kandinsky that included Münter, Auguste Macke (1887–1914), Jawlensky, Paul Klee and Franz Marc (1880–1916).

The following year Kandinsky and Marc produced an almanac for *Der Blaue Reiter* with contributions from the aforementioned artists as well as from Schönberg, who contributed an article on the relationship of painting to music, and Thomas von Hartmann (1885–1956), who wrote an article called 'Anarchy in Music'. Both Marc and Macke also contributed essays as well as visual images to the almanac. During this busy period, Kandinsky was submitting paintings for exhibitions in Zurich, Berlin, Amsterdam and Russia, travelling there in late 1911 to read excerpts from *Concerning the Spiritual in Art* to the All Russian Artists Congress in St Petersburg.

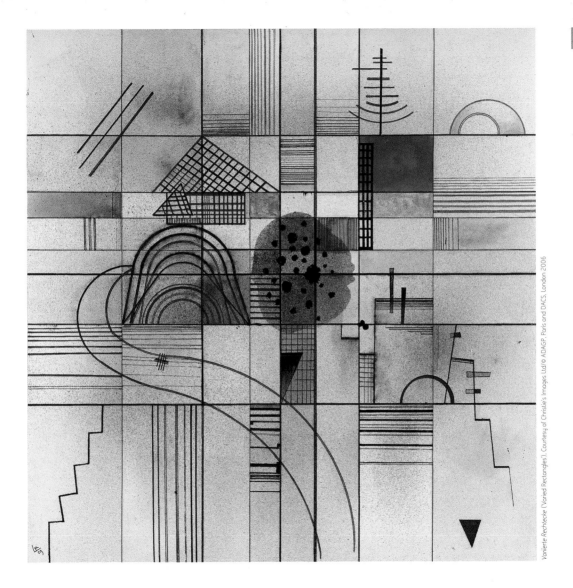

Despite his popularity in Europe at this time he was forced to return to Moscow in 1914 after the First World War was declared. This enforced repatriation was a difficult time for Kandinsky. He was now permanently separated from Gabriele Münter, limited as to his exhibition opportunities, and living in a country threatened by revolution. The ensuing civil war did little to help Kandinsky's painting career since he was now without bourgeois patrons. With his new wife Nina to support, he became an educationalist as part of *INKhUK* (Institute of Artistic Culture) and at the *VKhUTEMAS* (State Higher and Artistic and Technical Studios). After disagreements with the authorities and the new avant-garde in Russia, Kandinsky left in 1922 for a new teaching post in Germany at the Bauhaus.

Kandinsky's duties at the Bauhaus were as a teacher, in the wall-painting workshop, and on the theories of form as part of the basic course. These theories had already been formulated by Kandinsky in his *Concerning the Spiritual in Art* and in his work at Inkhuk. However, in 1926, after the Bauhaus moved to Dessau, Kandinsky published his

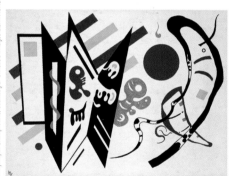

second most important text, *Point and Line to Plane*, a theoretical work that was highly influential in the development of graphic design. Despite his not-inconsiderable teaching duties, Kandinsky was still a prolific painter and continued to hold one-man exhibitions during the 1920s in Stockholm, Munich and Berlin. He also held solo exhibitions in The United States: New York in 1922 and on the West Coast in 1924.

Between the years 1925 and 1933, when Kandinsky finally left the Bauhaus, he produced more than five hundred paintings and watercolours. In 1928, to coincide with his sixtieth birthday and on becoming a German citizen, a major retrospective of his work was held, which toured five German cities. In 1929 he had his first one-man exhibition in Paris and in 1930 was exhibiting again in Paris and at the Venice Biennale. During his final years at the Bauhaus, Kandinsky had achieved truly international status as an artist with further exhibitions in major European and American cities, and was now included in the pantheon of great artists at the Museum of Modern Art in New York.

After the Nazis closed the Bauhaus in 1933, Kandinsky and his wife Nina moved to the Parisian suburb of Neuilly-sur-Seine. Although disappointed by the lack of sales in Paris and elsewhere as a result of the world Depression and

increasing political tensions; and having over 50 of his paintings confiscated by the Nazis as 'Degenerate Art', Kandinsky continued to paint with as much vigour, passion and enthusiasm as he had always shown. He was afforded a one-man show at Peggy Guggenheim's gallery in London, and shared an exhibition with Fernand Léger (1881–1955) and Paul Klee in New York, both in 1938. He continued painting up until the summer of 1944 when he became ill, dying in December less than two weeks after his seventy-eighth birthday.

Since his death, there have been many attempts to characterize Vasily Kandinsky and his paintings. There have been a number of retrospectives of his work, the first being as early as 1945 in New York. More recently, the Royal Academy, London, held a major exhibition of his watercolours, its president Sir Philip Dowson stating that, 'Kandinsky exemplifies the art of the century in so many ways. Along with such seminal figures as Einstein, Freud, Schönberg and Joyce, he revolutionized our world.' Dowson was referring of course to Kandinsky's role in realizing the full potential of Abstraction. Yet to pigeonhole Kandinsky as an abstract artist is a mistake. His art is much more than that: it was the spirit of his own age, an age of revolutionary art. As he said himself, 'Every artist, as child of his age, is impelled to express the spirit of his age.'

Kandinsky's artistic output in terms of volume and consistent quality is phenomenal by any standards and matched by very few artists in any generation. Although like many artists his paintings show an apparent dissimilarity between the early and mature works, Kandinsky showed one consistent theme throughout, the 'inner necessity' to paint. As his fellow artist Diego Rivera (1886–1957) has suggested, 'Kandinsky's art is not a reflection of life, it is life itself.'

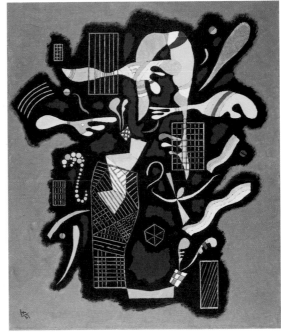

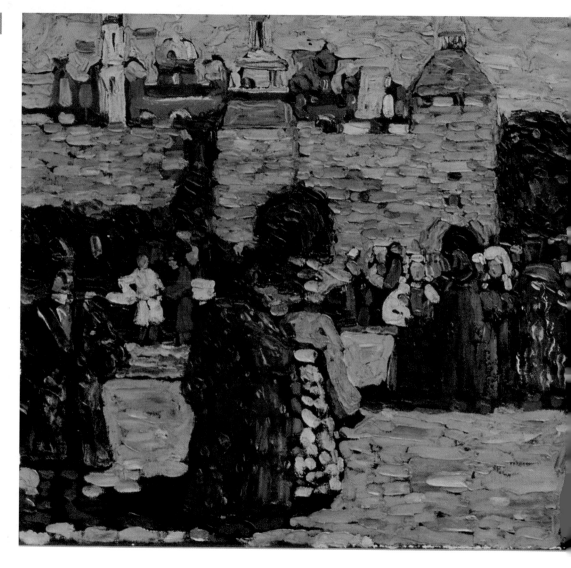

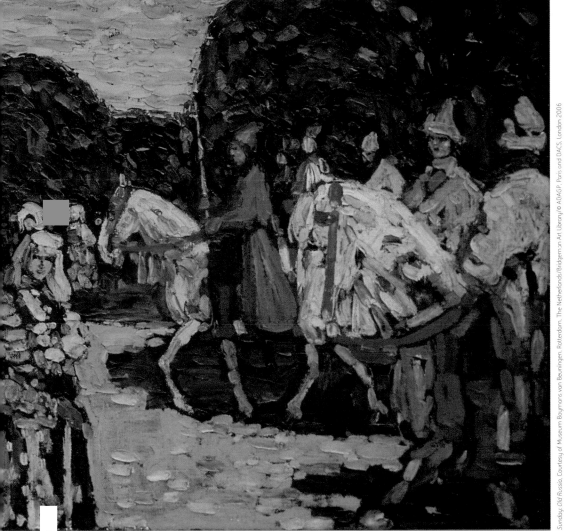

THE W

Kandinsky

GREATE

Influences

Sunday: Old Russia, 1904

With no formal art training, Kandinsky left Moscow, his home for the first three decades of his life, to pursue a career in painting. Unlike most men at 30 years of age, he turned his back on an established and very promising academic career in furtherance of what seemed a pipe dream. Kandinsky had been greatly moved by an exhibition in Moscow of Claude Monet's (1840–1926) 'Haystacks' series of pictures, which were currently touring.

Kandinsky chose to start his training and new career in a foreign city, Munich, where he moved with his young wife in 1896. Munich was a very cosmopolitan city and had recently witnessed the 'new art' of the *Sezession* ('Secession'). He began working at the studio of Anton Azbé (1862–1905), who taught him anatomical drawing, but also, more importantly, a Divisionist style of painting. It was a derivative of Impressionism that juxtaposed contrasting colours in order that each colour was defined by its complementary. There is, however, a strong sense of Kandinsky's own Russian traditional folklore in this work, something that was to be a recurrent theme in later years.

CREATED

Munich

MEDIUM

Oil on canvas

RELATED WORK

Claude Monet, 'Haystacks' series, 1889–1891

Vasily Kandinsky *Born* 1866 Moscow, Russia

Died 1944

An Arab Town, 1905

After receiving tuition at the studio of Anton Azbé and then at the Academy of Fine Arts in Munich with the Symbolist painter Franz von Stuck (1863–1928), Kandinsky was, by 1900, ready to undertake the challenges of becoming a painter on his own terms. In order to support himself he began teaching, and one of his pupils was Gabriele Münter (1877–1962), who was very soon to become his constant companion. It was with Gabriele that he went travelling across Europe between 1903 and 1909. They also travelled to Tunisia between December 1904 and April 1905.

Tunisia had become a French protectorate in 1881, after much wrangling with other interested parties such as Italy and Britain. Unlike most Western artists of this time, Kandinsky did not present his viewers with an idealized version of an Arab town. By using tempera as his medium to provide a very matt picture surface, he evokes the dryness synonymous with this desert town. In Kandinsky's early work we see a number of references to fairy tales, this painting referring perhaps to *Tales from the Arabian Nights*, which had been translated into English and other European languages during the nineteenth century.

CREATED

Probably Tunisia

MEDIUM

Tempera on card

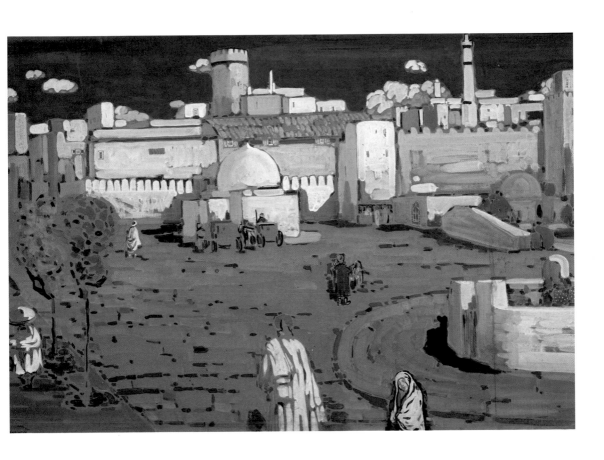

Song of the Volga, 1906

In this work we begin to see the synthesized ideas that Kandinsky was working towards at this time. The depiction of a fairy tale or folk tale motif using broad brushstrokes of bright colour, evokes a sense of the 'unworldly' from a former 'golden age' of Russian life. This image is in stark contrast to the Realism used by a number of Russian artists, such as Ilya Repin (1844–1930), at the end of the nineteenth century to depict the harshness of the boatmen's world. 'The Song of the Boatmen' was a traditional folk song intended to help the barge-haulers with their back-breaking work, 'Yo heave ho, Yo heave ho, Once more, once more, Yo heave ho, pull the barge against the river's tide'. The strong sense of tradition and legend in Kandinsky's work from this time suggests that he was seeking to depict the worldly and spiritual aspects of both new and old Russia.

The picture also suggests that Kandinsky is beginning to involve music in his painting, a factor that was to be so crucial in his work.

MEDIUM

Oil on canvas

RELATED WORK

Ilya Repin, *Bargehaulers on the Volga*, 1871

Zwei Mädchen ('Two Girls'), 1907

In this image of two girls, or two maidens, we begin to see Kandinsky simplifying his forms, through the influence of *Jugendstil* ('young style'). Members of the Secession in Munich adopted this 'young style' from 1896 until its demise in the first decade of the twentieth century. The journal *Die Jugend* ('Youth') was used to disseminate many of these new art and design ideas to a wider public, and there are similarities to the graphic design work of, for example, Ludwig von Zumbusch (1874–1940), who often illustrated the journal. *Jugendstil* has many of the familiar motifs from its corresponding Art Nouveau movement in other parts of Continental Europe; the dream-like quality and simplified curvilinear forms. By the time of this painting by Kandinsky, many of these other Art Nouveau influences had been widely disseminated and, in fact, the style was on the wane.

Kandinsky's image has none of the harsh, often satirical humour of Munich's Secession as exemplified by, for example, Bruno Paul (1874–1968). Instead, Kandinsky seems to have drawn on other Art Nouveau influences, such as at Darmstadt, where artists including Peter Behrens (1868–1940) used a much softer palette in their work.

MEDIUM

Linocut with hand colouring

RELATED WORK

Peter Behrens, design for a house at Darmstadt, 1901

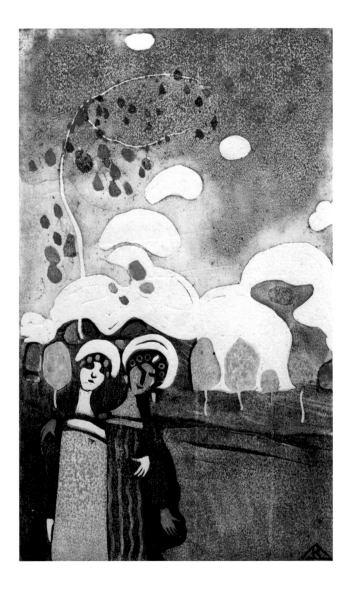

Szene ('Scene'), 1907

In the short time span between *Song of the Volga* and this painting, Kandinsky has simplified his forms and his technique for painting them. During the first half of 1907, Kandinsky and Gabriele stayed at Sèvres, outside Paris, where at this time paintings by Paul Gauguin (1848–1903) and Henri Matisse (1869–1954) were being exhibited. One can sense the influence of Matisse, particularly, in Kandinsky's work at this time through his use of simplified forms and use of brighter colours. In 1907 Matisse was working on his developed form of painting that later came to be known as Fauvism, a brief period of experiment in which he used colours in a non-natural way to express form. At this time Matisse was working on his text *Notes of a Painter* in which he articulated that 'a work of art must be harmonious in its entirety ... there must result a living harmony of colours'.

Matisse provided Kandinsky with a formula for using colour to express form, achieving Matisse's ideal of painting a picture that has a 'calming influence on the mind, something like a good armchair which provides relaxation from physical fatigue'.

MEDIUM

Gouache on black paper

RELATED WORK

Henri Matisse, *Landscape at Collioure*, 1905

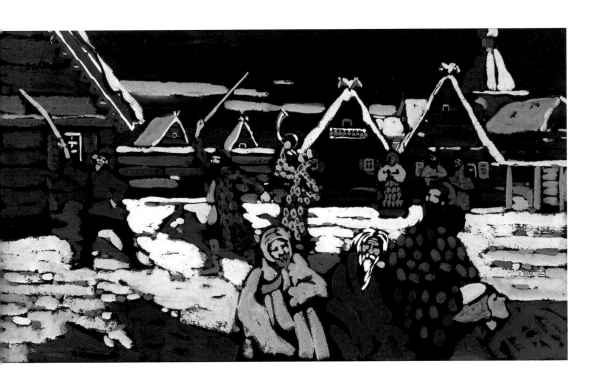

Arabian Graveyard, 1909

Courtesy of Hamburger Kunsthalle, Hamburg, Germany/Bridgeman Art Library/© ADAGP, Paris and DACS, London 2006

Apart from Matisse, it is clear that members of the Nabis group of artists, particularly Paul Sérusier (1864–1909), also influenced Kandinsky. The Nabis whose work had a particular currency during the 1890s, had taken their name from the Hebrew word meaning 'prophet', heralding the new spiritual avant-garde that took its lead from the work of Paul Gauguin. Gauguin sought to 'synthesize' the features of art as he saw them, that is natural forms and their appearance, the aesthetics of colour, line and form, and the artist's spiritual feelings about the motif. Its Symbolist aspirations were of interest to Kandinsky since they embraced notions of a spiritual world beyond mere appearance, which for him was the shortcoming of Impressionism.

In 1888, Sérusier had produced a small painting under the guidance of Gauguin entitled *Bois d'Amour at Pont-Aven*. This *tour de force*, which was subsequently nicknamed The Talisman, was the beginning of Sérusier's very subjective view of nature and was to have a profound effect, not only on the other Nabis painters, but others outside, such as Kandinsky.

CREATED

Munich

MEDIUM

Oil on cardboard

RELATED WORK

Paul Sérusier, *Bois d'Amour at Pont-Aven*, 1888

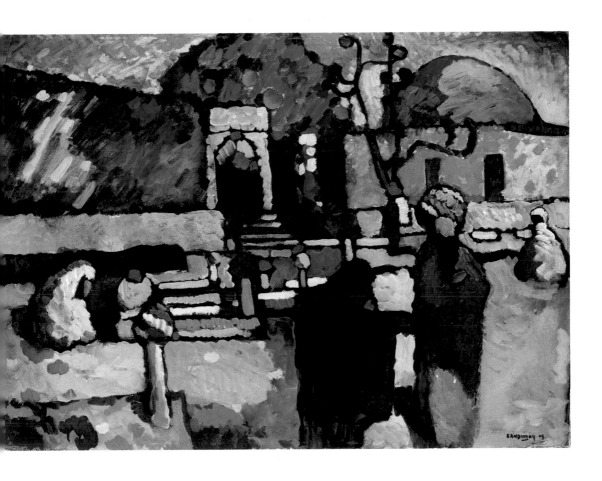

Landscape with a Steeple, 1909

In *Landscape with a Steeple* the colour is so dominant that figuration is almost subsumed as Kandinsky moves towards Abstraction. At this time Kandinsky, with his companion Gabriele Münter , began to spend much of his time south of Munich in a small town called Murnau, near the Alps. She bought a house, a perfect refuge where they could escape the hustle and bustle of city life in order to consider the more spiritual aspects of their art. Ironically the picture appears restless with contrasting colours vying for the viewer's attention.

Münter's work was every bit as strong as Kandinsky's at this time. They seemed to share a common language in the use of colour as a focal point, but Münter's paintings have less of an emphasis on Abstraction. Münter and Kandinsky were responsible for setting up the *Neue Künstlervereinigung* (NKV) (New Art Union) exhibitions of 1909 and 1910 in Munich. Münter's contribution included oil paintings and prints of still life and portraiture as well as landscapes.

CREATED

Murnau

MEDIUM

Oil on canvas

RELATED WORK

Gabriele Münter, *Winter Landscape*, 1909

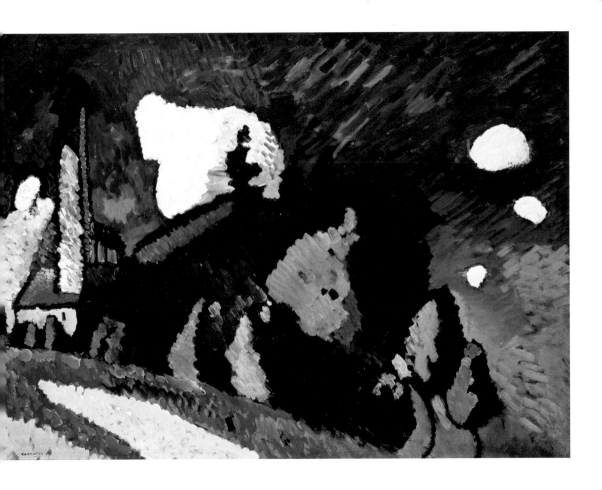

Winter Landscape, 1909

Courtesy of Hermitage, St Petersburg, Russia/Bridgeman Art Library/© ADAGP, Paris and DACS, London 2006

The house purchased by Gabriele Münter was also a popular meeting place for other artists sympathetic to Kandinsky's ideals. Two fellow Russian artists Alexei Jawlensky (1864–1941) and his companion Marianne Werefkin (1860–1938) were frequent visitors. Like Kandinsky, Jawlensky received some of his art training at the studio of Anton Azbé where he learnt the importance of line and colour. Although his work is often seen as German Expressionist, it has more in common with the French art of the Fauves, particularly that of Maurice de Vlaminck (1876–1958). From him and indeed from the work of Vincent van Gogh (1853–90), he derived the strong lines and thickly applied colour synonymous with those two artists. Certainly his own *Landscape with a Red Roof* is clearly indebted to van Gogh.

Perhaps more importantly, Jawlensky also imparted his 'synthetist' principles of art that he had learned from Paul Sérusier with whom he had an enduring friendship. Their Theosophical ideas on the importance of the soul found a willing respondent in Kandinsky who was, at this time, seeking to mirror his own soul in his art.

CREATED

Murnau

MEDIUM

Oil on canvas

RELATED WORK

Alexei Jawlensky, *Landscape with a Red Roof*, 1910

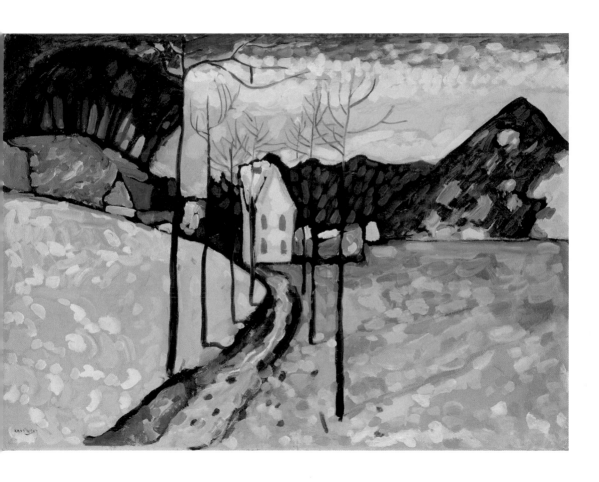

First Abstraction, 1910

The publishers of Kandinsky's woodcuts in 1904, Piper Verlag, published Wilhelm Worringer's (1881–1965) *Abstraktion und Einfühlung* ('Abstraction and Empathy') in 1907, in which the writer countered what he called the 'European classical prejudice of our valuation of art'. Worringer had noted that artists had already started to move away from objective considerations to subjective ones, seeking the ethereal and spiritual aspects of the human condition. This was evident in the work of, for example, Gauguin and also some of the Munich Symbolists, such as Franz von Stuck (1863–1928), under whom Kandinsky studied for a while in 1900. Worringer polarized this sense of human artistic feeling as an 'urge to empathy', to be countered by an equal 'urge to abstraction'. 'Just as the urge to empathy as a pre-assumption of aesthetic experience finds its beauty in the organic, so the urge to abstraction finds its beauty in the life-denying inorganic.'

This text continued to be published during the first half of the twentieth century, making it an important point of reference for all artists seeking the move towards Abstraction.

CREATED

Munich

MEDIUM

Pen, ink and watercolour

RELATED WORK

Robert Delaunay, *Simultaneous Windows*, 1913

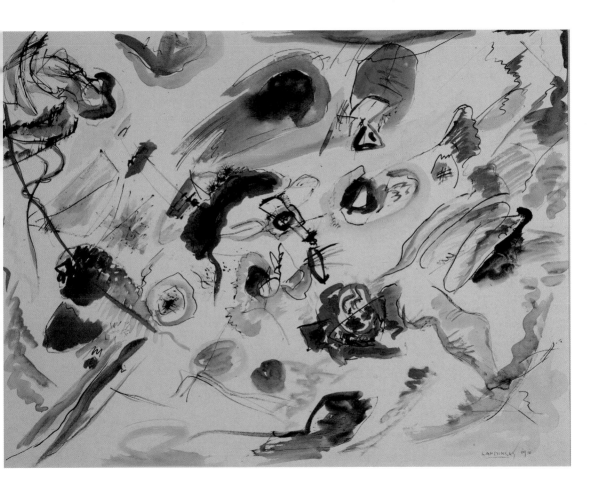

Improvisation, 1910

The 'Improvisations' that Kandinsky embarked on in 1909 and 1910 were a total leap of faith, and reflected his confidence as an artist, having left behind all references of the material world in favour of expressing a purely spontaneous emotional response to a motif or an idea. The works are an example of the *gesamtkunstwerk* ('total work of art') that artists were seeking at the end of the nineteenth and into the twentieth centuries. Their aspirations were to engage with other art forms in an attempt to create a more rounded work of art. Although later it had practical considerations for Kandinsky when he was at the Bauhaus, in its original context the *gesamtkunstwerk* was intended as a synthesis of other art forms, such as music.

Kandinsky, in his *Concerning the Spiritual in Art*, makes specific reference to the influence and inclusion of music in his own ideas of *gesamtkunstwerk*. In particular he refers to the atonal music of Arnold Schönberg (1874–1951), which departs from the conventions of European Classical tonal hierarchies. The abstract notions of Schönberg's music found a resonance with Kandinsky's own abstract aspirations.

CREATED

Munich

MEDIUM

Oil on canvas

RELATED WORK

Paul Klee, *Instrument for New Music*, 1914

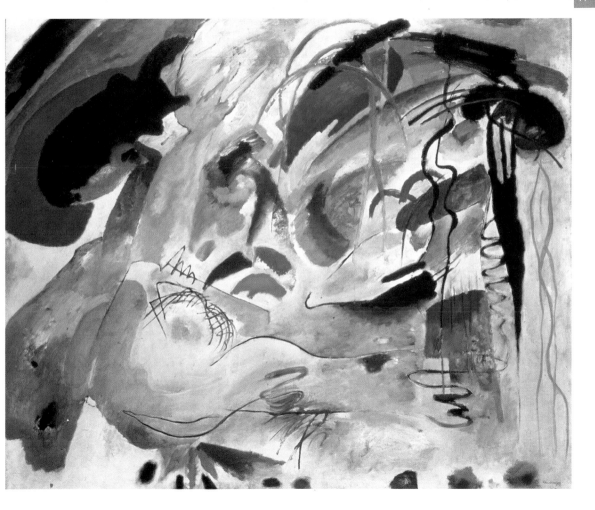

Saint Vladimir, 1911

In October 1910 Kandinsky left Murnau to visit his family in Moscow for the first time in seven years. It was also the first time that he and his companion Gabriele Münter had been separated for any length of time. On his arrival in Moscow he wrote to Gabriele in a euphoric voice about the wonders of Moscow, which for him were 'balm'. 'How different the people are. Why is life here ... more intense and gripping? How will the old religious art affect me? Shall I find the core that I seek, to touch?'

The answer was in this picture, in which Kandinsky returned to a more representational style in his depiction of the patron saint of Russian Catholics, Saint Vladimir. Vladimir was sole ruler of Russia in the tenth century and renowned for his cruelty. Yet, he was reformed after witnessing the progress of Christianity in Russia, later marrying the daughter of the Eastern Emperor, Basil II, and allowing his subjects to practise Christianity. Kandinsky's image is one that pays due deference to St Vladimir and his influence on Russia and its people.

CREATED

Possibly Moscow

MEDIUM

Oil on canvas

RELATED WORK

Eighth/ninth century Byzantine religious icons

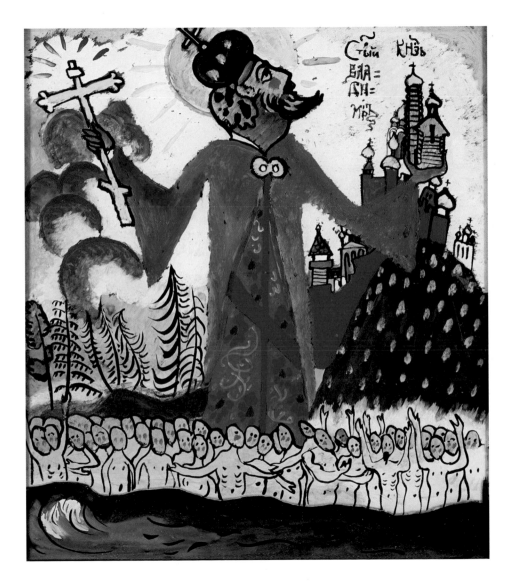

St Gabriel, 1911

In this painting of Saint Gabriel, Kandinsky combines his recent exposure to Russian religious icons in Moscow with a very individual interpretation of the *Jugendstil* of his adopted city Munich. Although more of a design and aesthetic ideal than a 'school of painting', *Jugendstil* had certain characteristics that lent themselves well to the graphic and visual arts. Its journal *Die Jugend*, founded in 1891, was published to promote the ideas and values of the Secession, a group of artists headed by Kandinsky's former tutor Franz von Stuck, who sought to distance itself from the staid academic tradition in Munich. In many ways, both stylistically and politically, it echoed Art Nouveau efforts in other European cities to promote a new art for a new century.

Art Nouveau style is characterized by the sinuous 'whiplash' lines, which Kandinsky used to good effect in his portrayal of Saint Gabriel. It is also surely no coincidence that the name was also that of his companion, her look of dismay perhaps reflecting the anxious letters she wrote to him during their long separation at this time.

CREATED

Possibly Moscow

MEDIUM

Oil on canvas

RELATED WORK

Gustav Klimt, *The Beethoven Frieze*, 1902

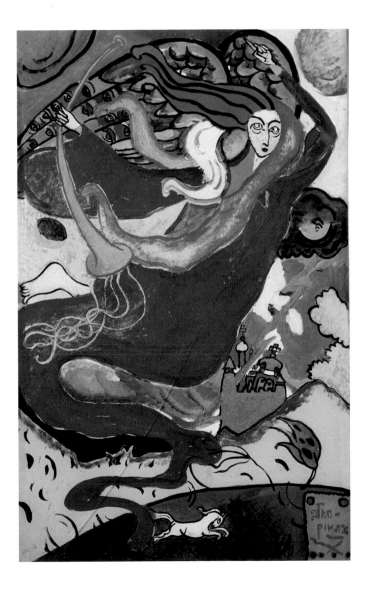

Woman in Moscow, 1912

Following the jury's rejection of Kandinsky's painting *Composition V* at the *Neue Künstlervereinigung* (NKV) exhibition in December 1911, both Kandinsky and Franz Marc (1880–1916) resigned from the society. They hurriedly arranged to show the work instead at the *Moderne Galerie Tannhauser* under their banner of *Der Blaue Reiter* ('The Blue Rider'). Gabriele Münter and Auguste Macke (1887–1914), as well as Henri Rousseau (1844–1910), Paul Klee (1879–1940), Albert Bloch (1882–1961) and Robert Delaunay (1885–1941) joined them. This marked the beginning of a period of intense friendship between Kandinsky, Macke and Marc, which lasted until the deaths of both Macke and Marc during the First World War.

All three artists had a preponderance for blue in their work, Kandinsky explaining in *Concerning the Spiritual in Art* that it was the 'heavenly' colour. Although stylistically different in terms of motif, Kandinsky was particularly drawn towards Marc with whom he shared the notion of the spiritual renewal of Western art through painting. In his essay for *Der Blaue Reiter* almanac, Marc stated that, 'it can be sensed that there is a new religion arising in the country, still without a prophet, recognized by no one'.

CREATED

Munich

MEDIUM

Watercolour on paper

RELATED WORK

Franz Marc, *Yellow Cow*, 1911

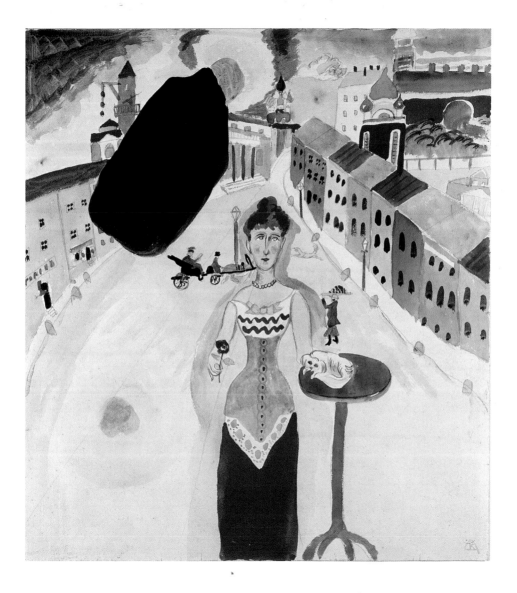

Der Blaue Reiter ('The Blue Rider'), 1912

The catalogue for *Der Blaue Reiter* exhibition announced the imminent publication of *Der Blaue Reiter* almanac, which Kandinsky and Franz Marc had been working on during 1911. Published by Piper Verlag in May 1912, the almanac became one of the most important manifestoes for the development of modern art throughout Europe. Although it was intended as a periodical, Kandinsky refused to contribute to a second edition, although its popularity ensured that it was reprinted in 1914.

The almanac was a testament to Kandinsky's and Marc's aspirations of a spiritual renewal in Western art. It included essays by Kandinsky, Macke and Marc and reproductions of works of art, not only by members of *Der Blaue Reiter* group, but others within the European avant-garde, such as Robert Delaunay, to whom they felt indebted. There were also works of art from previous epochs, demonstrating, for example, the skills in *verre églomisé* (glass painting) and manuscript illustration. The almanac was, however, designed to edify the public about *Der Blaue Reiter* ideals. Kandinsky stated, 'None of us seeks to reproduce nature directly. We are seeking to give artistic form to inner experience.'

CREATED

Munich

RELATED WORK

Gabriele Münter, *Open-air Café*, 1912

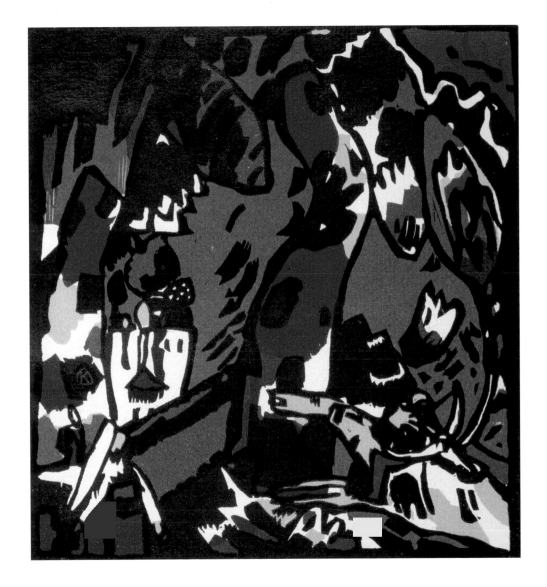

St George, 1914–15

When Kandinsky arrived in Munich in 1896, he would almost certainly have seen the work by the English artist and illustrator Walter Crane (1845–1915) in the journal *Kunst für Alle* ('Art for All'). The June 1896 issue of the journal carried a translated article by Crane, and a reproduction of his image of Saint George killing a dragon. The legend of Saint George was traditionally an allegory for the triumph of good over evil, or the death of Satan at the hands of Christianity. Crane's illustration was of George slaying the dragon who represented materialism, a key aspect of English Victorian life. Crane had been a part of the English Arts and Crafts ideals in which its leaders, John Ruskin (1819–1900) and William Morris (1834–96), had eschewed notions of materialism that had prospered during the nineteenth century.

This accorded with Kandinsky's own ideals of the death of materialism. The dragon as portrayed by Kandinsky is often seen, as in this image, as a caricature. Kandinsky's use of humour has, as Peg Weiss (1933–96) has pointed out in *Kandinsky in Munich*, a precedent in the Munich artist Thomas Theodor Heine's (1867–1948) work, which was reproduced in a 1903 edition of *Kunst für Alle*.

CREATED

Probably Moscow

MEDIUM

Oil on cardboard

RELATED WORK

Walter Crane, *Sir Galahad is Brought to the Castle of King Arthur*, 1890

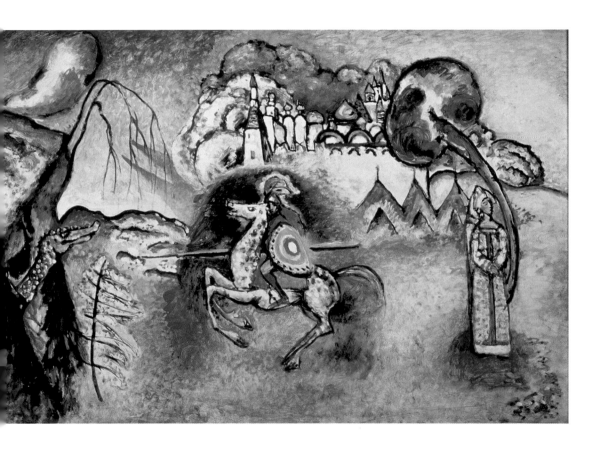

Imatra, 1917

Courtesy of Pushkin Museum, Moscow, Russia/Bridgeman Art Library/© ADAGP, Paris and DACS, London 2006

The outbreak of the First World War in August 1914 had caused Kandinsky and Gabriele Münter to flee to the safety of Switzerland where they stayed until the beginning of 1915. Kandinsky then travelled to Moscow by himself. In December 1915 he travelled to Stockholm where he stayed for three months with Gabriele, but it was to be their last time together. The separation from his companion of 13 years, and his decision never to return to Murnau, mark this as the end of the first decisive phase of Kandinsky's artistic career.

On his return to Moscow he was, of course, not a stranger to the artistic milieu. Apart from his visits in 1910 and 1912, he had regularly contributed articles to Russian art journals while in Munich. By the date of this picture, though, Kandinsky was out of step with the more radical aspects of the Russian avant-garde in post-revolutionary Russia. Unlike Kandinsky's notions of Abstraction, which were spiritual, the new avant-garde included artists such as El Lissitzky (1890–1941) and Kasimir Malevich (1878–1935) and was more formalist in its approach. During this temporary hiatus in Kandinsky's career he returned to a key theme of his earlier work, the Russian folk tale.

CREATED

Moscow

MEDIUM

Watercolour on paper

RELATED WORK

Kasimir Malevich, *Eight Red Rectangles*, 1915

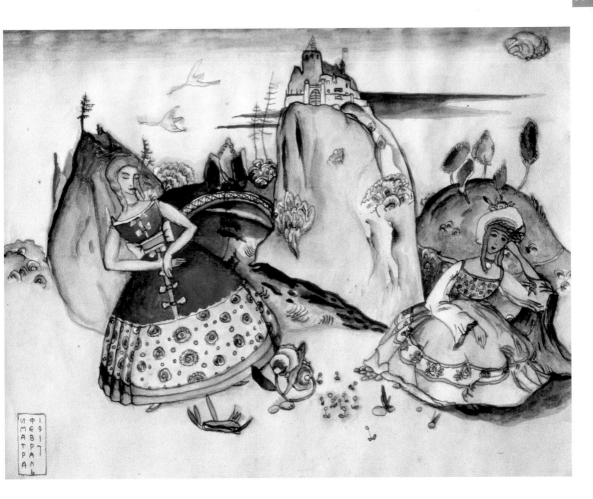

Composition No. 218, 1919

By 1909–10, Kandinsky began to separate his abstract paintings into three categories. The first were 'Impressions' which retained an element of naturalism. The second were 'Improvisations' which were considered to be spontaneous emotional reactions to an idea or a motif. Finally 'Compositions' were intended as the highest achievable resolution in a painting, since they contained elements of both 'Impressions' and 'Improvisations' as a part of their preliminary work, and often entailed reworking over a period of time.

In this highly resolved work, Kandinsky has begun his journey along the path of what he called the 'Great Abstraction'. For him a painting could be an Abstraction as long as it possessed 'soul'. His ideas are essentially Hegelian in that the highest function of art should be an expression of the Divine. Although this idea was originally manifest in the nineteenth century and appealed to the Romantic artists, Kandinsky considered that the idea could be expressed better if the 'form' was separated from the 'matter'. These thoughts were laid out by Kandinsky in his essay 'On the Question of Form', published in 1912 in the almanac *Der Blaue Reiter*.

CREATED

Moscow

MEDIUM

Oil on canvas

RELATED WORK

Caspar David Friedrich, *The Wanderer Above the Sea of Clouds*, 1818

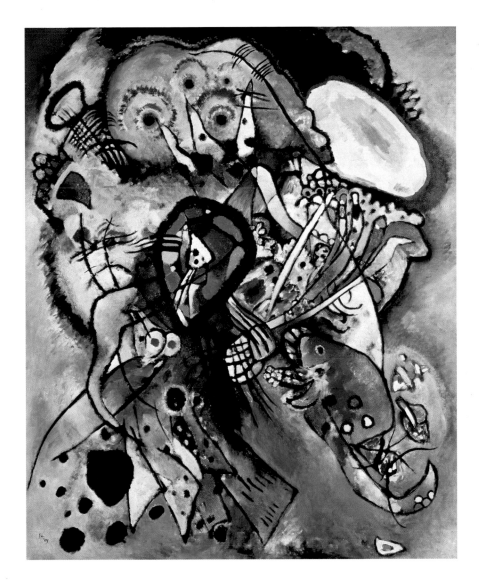

Composition Lyrique, 1922

In post-revolutionary Russia, Kandinsky's status as an artist was high enough for him to be included in proposals by the State for the reorganization of art and its education. In 1920 he submitted his 'Plan for the Physico-psychological Department of the Russian Academy of Artistic Sciences' to 'establish the principles of aesthetic artistic expression'. His plans, which included further research into primitive art through the setting up of 'laboratories', was, however, not acceptable to the State, who twice rejected his plans.

This rejection and Kandinsky's continued isolation from the Russian avant-garde were contributing factors to him accepting Walter Gropius's (1883–1969) offer to visit the Bauhaus in 1921. In 1917 Kandinsky had met and married Nina von Andreyevskaya, and it was with her that he travelled to Weimar where he accepted a painting professorship to teach at the Bauhaus from June 1922. The faculty included the artists Lyonel Feininger (1871–1956) and Paul Klee, both of whom would later, with Kandinsky, re-form *Der Blaue Reiter* group as the Blue Rider Four.

CREATED

Weimar

MEDIUM

Watercolour

RELATED WORK

Paul Klee, *Magnetic Apparatus for Plant Cultivation*, 1921

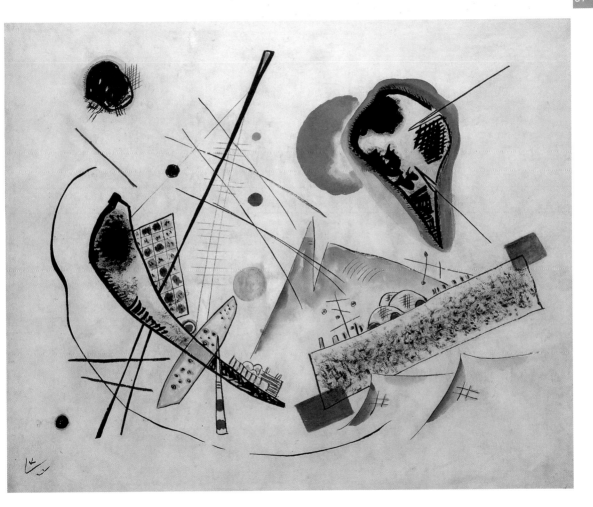

Lithographie für die Vierte Bauhausmappe ('Lithography for the Fourth Bauhaus Bag'), 1922

Courtesy of Christie's Images Ltd/© ADAGP, Paris and DACS, London 2006

By 1922, when Kandinsky arrived at the Bauhaus, Walter Gropius was already moving away from the image of the 'cathedral of Socialism', suggested by Lyonel Feininger's illustration on the front cover of the first Bauhaus prospectus in 1919. Like everyone else who came into contact with Gropius, Kandinsky was highly motivated by his ideas and his vision of the *gesamtkunstwerk*. Writing in 1922 Gropius affirmed that, 'the old attitude of *l'art pour l'art* ('art for art') is obsolete, and that things that concern us today cannot exist in isolation'. Referring to the progress being made in Russia concerning a more pragmatic attitude to the arts and sciences, he sought a 'big transformation from analytic to synthetic work'. Clearly he had both Kandinsky and Paul Klee in mind for this work, in place of the more charismatic, but idiosyncratic Johannes Itten (1888–1967), the then Master of Form in the painting workshops.

When Itten resigned in October 1922, Kandinsky had been in place only three months. Nevertheless Kandinsky was installed to teach a new course on form with Klee. This marked the end of the Expressionist phase of the Bauhaus.

CREATED

Weimar

MEDIUM

Lithograph

RELATED WORK

Gerhart Marcks, *The Owl*, a woodcut in the Expressionist style, 1921

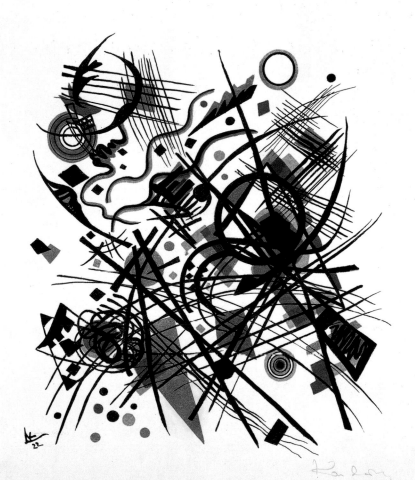

Launischer Strich ('Moody Strokes'), 1924

Walter Gropius was aware of Kandinsky's 'Plan for the Physico-psychological Department of the Russian Academy of Artistic Sciences' or *INDhUK* and sought to harness his ideas within the new Bauhaus, even though the more spiritual aspects of Kandinsky's oeuvre may have been at odds with his own ideals. In that respect Kandinsky had much in common with the first 'Master of Form' Johannes Itten, whom Gropius brought to the Bauhaus. Despite being a painter, Itten's talents were as a disseminator of mystic ideas of anti-materialism that he had learned as part of the pseudo-religion of Mazdaznan. The significance for the Bauhaus was that in Mazdaznan everyone has the innate ability to create, by adhering to its creeds of physical and mental exercises and a vegetarian diet, which brings one to a deeper understanding of a 'true' reality. Itten left in 1923, as the Bauhaus moved towards industrial considerations.

On a more pragmatic level, Itten introduced the so-called 'basic course' for all students to the Bauhaus, in which they were stripped of all artistic preconception learned during their formative years, laying the foundation for a more open-minded approach to their learning.

CREATED

Weimar

MEDIUM

Oil on board

RELATED WORK

Johannes Itten, 'Rhythmical Analysis of the painting *Adoration of the Magi*' 1921

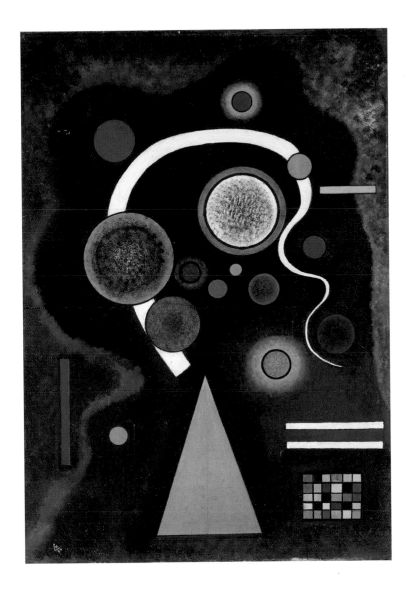

Loses im Rot ('Red Tickets'), 1925

The pseudo-religion of Theosophy played a vital role in the education of the students at the Bauhaus, firstly through Kandinsky and then later through the lectures of the *De Stijl* artist and polemicist, Theo van Doesburg (1883–1931). Kandinsky's interest was in Rudolph Steiner's (1861–1925) ideas that students, 'learning to think in images, even when there is no object to arouse his senses', can access spiritual wellbeing. At the Bauhaus, Kandinsky began to develop his own ideas around this notion using very specific colours. For example, the polarity of blue and yellow, the contrasts between black and white, and the primacy of the red, blue and yellow. Kandinsky also believed that he could use these combinations as a method of demonstrating his own visual aids to understanding the psychology of *gestalt* ('form'). This holistic approach to visual imagery had its beginnings in Germany in the early 1920s with the work of Max Wertheimer (1880–1943), who held that, in essence, 'the whole is greater than the sum of its parts', thus defying conventional empirical or positivist readings of pictures.

CREATED

Probably Dessau

MEDIUM

Oil on cardboard

RELATED WORK

Paul Klee, *Alter Klang*, 1925

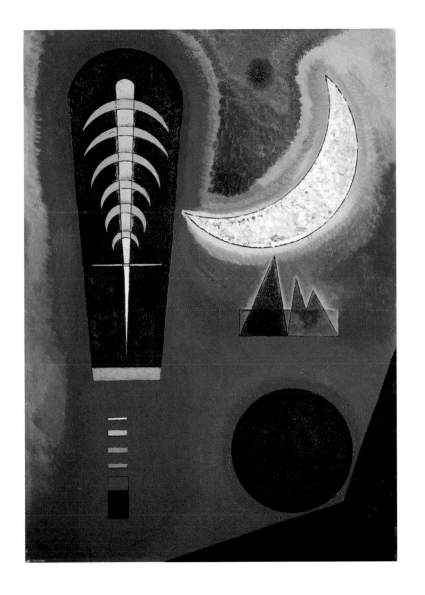

Deutliche Verbindung ('Clear Connection'), 1925

Despite being outside of the Russian avant-garde after the October Revolution, Kandinsky had nevertheless absorbed many of the ideas of the Constructivists, particularly the work of El Lissitzky who was later to be an important influence on the Bauhaus aesthetic, through László Moholy-Nagy (1895–1946). At the Bauhaus, Kandinsky began working on a synthesized version of Lissitzky's aesthetic that was more relevant to his own ideas of spirituality rather than the pragmatic Communist agenda. In 1926 he published his essay 'Point and Line to Plane', in which he extended Lissitzky's ideas of the utilization of geometric shapes as extolled in *Proun*, by suggesting that the shapes have an 'inner effect on the living subjectivity of the observer'. Kandinsky's suggestion is that the 'point' on a painting is not itself geometric, but possesses a certain potential for extension such as a square or other geometric shape. A line emanating from it is a force, which has been determined by the artist. In essence where lines are straight and unopposed it creates lyricism, but where they interconnect with other lines (forces) it creates a *mise en scène*.

CREATED

Probably Dessau

MEDIUM

Watercolour and pen and ink on paper

RELATED WORK

El Lissitzky, *Proun 12*, 1920

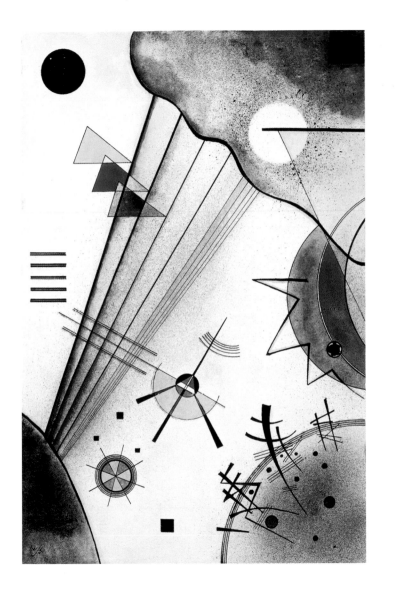

Schweben ('To Float'), 1927

When the Dutch *De Stijl* artist, architect and theoretician Theo van Doesburg (1883–1931) arrived at Weimar in 1921, he began a series of lectures aimed at Bauhaus students that was critical of the predominance of Expressionist ideas at the school. Walter Gropius was forced to listen and although he introduced a number of personnel reforms which did not include van Doesburg, the *De Stijl* aesthetic became yet one more aspect of study at the Bauhaus.

Kandinsky too was influenced by the *De Stijl* aesthetic, sharing the idea of depicting geometric shapes in space. In *Schweben* we see Kandinsky coming very close to the aesthetic of *De Stijl* and the Constructivists. He has removed the biomorphic or organic shapes, synonymous with many of his paintings, and replaced them with pure geometry. Even the title, which means 'to float', suggests that there is a van Doesburg 'architectonic sculpture' within it. From an architectural viewpoint, van Doesburg suggested that colour could be used to delineate spatial arrangements within an interior, and thus like Kandinsky sought the notion of 'living within the painting'.

CREATED

Dessau

MEDIUM

Oil on board

RELATED WORK

Theo van Doesburg, *Colour Design for Cine-dancing, Strasbourg*, 1926

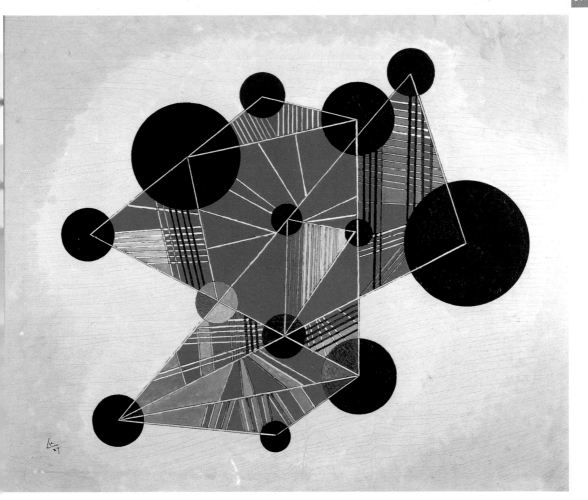

Leaning Semicircle, 1928

Following the departure of Johannes Itten and the change of direction at the Bauhaus by the end of 1922, the basic course needed a new person at the helm to implement Gropius's new maxim of 'Art and Technology – A new unity'. Gropius selected László Moholy-Nagy (1895–1946), a Hungarian Constructivist who had participated in Theo van Doesburg's Constructivist Congress at Weimar in 1922, which also included such luminaries as El Lissitzky, and Hans Arp (1886–1966). Despite the shortcomings in his use of the German language, Moholy-Nagy fulfilled his role with great enthusiasm and gusto. He transformed the basic course using Constructivist ideals that emphasized the pragmatic use of geometric shapes and the 'line' in the pursuit of design solutions. Moholy-Nagy became Gropius's right-hand man at the Bauhaus, and established himself as his confident and advisor, a position that Kandinsky had enjoyed until that time.

Although his pragmatic ideas were radically different to Kandinsky's, in terms of the function of art, it is clear that from the mid 1920s he exercised a considerable influence on the Russian's oeuvre with his use of geometric forms.

CREATED

Dessau

MEDIUM

Watercolour, pen and ink

RELATED WORK

László Moholy-Nagy, *Z IV*, 1923

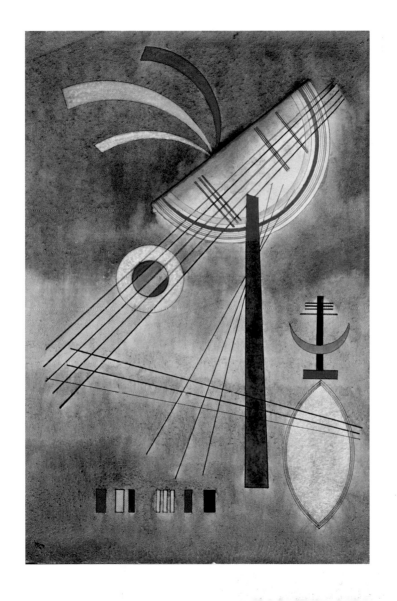

In Einander ('Overlapping'), 1928

After the move from Weimar to Dessau, Kandinsky lived in a house next door to his friend and fellow painter Paul Klee. Both artists began to share ideas by working even more closely together, and even persuaded Gropius to allow them to set up a free painting course for the students at the Bauhaus, which would also enable them to develop their own ideas about painting and its meaning. Both artists began to use a transparency in their 'forms' that allowed them to 'overlap' as in this work. There is the sense that the 'forms' are floating amoeba-like against the red background. One of the Bauhaus tutors was Ludwig Hirschfeld-Mack (1893–1965), who had experimented with light in the glass-painting workshops in the presence of Paul Klee. Klee's own work at this time was also developing a sense of these 'floating' and overlapping transparent forms. The French artist Robert Delaunay, whose Cubist pictures were essentially inspired by light sources, had, of course, influenced both artists in their pre-Bauhaus days.

CREATED

Dessau

MEDIUM

Watercolour, pen and black ink

RELATED WORK

Paul Klee, *Red Balloon*, 1922

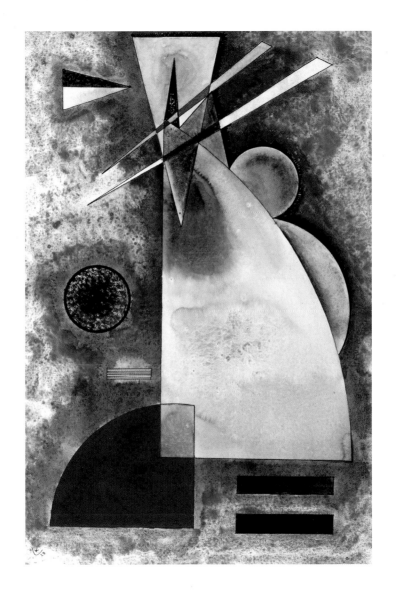

Gedrngt, 1928

When Kandinsky arrived at the Bauhaus, Oskar Schlemmer (1888–1943) had already been there for over a year. Schlemmer was the Master of Form in the sculpture workshops, his preoccupation being the depiction of the human form in space and its Abstraction; his figures often resembling figure-drawing marionettes. Schlemmer sought to depict his figures in a shallow space using a geometric language, and they were devoid of the emotion and alienation that he felt was part of the current human condition in the modern world.

Schlemmer also had a penchant for the theatre, later devising a 'mechanical ballet' in the theatre workshops. He first performed his so-called 'Triadic' ballet in 1922. The puppet-like characters possess geometric forms, triangular and pyramid shapes, the elements of which can be traced in Kandinsky's forms at this time. Kandinsky's own interest in the theatre is also not traditional, as he merely sees it as a vehicle, like Schlemmer, for the *gesamtkunstwerk*. In 1914 Kandinsky's own stage composition, *The Yellow Sound*, which was based on aspects of some of his own 'Improvisation' paintings, was due to be performed, but never materialized due to the First World War.

CREATED

Dessau

MEDIUM

Watercolour and Indian ink on paper

RELATED WORKS

Oskar Schlemmer, *Female Dancer*, 1922–23

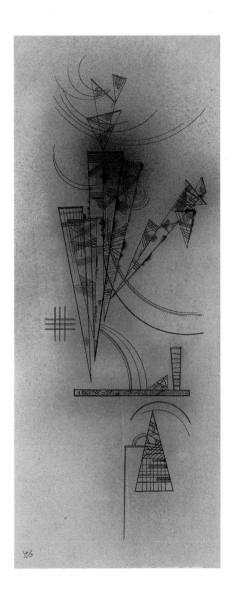

Auf Satten Flecken ('Full of Stains'), 1929

At the time of *Auf Satten Flecken*, Walter Gropius had resigned as director of the Bauhaus and it was under the new leadership of Hannes Meyer (1889–1954). It was a time of great uncertainty since Meyer was not altogether popular. Kandinsky fared reasonably well as Meyer had great respect for his artistic theories, if not for his painting. The painting *Auf Satten Flecken* seems to sum up the mood of the time very well; Kandinsky's lighter and fresher palette giving way to more sombre and brooding tones.

This period tended to overshadow events of the previous year when Kandinsky was finally able to achieve a musical and visual *gesamtkunstwerk* that ameliorated his disappointment with the failed *The Yellow Sound*. Kandinsky had always been interested in music and its relationship with painting and the other arts. In Paul Klee, a musician turned painter, he found the perfect soul mate. Kandinsky was involved in a stage production of Modest Mussorgsky's (1839–81) *Pictures at an Exhibition*, in Dessau. For this he created a number of very ambitious sets using geometric props set against a black backdrop; suggesting one continuous painting that homogenized the separate scenes.

CREATED

Dessau

MEDIUM

Gouache on paper, laid down on card

RELATED WORKS

Paul Klee, *Album Page for a Musician*, 1924

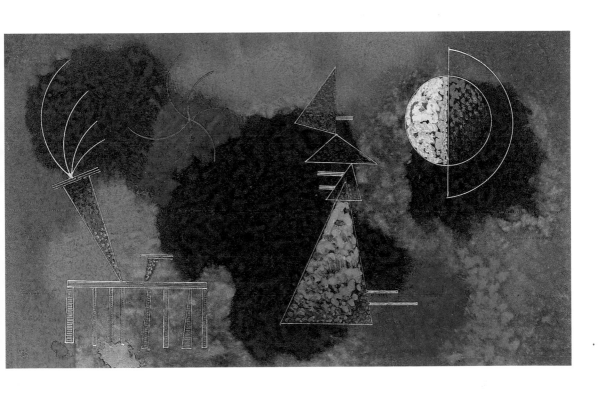

Ausser Gewicht
('Out of Weight'), 1929

Part of Kandinsky's remit on arrival at the Bauhaus was to take charge of the mural-painting workshop. Gropius, as part of his reforms in 1923, had suggested that the walls of the art school itself should be painted or decorated in some way, providing an opportunity for the students to put into practice what they had learned in Kandinsky's class. Oskar Schlemmer, the Master of Form in the sculptural workshops, was also involved, in order to provide 'plasticity' to the work. Klee, who was part of the mural-painting workshop, and Kandinsky were, like Schlemmer, interested in geometric forms as depicted in space.

One of Kandinsky's first students was Herbert Bayer who in his final year at the Bauhaus created a number of wall paintings for the school. In these he used a series of interlocking geometric shapes and lines that combine Schlemmer's use of forms in space and Kandinsky's brilliant use of primary colours in those forms; the powerful red square, the mysterious blue circle and the passive yellow triangles. Kandinsky reinterprets Bayer's work in this 1929 work *Ausser Gewicht*.

CREATED

Dessau

MEDIUM

Watercolour and Indian ink on paper

RELATED WORKS

Herbert Bayer, mural paintings for the Bauhaus, 1923

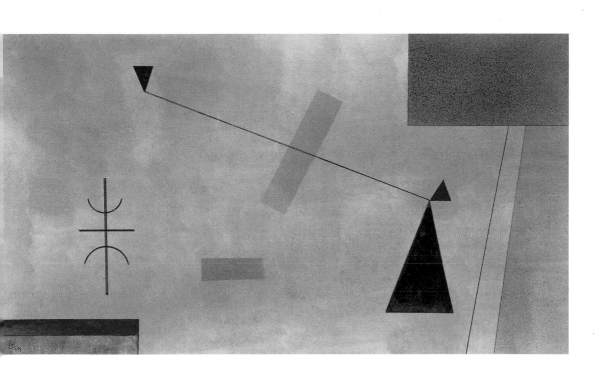

Woodcut from *Holzschnitt* for the journal *Cahiers d'Art*, 1936

The Masters' houses at Dessau provided a perfect opportunity for the Bauhaus staff and students to design and make furniture and domestic ware for their interiors. By the end of the 1920s many of the more promising students had graduated and become enterprising designers or tutors themselves. The 'apprentices' of the early 1920s, Joseph Albers (1888–1976), Joost Schmidt (1893–1948) and Marcel Breuer (1902–81), who later all taught at the workshops, were involved in the design and execution of the *Haus am Horn*, the centrepiece for the Bauhaus exhibition of 1923.

Breuer's early attempts at chair design, as exemplified at the Sommerfield House project, were informed by Itten's basic-course folk-art instruction. His later designs were informed by his exposure to the *De Stijl* aesthetic of Gerrit Rietveld (1888–1964) and his famous red-blue chair. Although his version of the chair is somewhat clumsy and folk-arty, the lines are more refined and at least considerate of simplified design. His designs for the bedroom furniture at the *Haus am Horn* are fully resolved using Constructivist ideals. These resolved designs based on geometric forms became an inspiration for Kandinsky while at the Bauhaus.

CREATED

Dessau

MEDIUM

Woodcut

RELATED WORKS

Marcel Breuer, designs for the bedroom at *Haus am Horn*, 1923

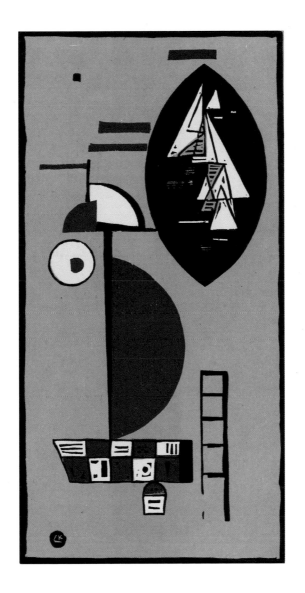

Weiss ('White'), 1930

Hannes Meyer's departure from the Bauhaus was almost as swift as his arrival. As problematic as his tenure of the directorship was, Kandinsky was relatively unscathed by his presence. His successor was less accommodating. Ludwig Mies van der Rohe (1886–1969), a conservative by comparison to the leftist Meyer, was appointed in 1930. His main brief was to restore the credibility of the school by freeing it from its political affiliations.

Under Mies van der Rohe, the school became principally one of architectural instruction. Of the original Masters, only Klee, who resigned the following year, and Kandinsky remained. Although Kandinsky shared a common aim with Mies van der Rohe, in exploring spatial design, the new director's pragmatism ensured that the painter's tuition and influence were whittled down. It is therefore difficult to know why Kandinsky stayed. However, the additional free time allowed him to develop some of his theories maintaining the ideology that the creative process was as intuitive as it was intelligent. This apparently simple design seems to encapsulate that principle, not least because of its simplistic title.

CREATED

Dessau

MEDIUM

Oil on board

RELATED WORKS

Ludwig Mies van der Rohe, design for a building in Friedrichstrasse, Berlin, 1921

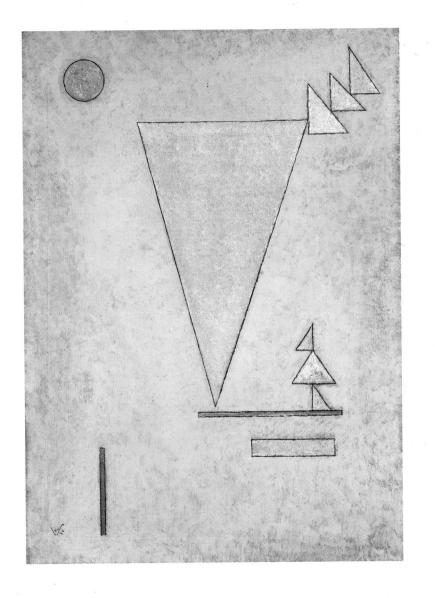

Flächen und Linien ('Surfaces and Lines'), 1930

From 1930 until the closure of the Bauhaus in 1933, Kandinsky had an ambivalent attitude toward the Bauhaus and its executive. The isolation of Kandinsky and Klee from the mainstay of Bauhaus activity in 1930 seems to have increased their resolve of fellowship against the mutual hostility they must have felt. Even the students had by this time called for their dismissal because of their perception of the 'Ivory Tower' mentality.

The success of *Pictures at an Exhibition* in 1928 was a high point in Kandinsky's career at the Bauhaus. Thereafter there was a tendency to draw musical parallels with all visual material by both Kandinsky and Klee. In fact Klee's son Felix was responsible for some of the musical arrangements of the production. Klee painted a number of so-called Fugue pictures, such as *Fugue in Red* and others with musical connotations. Kandinsky had in 1911 already articulated his musical empathy in *Concerning the Spiritual in Art*, stating that, 'music is the art ... (which is) the expression of the artist's soul'. This picture shares a common vocabulary with Klee in the random grouping of floating, seemingly disparate, objects.

CREATED

Dessau

MEDIUM

Oil on board

RELATED WORKS

Paul Klee, *Seeming Possibilities at Sea*, 1932

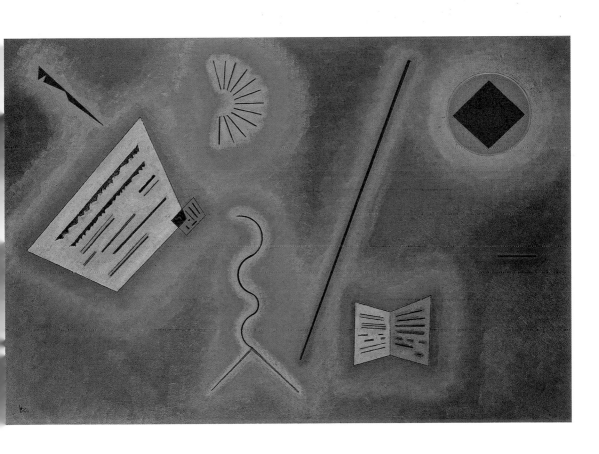

Whimsical, 1930

Kandinsky's isolation from, and reduced commitment to, the Bauhaus from 1930 on, allowed him to pursue his own painting interests, which adopted a somewhat whimsical mood as this painting shows. He returned to a more figurative style that included recognizable motifs, such as the arabesque figures, the keyboard denoting Kandinsky's affection and empathy for music and a somewhat sentimental use of the church and its spire, perhaps a reminiscence of his days at Murnau. The idiosyncratic vessel seems to be an indulgence by the artist suggesting the possibility of futuristic space travel.

Its capricious title belies its highly symbolic content, so derivative of Klee's dream-like Symbolism. The picture seems to encapsulate Kandinsky's influences to date. The ship and its passengers, a metaphor representing safety and salvation for Kandinsky in the light of his Theosophical beliefs; its punctuation by Constructivist motifs, for instance, the aggressive red wedge alluding to Lissitzky's Communist influence. The steeple in the background alluding to Lyonel Feininger's 'cathedral of Socialism' and the keyboard symbolizing not just his empathy for music, but his deep affection for Klee.

CREATED

Dessau

MEDIUM

Oil on cardboard

RELATED WORKS

Paul Klee, *Refuge*, 1930

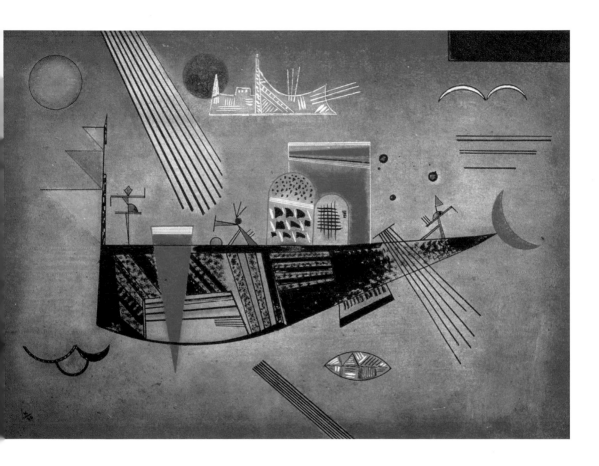

Transmission, 1935

In 1933 the Bauhaus was closed for good, despite Kandinsky helping to re-establish the school at Berlin after the Nazis closed the Dessau building. Altogether Kandinsky had been at the Bauhaus for 11 years, and at the end of it his theories on art were still anti-rationalist in that he sought an 'inner necessity' in his paintings. Along the way, others had influenced him including the Constructivists, but his paintings were always tempered by spiritual considerations, as articulated in his book *Concerning the Spiritual in Art*. It was this ability, to combine these tensions in his work, that he took forward to his new life in Paris after leaving Berlin.

Transmission appears to be a transitional work. Kandinsky had already become more lyrical in his work at the end of the Bauhaus period, combining elements of Constructivism with anecdotal references. In *Transmission* he uses the bold yellow and red lines as Constructivist elements, but the background drawing now contains a new element, the ladder linking the two halves of the composition, a favourite motif of the artist Joan Miró (1893–1983), who he met in 1933 on his arrival in Paris.

CREATED

Paris

MEDIUM

Oil, water and Indian ink on paper

RELATED WORKS

Joan Miró, *Dog Barking at the Moon*, 1926

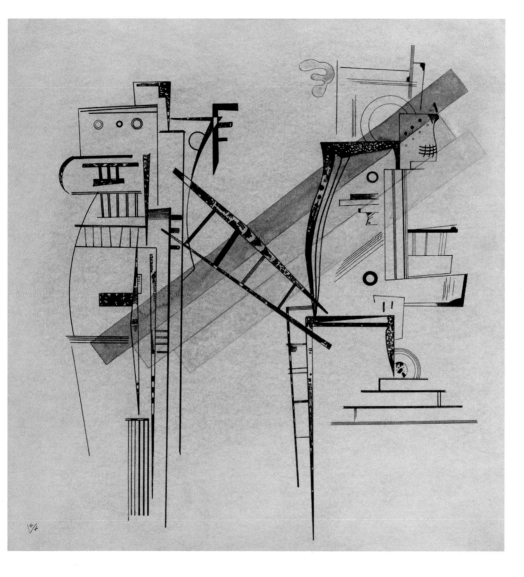

La Ligne Volontaire ('The Voluntary Line'), 1936

Kandinsky had already met Hans Arp twice before arriving in Paris. The first time was in 1911 in Munich when he suggested that Arp participate in the second *Blaue Reiter* exhibition; the second was at the Constructivist Congress at Weimar in 1922. Arp was somewhat unusual in his adoption of both Surrealist and Constructivist ideas during the 1920s, ideas that, generally speaking, were antithetical. His Surrealist aspirations stem from his early years in Zurich as a founder of the Dada group. Unlike many of the other Dadaists, Arp's work extended beyond shocking the art establishment, since for him it allowed experimentation with new forms based on chance. The Surrealist writer and leader André Bréton (1896–1966), later codified this as Automatism, originally a literary strategy for accessing the unconscious, but later used by artists to visualize such ideas. The vocabulary of Automatism was varied using random lines, colour spattering techniques and collage of disparate objects.

Kandinsky did not belong to the Surrealist group in Paris, but in *La Ligne Volontaire* he uses the randomness of Automatism in a very deliberate and considered way, its ambiguity extending to the title.

CREATED

Paris

MEDIUM

Gouache on paper

RELATED WORKS

Hans Arp, *Constellation According to the Laws of Chance*, 1930

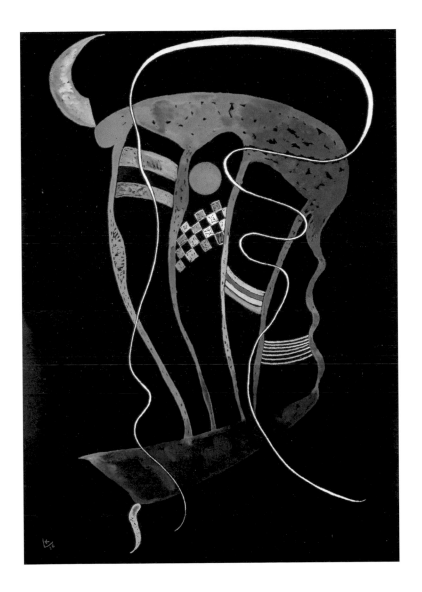

Simple Complexity or *Ambiguity*, 1939

The oxymoronic title suggests that Kandinsky was unable to resolve this painting. It is nevertheless a very considered, if ambiguous work that takes its lead from the work of Hans Arp. At the end of the First World War, Arp began to experiment with 'biomorphic' forms, exploring the potential of juxtaposed forms in his collages. He used natural forms such as stones and other debris that he had picked up on the beach. For him there was an element of chance involved in this selection process, an aspect that was later to inform his Surrealist aesthetic. Arp then drew or painted some of these forms from memory in a random way without referring to the motif, symbolizing the 'chance' aspects of nature. Many of these forms were a derivation of Kandinsky's own ideas from his *Blaue Reiter* period. Arp, however, took a different direction to Kandinsky, when he began to sculpt these forms using both 'biomorphic' and Constructivist idioms.

Kandinsky's own work at the end of his life, returned to these 'biomorphic' forms, themselves derivative of Arp's oeuvre.

CREATED

Paris

MEDIUM

Oil on canvas

RELATED WORKS

Hans Arp, *Head*, 1926

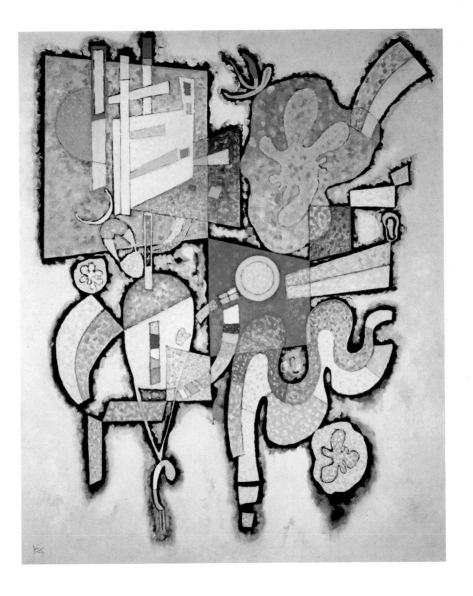

$4 \times 5 = 20$, 1943

The enigmatic title of this painting belies the total resolution of Kandinsky's work at the end of his long career as a painter. The compartmentalization of the work also belies his lack of a regimental approach to painting. He had absorbed much of what the Constructivists had imparted, but he was always tempered by the 'inner necessity', the presence of which he remained as convinced as ever of, throughout his career. This 'inner necessity' is present in $4 \times 5 = 20$ – its use of colour as vibrant and exciting as his early folk-art paintings. The painting is 'constructed' in a grid pattern that is as formulaic as those of the Constructivists or of the *De Stijl* artists such as van Doesburg and Piet Mondrian (1872–1944). Kandinsky continued to use the primaries of red, blue and yellow, and juxtaposed black and white as per the colour theories he espoused in *Concerning the Spiritual in Art*.

There is also due deference to the many late influences on his artistic career, such as the biomorphic forms of Arp and the continued use of the ladder motif that is derivative of Miró.

CREATED

Paris

MEDIUM

Oil and gouache on board

RELATED WORKS

Piet Mondrian, *Composition in White, Red and Blue*, 1936

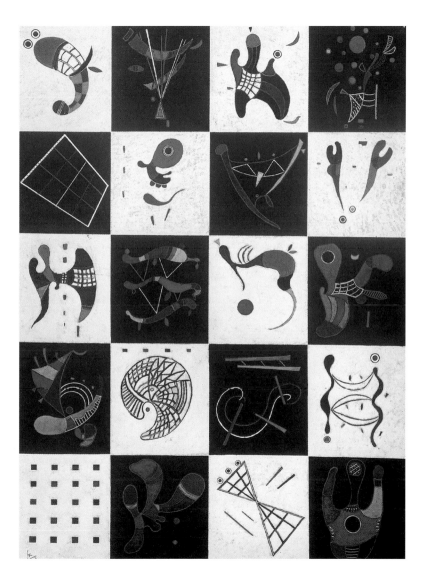

Kandinsky

Early Ideas

River in Autumn, 1900

By 1900, Kandinsky had been in Munich for four years, and the *Sezession* ('Secession') had been established for eight. Unlike other Secessions, Munich's was not a reaction to a repressive regime of academic art. Although it had seceded from the academy it was, ironically, its (the academy's) liberal attitude, and the inclusion of some experimental modern art in its exhibitions, that threatened to undermine the overall quality of the exhibition, compromising the Secessionists' work. At this time Munich was seen as being at the forefront of progressive art, vying with Paris as cultural capital of Europe. The artists of the Munich Secession, however, tended to avoid depictions of modernity and city life, favouring the development of Symbolist motifs, firstly through *Jugendstil* and latterly through Expressionism. The subject matter of their work variously included the *femme fatale* and other allegorical Symbolist motifs. Kandinsky was already cutting his own line using Van Gogh's proto-Expressionist idiom, tempered with the landscape paintings of the Secessionists' contemporaries, the so-called Worpswede School, such as Otto Modersohn (1865–1943), who also used colour to express form and emotion.

CREATED

Munich

MEDIUM

Oil on cardboard

RELATED WORKS

Paula Modersohn-Becker, *Poorhouse Woman in the Garden*, 1905

Vasily Kandinsky *Born* 1866 Moscow, Russia

Died 1944

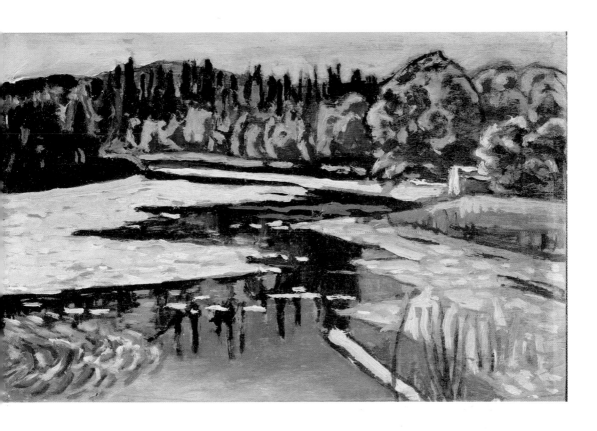

The Walk, 1903

One of Kandinsky's earliest artistic enterprises was the formation of an association of artists called Phalanx in 1901. Having previously studied briefly under Franz von Stuck (1863–1929), the leader of the *Sezession*, Kandinsky came to realize that the cultural scene around Munich, far from being progressive was in fact rather tame and bourgeois. Yet he was drawn to one aspect of their work, which was the *Jugendstil* aesthetic. For Kandinsky it was more than merely copying the Jugendstil look, it was the unworldliness of its aesthetic that attracted him to it, and its potential for Abstraction. These were two of the aspects that became a recurring theme in Kandinsky's work from this time on.

Initially the Phalanx exhibitions were limited to those artists within his Munich circle, but by the time of *The Walk*, Kandinsky was incorporating a number of French artists. In 1903 he included the work of Claude Monet, whose 'Haystacks' series had inspired him to become an artist in the first place. It is clear from this work that Impressionism, and its preponderance for colour, also greatly influenced him.

CREATED

Munich

MEDIUM

Gouache on paper

RELATED WORKS

Claude Monet, *Girls in a Boat*, 1887

Kallmunz – Gewitterstimmung (Die Postkutsche) ('Kallmunz – Stormy Mood (The Post Coach)'), 1903

Although Kandinsky was in his late thirties at the time of this painting, it shows the lack of resolution one associates with an artist at the beginning of his career, who is as often as not still absorbing a number of influences. Such a conclusion would, however, be a mistake. The year 1904 marked the end of the 'Phalanx' period in which he had started his own art school less than two years previously. As a tutor he took his students to the more rural parts of Bavaria to paint from nature. At first glance, *Kallmunz – Gewitterstimmung* is an Expressionist-style landscape that includes the town's medieval castle. In terms of its painterly qualities it pays due deference to Van Gogh, but Kandinsky imbues the work with his own imagination, the sense of 'unworldliness' inspired by the folk-tales and legends of his childhood in Russia. Many of these stories would also have found a resonance with the inhabitants of Bavaria. There is a sense in this painting of a kind of transfiguration by Kandinsky that elevates it from a mimesis of nature to an idealized form, based on an 'inner need'.

CREATED

Munich

MEDIUM

Oil on canvas

RELATED WORKS

Adolf Hölzel, *Dachau Moor IV*, 1900

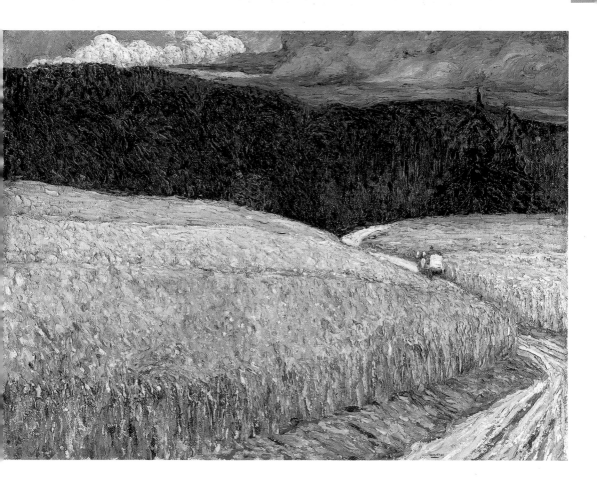

Rapallo, 1905

One of Kandinsky's students at the Phalanx School was Gabriele Münter, who from 1902 also became his companion. After 1903 they began travelling around Europe together, often for several months at a time, and from December 1905 until April 1906 they visited Italy, where this picture was probably executed.

Prior to that, Kandinsky had already met Alexei Jawlensky in Munich, at Azbé's studio. Jawlensky had originally trained in Paris and was therefore exposed to the French avant-garde Post-Impressionists, such as Georges Seurat (1859–91) and the later works of Camille Pissarro (1830–1903), both of whom painted in a Divisionist style of juxtaposed colours. Kandinsky, with Münter, also travelled to Holland in May and June 1904, and probably saw the early work of Piet Mondrian (1872–1944) who had also adopted a Divisionist technique prior to his experiments with Abstraction. The paintings of both Kandinsky and Mondrian from this period demonstrate a tendency to paint in a Divisionist manner, using heavy impasto brushstrokes of paint applied, giving the works an immediate feel. It is Kandinsky, though, who emphasizes an early affinity for the use of primary colours, rather than Mondrian, who at this stage is still using a muted palette.

CREATED

Probably Italy

MEDIUM

Oil on canvas

RELATED WORKS

Piet Mondrian, *Still Life with Sunflower*, 1907

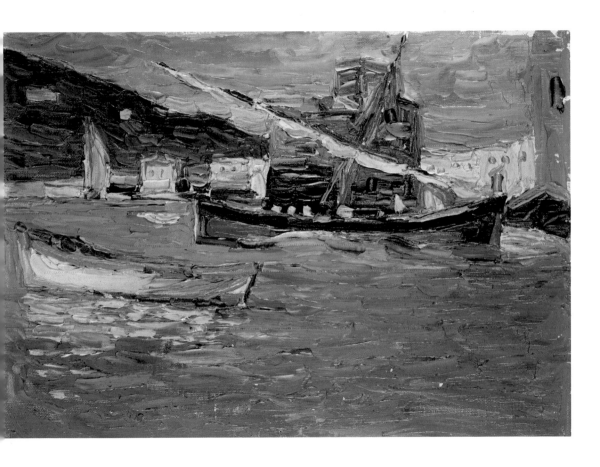

Die Rosen ('Roses'), 1905

Courtesy of Christie's Images Ltd/© ADAGP, Paris and DACS, London 2006

In her book *Kandinsky in Munich*, Peg Weiss suggests that Kandinsky possibly visited the Darmstadt artists' colony's exhibitions at the turn of the century, as Kandinsky's own sensibilities thereafter became more akin to the Darmstadt version of the *Jugendstil* aesthetic.

Without mentioning specific Kandinsky artworks that she suspected may have been inspired by th exhibitions, Weiss makes the point that the artist's visit would have reminded him of childhood experiences of visiting peasant houses. She quotes Kandinsky: 'As I finally stepped into the room, I felt myself surrounded on all sides by the painting, into which I had finally moved', teaching him to 'live and move within the picture'. The houses at Darmstadt, designed by Peter Behrens (1868–1940) and Joseph Maria Olbrich (1867–1908), have a fairy-tale or folk-tale dimension to them that was probably inspirational to Kandinsky. Moreover Kandinsky would have been empathetic to Darmstadt's aspiration as an expression of a *gesamtkunstwerk*. Kandinsky's interpretation of Darmstadt's *Jugendstil* can be seen in a number of his paintings after 1902 and may well have contributed to an invitation from Peter Behrens in 1903 to teach at the Düsseldorf Academy. The painting *Die Rosen* is a continuation of that Darmstadt influence.

CREATED

Probably Bavaria

MEDIUM

Gouache on card

RELATED WORKS

Joseph Maria Olbrich, Design for the Christiansen House, Darmstadt, 1900

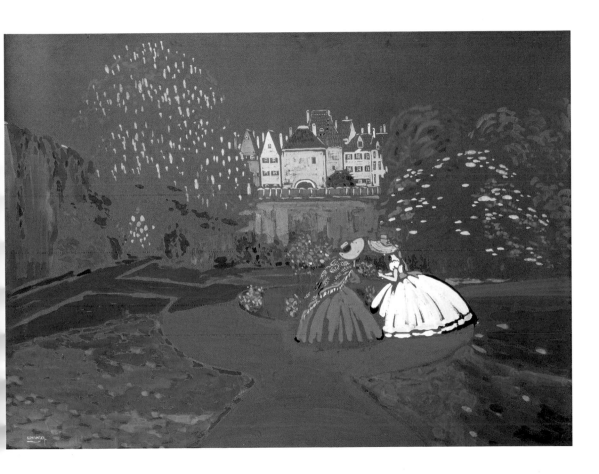

Grüne Frauen ('Green Ladies'), 1907

The linocut *Grüne Frauen* is a fusion of a number of artistic influences on Kandinsky at this time that precedes his more resolved woodcuts. This transitional period coincided with the final stage of Kandinsky and Gabriele's peripatetic lifestyle in which they toured Germany from the late summer of 1907 until the spring of 1908. The journey took in a visit to the Secession group in Berlin as well as the new *Die Brücke* ('The Bridge') group of avant-garde artists in Dresden.

Die Brücke signified the transition from the artistic 'old world' to the new and the bridge between art and life, and to this end its members were inspired by the writings of Friedrich Nietzsche (1844–1900). The artists of *Die Brücke* sought to express their art as a *gesamtkunstwerk* ('total work of art') in which some of the artists, such as Ernst Ludwig Kirchner (1880–1938), decorated their studios with handmade furniture and painted wall decorations. The designs for the wall decorations used a decorative *Jugendstil* that also included some references both to African art and to the traditions of medieval German printmaking. It was the latter that was of particular interest to Kandinsky.

MEDIUM

Linocut

RELATED WORKS

Ernst Ludwig Kirchner, *Bathers at Moritzberg*, 1909

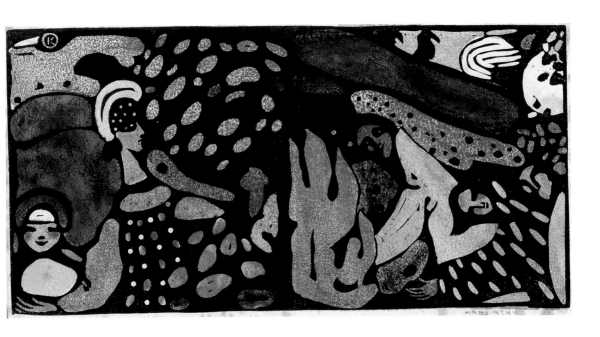

Klänge ('Sounds'), 1907–12

Kandinsky produced his first set of woodcuts for the publisher Piper Verlag in 1904, entitled 'Poems Without Words', which he also exhibited in Paris at the *Salon d'Automne*. They were inspired by the Symbolist poetry of Kandinsky's contemporary Stefan George (1868–1933). It was in his next group of woodcuts, a volume of prose-poems published under the title *Xylographies* with their obvious musical connotations, that Kandinsky developed the idea of the 'Klang', an onomatopoeic term that refers to the sound or resonance between a viewer and the work of art. Following the *Die Brücke* or bridge analogy, Kandinsky saw these 'Klangs' as a vehicle to negotiate the route from representation to Abstraction. As with the prose-poem, Abstraction was marked by the lack of conformity to academic rigour.

The move from figurative to abstract can be seen most comprehensively using one particular motif of Kandinsky's, his use of the horse and rider. From his earlier paintings, such as *Crusaders* (1903) to *Cossacks* (1910–11), it is possible to trace the linear development through these woodcuts from 1907.

CREATED

Munich

MEDIUM

Woodcut on paper

RELATED WORKS

Karl Schmidt-Rottluff, *The Road to Emmaus*, 1918

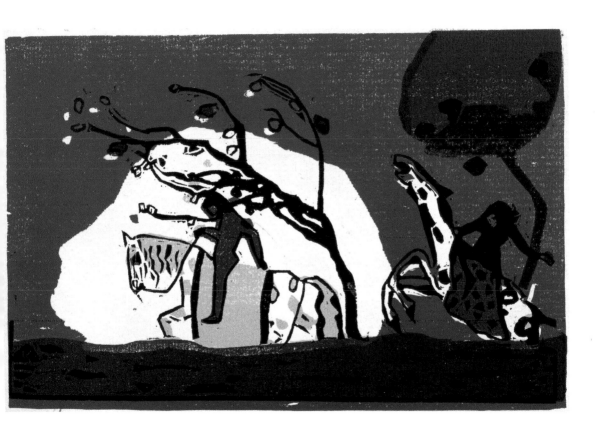

Klänge ('Sounds'), 1907–12

Kandinsky saw the 'Klang' as a *gestamtkunstwerk*. His final group of woodcuts called *Klänge* produced between 1907 and 1912, and published in 1913, was a perfect synthesis of word, picture and 'sound'.

The *gestamtkunstwerk* had a common currency in Europe, not just in Germany, during the second half of the nineteenth century following the composer Richard Wagner's (1813–83) use of the term to describe a total work of art for the stage that included visual stimuli, such as backdrops, to enhance the overall viewing and listening experience of the audience for his operas. The *gestamtkunstwerk* had a particular resonance with a number of European artists, at the turn of the century, feeling that there was a growing isolation for any one particular art form within the larger cultural picture. Artists as diverse as Paul Gauguin (1848–1903) and Ferdinand Hodler (1853–1918) responded to these ideas and attempted to create a more homogeneous language of art. Kandinsky's *Klänge* is a similar response, one artist creating both text and image. The artist moved even closer to Wagner's ideal of the *gesamtkunstwerk*, creating a stage production called *The Yellow Sound* in which he sought to combine movement and song with shapes and colour.

CREATED

Munich

MEDIUM

Woodcut on paper

RELATED WORKS

Gustav Klimt, *Beethoven Frieze*, 1902

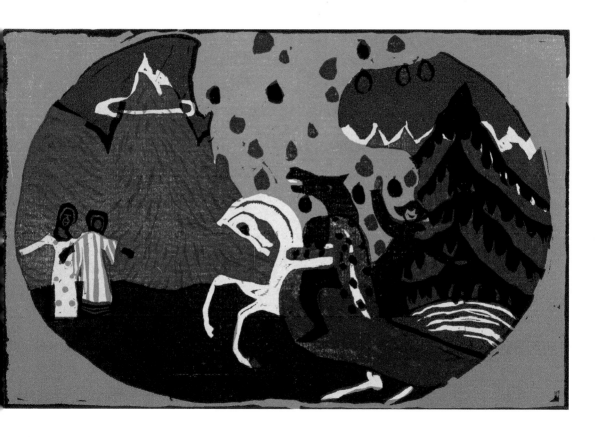

Herbstlandschaft mit Booten ('Autumn Landscape with Boats'), 1908

Before settling again in Bavaria, Kandinsky and his companion Gabriele Münter travelled to France where they spent just over a year at Sèvres near Paris. He arrived at a time when the work of the Fauve artists, such as Henri Matisse (1869–1954), André Derain (1880–1954) and Maurice de Vlaminck (1876–1958) was being exhibited. Kandinsky's response to the work is palpable in *Herbstlandschaft mit Booten*. His palette is now very bright, using the colours themselves to express form without the formal descriptive considerations. The deliberate juxtaposition of the colours, for example, the blue against the yellow, now informed Kandinsky of a new vital element that he was to formalize two years later in his *Concerning the Spiritual in Art*. The lushness of the paint gives his work a new vibrancy, with its broad brushstrokes of simplified forms that were later to inform his Abstractions.

In this work Kandinsky comes closest to the landscape paintings of Vlaminck in its use of expressive colour and broad impasto paint quality. The decorative quality of Kandinsky's work, though, shows his indebtedness to Matisse.

CREATED

Germany

MEDIUM

Oil on board

RELATED WORKS

Maurice de Vlaminck, *The Blue House*, 1906

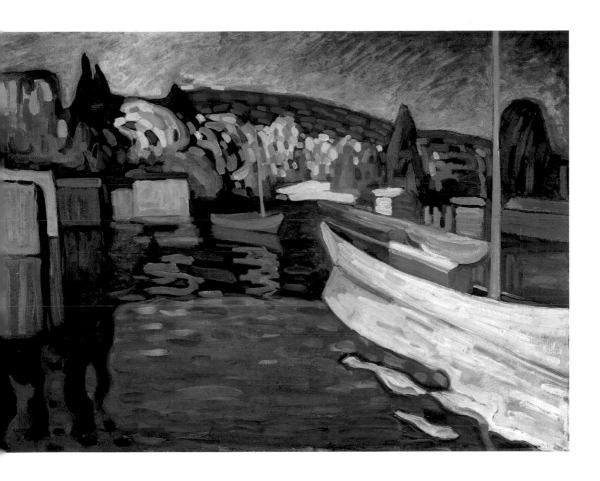

Women in Crinolines, 1909

Courtesy of Tretyakov Gallery, Moscow, Russia/Bridgeman Art Library/© ADAGP, Paris and DACS, London 2006

In 1909 Kandinsky and Gabriele Münter settled into the rural landscape of a small town in the Bavarian Alps called Murnau. Although his work is still informed by his recent exposure to the Fauve artists, Kandinsky's paintings of this time have a restless quality about them, the application of the paint inconsistent in the work. In this painting, for example, the paint is applied variously, sometimes as a broad area of colour and in other places as splodges of colour flicked on with the brush. When looking at the painting, the eye, unable to rest, is continually darting across the canvas to resolve the whole. Kandinsky takes the colours and tonal values of each to extremes.

This work is paralleled by the formation of a new group of artists, the aptly named New Society of Munich Artists. It was different to Phalanx, in that Kandinsky began to surround himself not just with painters, but with dancers, musicians, art historians and others who could enable him to gain a more rounded understanding of the cultural scene, and he provided a discussion forum that was always critical of the conservative mainstream in Munich.

CREATED

Munich

RELATED WORKS

Gabriele Münter, *Jawlensky and Werefkin in the Meadow*, 1909

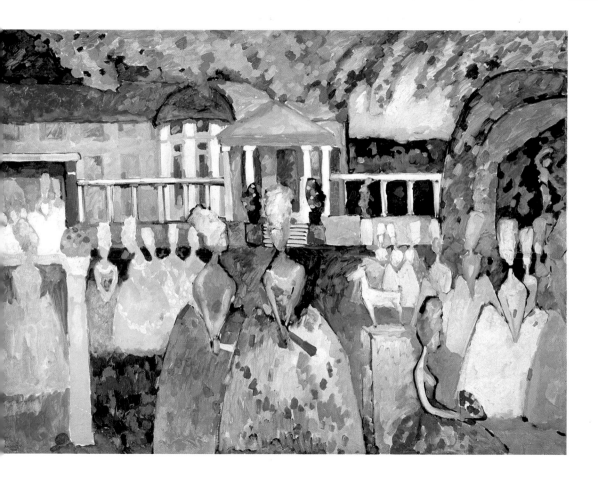

The Blue Rider, 1909

The New Society of Munich Artists proved to be fertile ground for the dissemination of new ideas at a time when Kandinsky was seeking a new language in his art as he moved inexorably towards Abstraction. The society staged a number of exhibitions. In the second such exhibition in 1910, Kandinsky brought a large number of works in from Holland and France by Fauve artists such as André Derain (1880–1954), the Cubist artists Pablo Picasso (1881–1973) and Georges Braque (1882–1963) and work by Kees van Dongen (1877–1968), representing a truly international array to a Munich that needed revitalizing.

Also at this time, Kandinsky began discussing co-operative *gesamtkunstwerk* ideas for the stage with the Munich Artists' Theatre. One of the most interesting ideas for Kandinsky's own development as an artist was the discovery of *verre églomisé* (gilded glass) work known in Bavaria as *hinterglasmalerei*. These glass paintings were developed during the medieval period, but the technique had been used in the nineteenth century, particularly in Bavaria, for decorative panels. What attracted Kandinsky was the simplified forms, often patchwork in style with an abstract quality. Gabriele Münter visited Heinrich Rambold (1872–1955) in Murnau to learn the technique, and taught it to Kandinsky. The style of these traditional folk-art paintings is replicated in this work, albeit as oil on canvas.

CREATED

Murnau

MEDIUM

Oil on canvas

RELATED WORKS

Gabriele Münter, *Bavarian Landscape with Farmhouse*, 1911

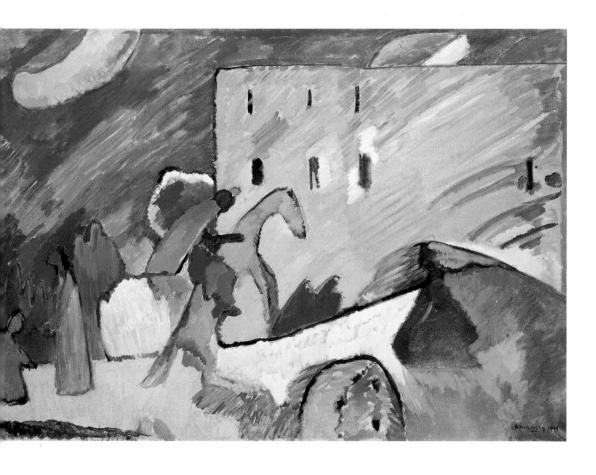

Marche Funebre ('Funeral March'), 1909

Although not a member of Kandinsky's circles in Munich, the artist Adolf Hölzel (1853–1934) was well known to him, and had been making developments in his art parallel to those of Kandinsky. Hölzel, a founding member of the Secession in Munich, had himself been making inroads towards Abstraction at the turn of the century. His own 'modern' work was, like Kandinsky's, originally based on French Impressionism and then on the Divisionist style of Georges Seurat (1859–91). By the end of the century he, like others who were more attuned to Symbolism, was seeking a new artistic language in which he could express his 'inner self'. In the first decade of the twentieth century he produced a number of works based on religious themes. His painting *Composition in Red I* is an abstracted version of the 'Empty Tomb of Jesus' scene, pictorially created a number of times since the Renaissance. The figures and the landscape are barely discernable, and Hölzel eschews all notions of a narrative by referring to it only as a 'composition'.

Kandinsky is also moving towards Abstraction in this work, which later also loses its narrative and becomes more pronounced in his *Improvisation 6*.

CREATED

Munich

RELATED WORKS

Adolf Hölzel, *Composition in Red*, 1905

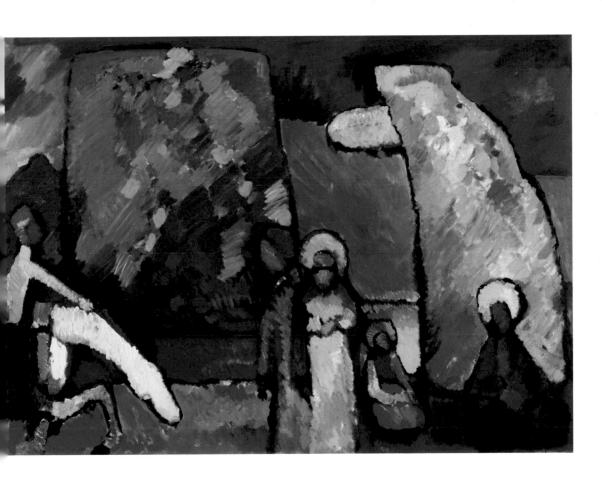

Murnau – Landschaft mit Kirche I ('Murnau – Landscape with Church I'), 1909

Courtesy of Christie's Images Ltd/© ADAGP, Paris and DACS, London 2006

Kandinsky was brought up in the tradition of the Russian Orthodox Church, a faith that he maintained throughout his life, at least spiritually. Like many other open-minded people at the turn of the century he was also absorbing Theosophical ideas based on the teachings of Madame Blavatsky (1831–91) and Rudolph Steiner (1861–1925). Kankinsky's interest was noncommittal, but he shared, like many others in the wake of a burgeoning materialistic and self-centred world, a deeply held conviction that spirituality was most important if one were to discover one's own 'inner self'. His interest in Theosophical teachings was cursory and stemmed from his relationship with Gabriele Münter and her interest in the subject, in which she was pursuing a pseudo-scientific, pseudo-philosophical vision of art. Nevertheless there are some aspects of Theosophy that Kandinsky absorbed, most notably the enigmatic qualities of colour and form, which for the Theosophists have the power to 'enrich the soul' through vibrations of psychic energy, in Kandinsky's parlance a 'Klang'.

Theosophical teachings did inform a number of avant-garde artists at this time, including Piet Mondrian, who was later to be influential to Kandinsky while at the Bauhaus.

CREATED

Murnau

MEDIUM

Oil on board

RELATED WORKS

Gabriele Münter, *Tombstones in Kochel*, 1909

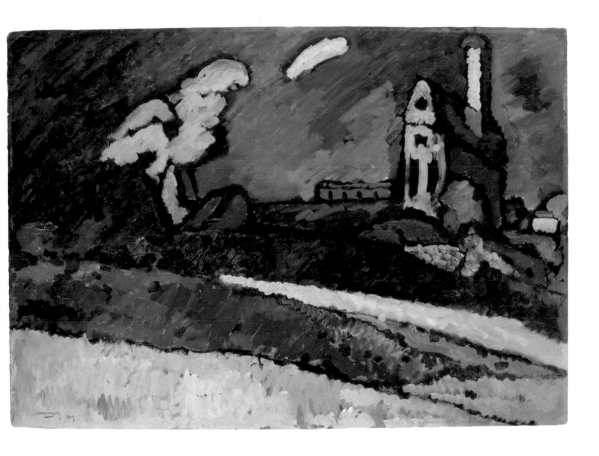

Improvisation, 1910

Among the first of Kandinsky's truly abstract works, where the motif is not easily discernable, were his 'Improvisations', which were intended as spontaneous emotional reactions to an idea or a motif. His 'abstract' titles are intended as non-specific references to music and are expressions of an 'inner self' that has a specifically anti-materialist agenda.

Of course the musical analogies were not mere whim for Kandinsky. As a child he was taught to play both the piano and the cello. He had loved the music of Wagner since childhood and was at the time of this painting beginning a lengthy correspondence with the composer Arnold Schönberg (1874–1951), whose atonal music is imbued with the essential qualities of Abstraction. Two years later, Schönberg contributed to Kandinsky's *Der Blaue Reiter* almanac, demonstrating the affinity both men had for the relationship between music and painting. At this time Kandinsky was working on his Modernist theories, published in 1912 as *Concerning the Spiritual in Art*. Michael Sadler, its English translator, remarked in his introduction that in breaking down the barriers between music and painting, 'Kandinsky is painting music'.

CREATED

Munich

MEDIUM

Oil on canvas

RELATED WORKS

Paul Klee, *The Pianist in Distress*, 1909

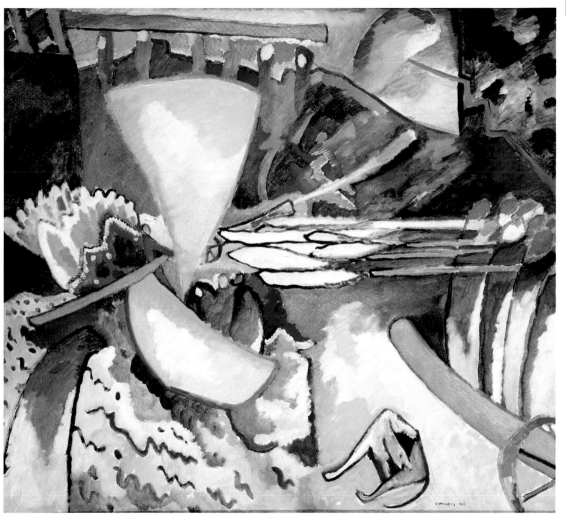

Improvisation VII, 1910

Courtesy of Tretyakov Gallery, Moscow, Russia, Giraudon/Bridgeman Art Library/© ADAGP, Paris and DACS, London 2006

In his *Concerning the Spiritual in Art* Kandinsky refers to his 'inner need' or 'inner necessity' as 'an ever advancing expression of the eternal and objective in terms of the historical and subjective'. By this, Kandinsky meant that the processes involved in making a work of art had to comprise the visual perception of an object that was then manifest as an expression of an artist's 'inner necessity', and that for it to function as a work of art it was necessary to evoke an empathy in the viewer of the object through the work of art. Kandinsky believed that in order to achieve this it was necessary for an artist to 'choose only forms which are sympathetic to his inner self'.

According to Kandinsky, there were two elements in a work of art. The first is the 'inner' element, in essence the soul of the artist, which is stimulated through the body by the senses, thereby stimulating other senses to produce the work of art, or the 'outer'. For Kandinsky, the absence of this 'inner' element will result in a work of art that is 'a sham'.

CREATED

Munich

MEDIUM

Oil on canvas

RELATED WORKS

Franz Marc, *Playing Forms*, 1914

Composition II, 1910

Kandinsky exhibited this work at the second exhibition of the New Society of Munich Artists in 1910. It was derided by the Munich art critics as the work of a 'madman' and virtually its only defendant was the then virtually unknown artist Franz Marc (1880–1916), who was subsequently invited by Kandinsky to join the society.

Kandinsky's 'Compositions' are the most resolved of his works of this period, often involving a number of preliminary studies, particularly the 'Improvisations' and 'Impressions'. In the *Study for Composition II* the human forms and the landscape are, although highly abstracted, still discernable. Kandinsky had realized at this point that the human figure did not need to be represented as a form itself, he needed only to symbolize the traits of the human condition through pictorial elements. It was to be another two years before Kandinsky was sufficiently confident to produce purely abstract works, which did not have objects. In the meantime he continued to use a number of motifs, apart from the human form, such as horses and their riders, castles and churches and a number of elements from folk tales and legends.

CREATED

Munich

MEDIUM

Oil on canvas

RELATED WORKS

Gabriele Münter , *Landscape with White Wall*, 1910

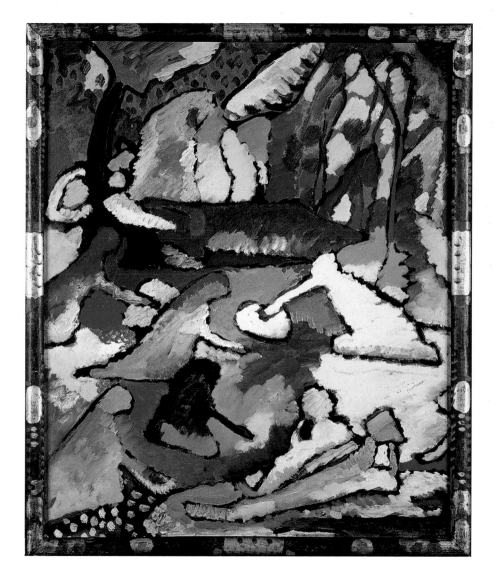

Cover for the catalogue *Der Blaue Reiter* ('The Blue Rider'), 1911

As Kandinsky moved inexorably towards Abstraction, many members of the New Society of Munich Artists felt alienated towards him and his artistic agenda. Most spiteful of all were the German artists, such as the conservative Carl Vinnen (1863–1922), who were critical of foreign artists within the society. This included members such as the Russian Alexei Jawlensky (1864–1941) and the presence of a number of invited exhibitors from France in the 1910 exhibition. However, there can be no doubt that the remarks were specifically aimed at Kandinsky who was by now the unofficial leader of the avant-garde in Munich.

Kandinsky and his friends, including Franz Marc, decided to resign from the society when, in December 1911, Kandinsky's painting *Composition V* was turned down by the jury, who gave a flimsy excuse for its exclusion. The mass exodus of its key proponents, who backed Kandinsky, sealed the fate of the society. Kandinsky hurriedly organized the now famous *Der Blaue Reiter* exhibition, in the adjoining room to the society's exhibition within the Moderne Galerie Tannhausser, and it took place on the 18th December, less than two weeks after the split.

CREATED

Munich

MEDIUM

Printed catalogue

RELATED WORKS

Alexei Jawlensky, *Still Life with Begonias*, 1911

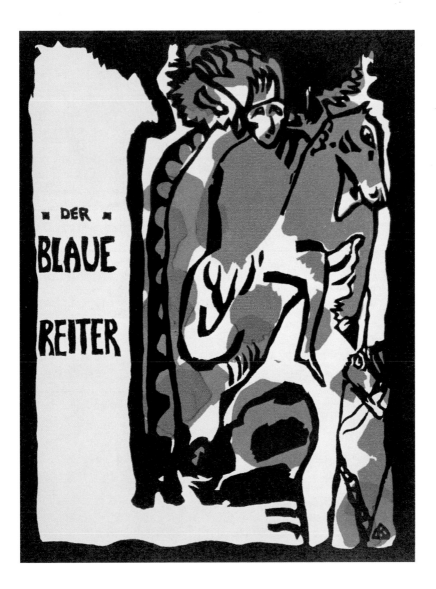

Sunday Impression, 1910

The Sunday promenade was a popular motif for a number of artists, particularly from the final years of the nineteenth century. The works, such as Georges Seurat's *Sunday Afternoon on the Island of la Grande Jatte*, were often critical commentaries on the bourgeoisie and their sensibilities. At the turn of the century a number of so-called Expressionist artists used this motif in a more sinister style that demonstrated man's alienation within an urban environment. The exponents of this style in Germany were *Die Brücke* group of artists in Dresden, and in particular one of its proponents Ernst Ludwig Kirchner (1880–1938).

In Kirchner's hands the seemingly harmless pleasure of promenading is turned into an expression of anxiety. As he wrote, 'The more I mixed with people, the more I felt my loneliness.' Kirchner examined these feelings by exploring the expressive qualities of colour and form, the development of which was paralleled by Kandinsky's own period of Expressionism. Kandinsky is, however, more in tune with Paul Klee's ideas of 'making things visible' rather than seeking to reproduce that which is visible, since Klee's ideas were more likely to communicate the human condition to the viewer.

CREATED

Munich

RELATED WORKS

Ernst Ludwig Kirchner, *Street, Dresden*, 1908

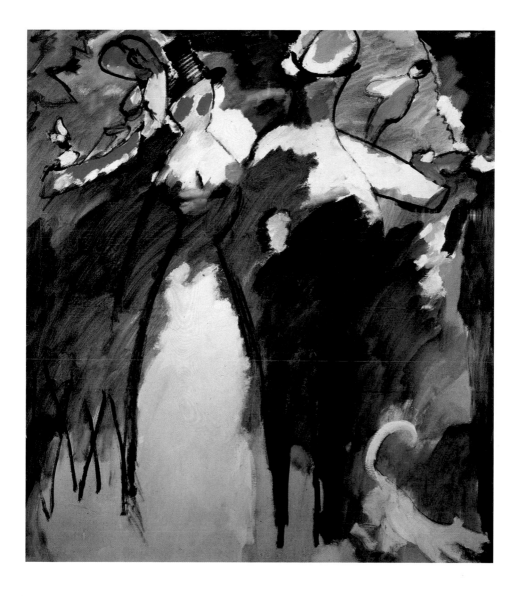

All Saints No. 1, 1910

In *Concerning the Spiritual in Art*, Kandinsky begins to espouse his ideas concerning the primary role of colour, as an expression of its form, in painting. He suggests that the spirit can be strengthened and developed by regular exercise. To achieve this Kandinsky uses the effect of colour on men as a metaphor for spiritual development, and in so doing explains his own agenda for painting.

Kandinsky refers to the pleasurable, but transient, effect of looking at an artists' palette with its array of colours. It is an impression on the soul, which does not affect the soul, but may start a chain reaction of related sensations. Kandinsky likens it to a child discovering the world in which he sees a light and tries to hold it, only to burn his fingers, thus developing a respect for the flame. As his experiences of other phenomena grow then he realizes that the light has more positive connotations in that it can light the darkness, and is essential for warmth. Thus he develops a more rounded attitude to light in which the forces of the various properties are balanced. So it is with colour.

CREATED

Munich

MEDIUM

Oil on canvas

RELATED WORKS

Paul Klee, *Composition*, 1915

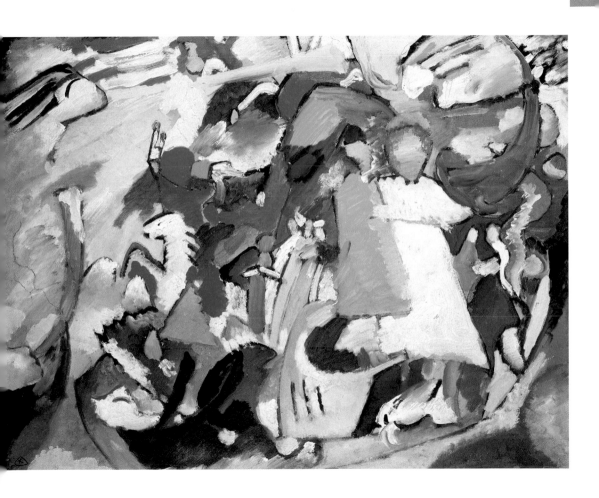

Improvisation No. 19, 1911

For Kandinsky, what he called the 'psychic effect of colour' on man could be either direct or an associative experience. The direct experience is a physical one in which the eye is attracted to certain colours and repelled by others, a sensation that may vary in intensity and impression. Kandinsky suggests that for 'a more sensitive soul the effect is deeper and intensely moving'. This will manifest itself in a 'corresponding spiritual vibration'. As an example Kandinsky suggests that red may be analogous to the 'flame' or to blood and therefore may excite or repel through its associative process depending on the viewer's own previously related sensations. He also points out that this is too simplistic, since the route to the soul may be more direct even in more 'sensitive souls'.

Kandinsky's writings on this subject have to be seen within a medical discourse that had currency at the turn of the century: synaesthesia, a neurological blending of the senses in which people can 'hear', 'smell' and 'taste' colours, as well as 'seeing' sounds.

CREATED

Munich

MEDIUM

Oil on canvas

RELATED WORKS

Frantisek Kupka, *Discs of Newton*, 1911

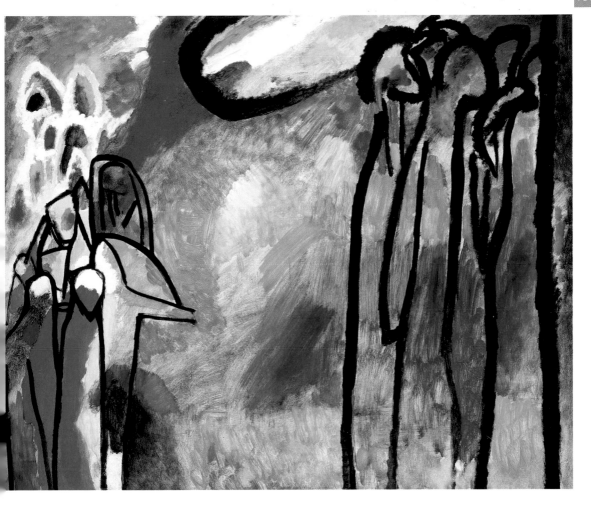

Cossacks, 1910–11

This work may well have fitted into Kandinsky's 'Composition' series since it is so highly resolved. It was, however, completed at a time when the artist was experimenting with forms, a time in which he retained aspects of his figurative work. In *Cossacks* Kandinsky gives the viewer a clue in the title as to the motifs to look for. The time of the painting is of course pre-Russian Revolution when the Cossacks were legendary soldiers and had a romantic and favourable image within what was still Imperialist Russia. It was their military prowess and freedom to exercise it that gained them respect within the Imperial Court in suppressing uprisings in a vast kingdom. They were also instrumental in helping to defeat Napoleon's advances into Russia at the beginning of the nineteenth century.

In this work the motifs are clearly shown. On the right are three red-hatted Cossacks, with two of them holding their lances in the upright position, being commanded by the red-hatted Cossack on the left of the picture, curved sword waving in the air.

CREATED

Munich

MEDIUM

Oil on canvas

RELATED WORKS

Pablo Picasso, *Still Life with Aniseed Brandy Bottle*, 1909

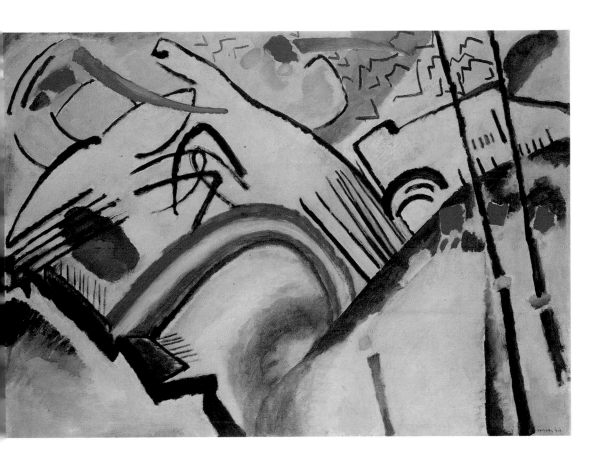

Sketch 160A, 1912

As with many of his works of this time, Kandinsky had not moved away from representing recognizable forms from nature in his Abstractions. In this picture one can still discern a bird and a horse with rider. The latter was a recurring motif in Kandinsky's work and held such significance for him that he named *Der Blaue Reiter* exhibition and subsequent almanac after the motif.

Der Blaue Reiter almanac came out in 1912 and contained a significant contribution to the understanding of modern art, not just by Kandinsky, but by other artists, for instance Franz Marc and Auguste Macke (1887–1914), who contributed images and essays. There were also pictures by other avant-garde painters such as Van Gogh and Matisse, an illustrated article by Robert Delaunay (1885–1941), and a number of references to Russian folk art, Japanese drawings, mosaic work and Mexican sculptures. There were also contributions from avant-garde musicians and composers, such as Arnold Schönberg, who wrote about the relationship of music and lyrics and Thomas von Hartmann who contributed an article called 'Anarchy in Music'. Kandinsky also contributed the score for a theatre work (never performed) called *The Yellow Sound*.

CREATED

Munich

MEDIUM

Oil on canvas

RELATED WORKS

Robert Delauney, *Sun and Moon*, 1913

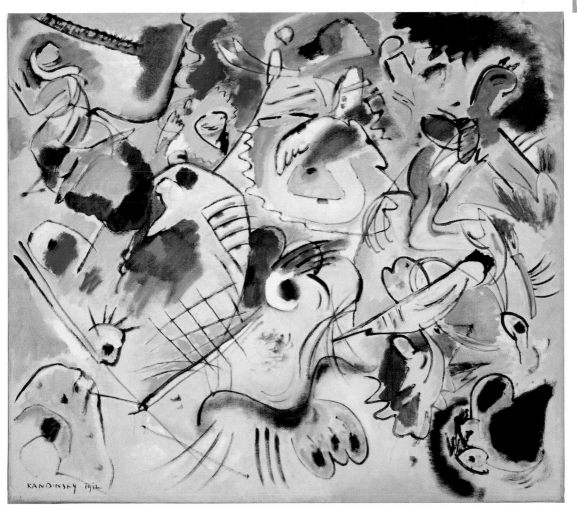

KANDINSKY 1912

Deluge II, 1912

Although in *Concerning the Spiritual in Art*, Kandinsky produced one of the first 'manifestoes' for modern art, it was by no means his last text on the subject. In the following year he contributed a major essay entitled 'Concerning the Question of Form', to *Der Blaue Reiter* almanac. His coauthor and contributing essayist to *Der Blaue Reiter* almanac, Franz Marc, shared Kandinsky's aspiration of a spiritual renewal in Western painting, but sought it through his mystical depictions of nature, particularly animals. In his essays 'The Savages of Germany', and 'Two Pictures', he talked about the 'great struggle for a new art' by the 'savages' in Germany. By this he is referring to an epithet given to all 'modern' artists in Germany by the establishment, which included *Die Brücke* in Dresden, the Secession in Berlin, and his own group in Munich. Marc countered their remarks by reminding them that, 'all works of art created by truthful minds, without regard for the work's conventional exterior remain genuine for all times'. Auguste Macke also contributed an article to the almanac called 'Masks', based on notions of the 'primitive'.

CREATED

Munich

RELATED WORKS

Auguste Macke, *The Storm*, 1911

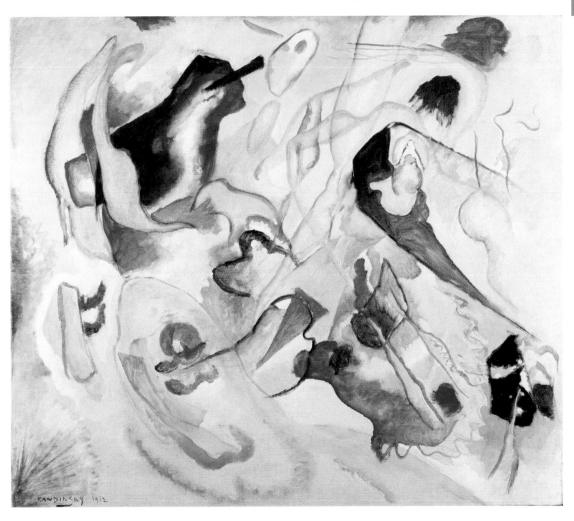

Picture with a Black Arch, 1912

At this stage in Kandinsky's career one can see why he did not totally move from representation to Abstraction in one go. Apart from an obvious need to experiment with abstracting forms from the motif, Kandinsky was aware of the perils of moving away from nature without fully comprehending the use of colour and form in the composition. According to Kandinsky, we (Western artists) are still at the elementary stage of our painting and are 'little able to grasp the inner harmony of true colour and form composition'. Although Kandinsky was aware of the freedom that colour afforded the artist towards the aspiration of Abstraction and its subsequent autonomy, it would be meaningless until such experimentation was complete.

Picture with a Black Arch is one such transitional painting that exemplifies this dichotomy. There is a tension rather than a harmony in the work, between the forces of the primary colours, yellow, red and the blue. According to Kandinsky, the red has 'unbound warmth' while the yellow has an 'irresponsible appeal', which the 'heavenly' blue seeks to resolve by 'rest'. The tension is set up by the graphic symbol of the arch.

CREATED

Munich

MEDIUM

Oil on canvas

RELATED WORKS

Franz Marc, *Tyrol*, 1913–14

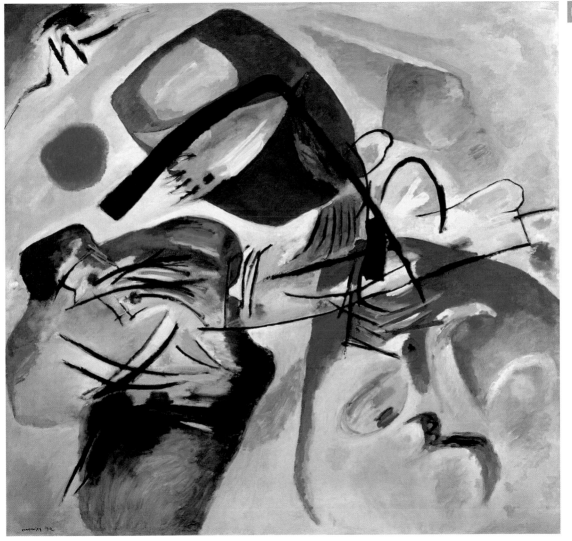

Composition VII, 1913

Courtesy of Tretyakov Gallery, Moscow, Russia/Bridgeman Art Library/© ADAGP, Paris and DACS, London 2006

The most fully developed of all Kandinsky's 'abstract' paintings at this time were his 'Compositions', large-scale works intended by the artist as his most complete works and as the centrepieces of exhibitions. His *Composition VI* and *Composition VII* are the culmination of this experimental period in which he was moving towards Abstraction. There are many preliminary drawings and sketches for these paintings that demonstrate the complexity of the work. He chose to exhibit *Composition VI* at the *Erster Deutscher Herbstsalon* in Berlin in September 1913, an important forum for progressive artists based on the successful *Salon d'Automne* in Paris. His friends from *Der Blaue Reiter*, Auguste Macke and Franz Marc, also exhibited their work. The exhibition contained works by, and was dedicated to the memory of, the French naive artist Henri Rousseau (born in 1844), who had died in 1910. This truly international exhibition also exhibited works by other members of the avant-garde including Fernand Léger (1881–1955) and Jean Metzinger (1883–1956), and the Italian Futurists Umberto Boccioni (1882–1916) and Gino Severini (1883–1966).

Kandinsky's work was also represented at another landmark exhibition in 1913 with an international flavour, the Armoury Show in New York.

CREATED

Munich

MEDIUM

Oil on canvas

RELATED WORKS

Auguste Macke, *Zoological Garden*, 1913

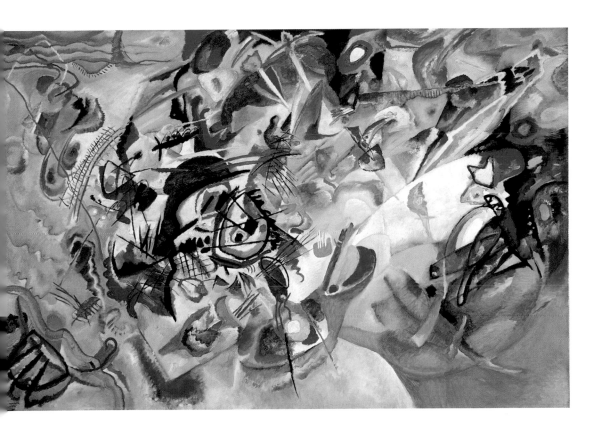

Improvisation of Cold Forms, 1914

In 1914 Kandinsky was due to deliver a lecture on his work at the opening of an exhibition in Cologne. He was unable to attend because of the war and instead sent a typescript of the text, which serves as a useful reference for his work to date, as he saw it. He begins by referring to the impulses that made him want to paint, his love of nature and his even deeper love for colour, becoming frustrated that he was never able to reconcile both adequately in painting a landscape. 'At the same time I felt within myself incomprehensible stirrings, the urge to paint a picture.' He continues, 'Because I loved colours more than anything else, I thought even then, however confusedly, of colour composition, and sought that objective element which could justify the choice of colours.'

Kandinsky states that to date he and his work have been misunderstood, and misrepresented, putting the record straight by saying that, 'I do not want to paint music...(nor) paint states of mind'. He also states that he does, 'not want to show the future its true path'.

CREATED

Munich

MEDIUM

Oil on canvas

RELATED WORKS

Franz Marc, *Tower of Blue Horses*, 1913

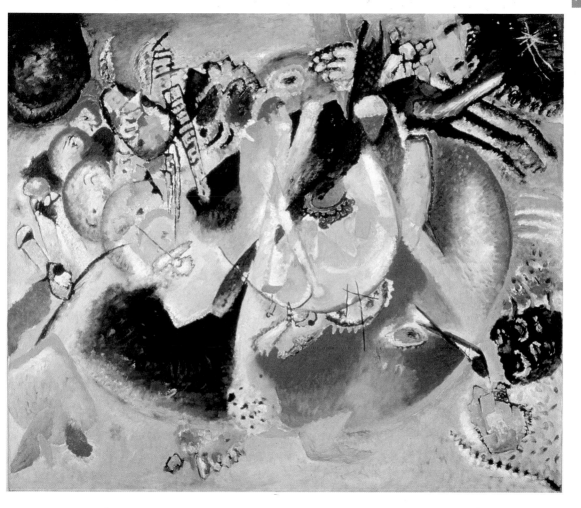

Exotic Birds, 1915

Kandinsky was only one of a number of avant-garde artists at this time who felt the need to explain their work to an ever-more-confused viewing public. In fact such was the progress of the avant-garde in Europe between the years 1908 and 1914, that there was a plethora of artistic writing by artists seeking to explain their oeuvre and its agenda. For Kandinsky it was an expression of the 'inner necessity' through the language of colour, for others it was tackling the depiction and interpretation of the 'modern' using a new artistic language.

In Paris, Fernand Léger was also writing about his own 'inner necessity' in his depictions of modernity. His essay 'Contemporary Achievements in Painting', written in 1914, states that, 'If pictorial expression has changed, it is because modern life has necessitated it.' Léger's Cubism is based on his ideas of a modern artistic language based on the 'inner need' to depict modernity. Foil to Léger's depictions are those of Henri Matisse, who, in his 1908 essay 'Notes of a Painter', sought to explain his use of colour, which appears more intuitive and less scientific than Kandinsky's.

MEDIUM

Watercolour on paper

RELATED WORKS

Paul Klee, *Birds Making Scientific Experiments in Sex*, 1915

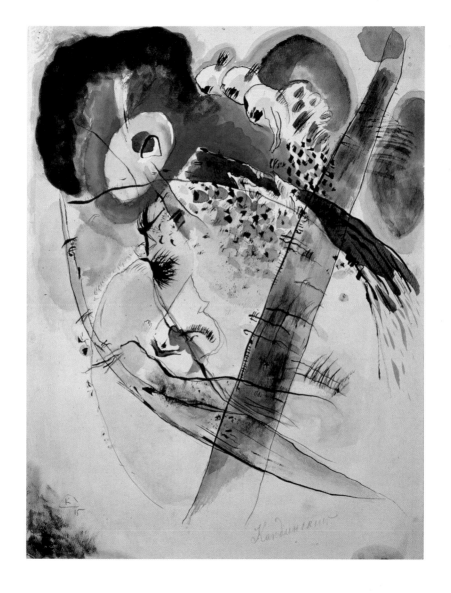

Painting on a Light Ground, 1916

The year 1916 marked a turning point for Kandinsky as he finally turned his back on all connections with the Munich period, both in terms of his career and in his personal life. At the outbreak of the First World War, Kandinsky was forced to leave Germany and return to his Russian homeland. He spent the first three months of the war in Switzerland with his companion Gabriele Münter before returning to Russia. Gabriele subsequently returned to Munich, but in the summer of 1915 she went to Stockholm, where in December she again met up with Kandinsky and they spent Christmas together. Finally leaving her in March 1916, Kandinsky was not to see Gabriele again. Their separation was painful for both artists, Gabriele suffering from depression for some years after and Kandinsky painting very little until the 1920s. While Gabriele never stinted in her praise of Kandinsky and remained to some degree obsessed with him, Kandinsky never mentioned her or her work again.

In spite of this unhappy ending, when together their relationship was paralleled by the most productive and innovative period for both artists, particularly Kandinsky. As the writer of the definitive book on their relationship, Annegret Hoberg remarked, ' From 1908 onward (they) were deeply involved in the momentous and dramatic events attending the birth of Modernism.'

CREATED

Stockholm

MEDIUM

Oil on canvas

RELATED WORKS

Gabriele Münter , *Kandinsky and Erma Bossi, After Dinner*, 1912

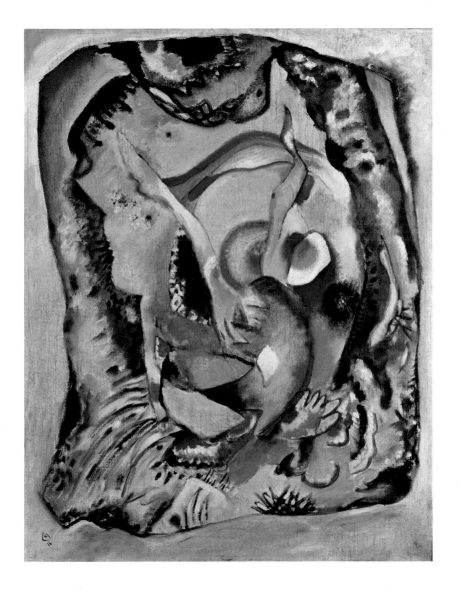

Amazon, 1916

Despite his voluntary exile in Munich, Kandinsky had maintained his connections with Russian artists, writing a number of articles and disseminating information to the rest of Europe on Russian art. As early as 1907 there had been a shift in Russian art that paralleled Kandinsky's own development. For example, the Burliuk brothers David (1882–1967) and Vladimir (1886–1917) had also originally found inspiration for their painting in Russian folk art prior to being inspired by exposure to the Fauvists. The Burluiks had participated in Kandinsky's group exhibition of the New Artists' Society of Munich in 1910, where they saw the work of Matisse and Vlaminck. Similarly Kandinsky participated in the *Karo Bube* exhibition in Odessa in 1910, a group whose members included the Burluiks, Natalya Goncharova (1881–1962), Mikhail Larionov (1881–1964) and Kasimir Malevich (1878–1935), who was shortly to play a pivotal role in the development of the Russian avant-garde at the time of the Russian Revolution.

Kandinsky's *Concerning the Spiritual in Art* was also translated into Russian in 1914 and helped to disseminate his ideas and theories to that avant-garde.

CREATED

Russia

MEDIUM

Oil on canvas

RELATED WORKS

Natalya Goncharova, 'Evangelist' series, 1910

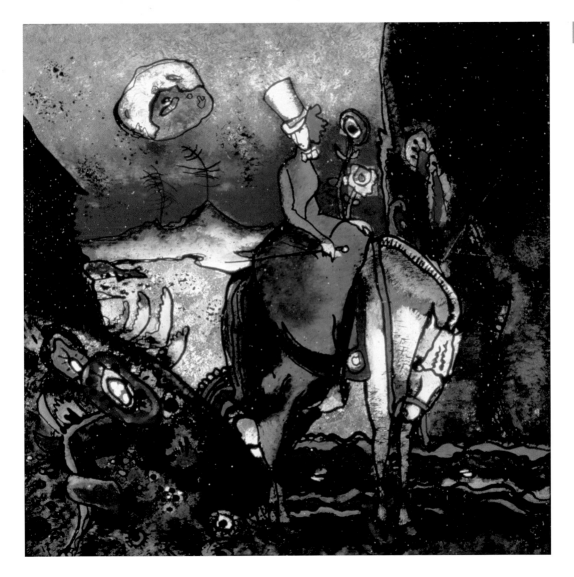

Composition, 1917

By Kandinsky's own standards his output of work during the years from 1914 to 1921 was not prolific. Soon after his separation from Gabriele and his arrival back in Moscow, he met and married the daughter of a Russian army general Nina de Andreevsky, a happy union that lasted until Kandinsky's death in 1944. Although his personal life was happier he was unable to settle back into painting again, at times producing almost no work at all. Part of the problem was the lack of available materials because of the war, but it was mainly the difficulties and uncertainties he faced in his painting as he wrestled with Abstraction.

Politically, Russia also faced an uncertain future. In February 1917 the Tsar had been overthrown in the first of the revolutions, resulting in an insecure centralist government that throughout 1917 continued to lose support because of the appalling losses at the Front. The Bolsheviks under their leader Vladimir Lenin seized control of the Soviet in the second of the revolutions in October, thereby ensuring a future Communist State.

CREATED

Moscow

MEDIUM

Watercolour, pen and brush and Indian ink

RELATED WORKS

Michail Larionov, *Soldier at Rest*, 1911

Zubowskaja Ploschad, 1917–20

This Expressionist-style picture by Kandinsky demonstrates how far he had moved away from the avant-garde mainstream on returning to Russia. The length of time taken over the picture is also indicative of his struggle to find the right idiom. By contrast his fellow Russian Kasimir Malevich was making great headway with his Abstractions. One of Malevich's first major paintings was *Eight Red Rectangles*, which he exhibited at the Dobychina Gallery in Petrograd in 1915. This was one of nearly 40 abstract paintings that consisted of flat geometric shapes placed against a light background. They lack the lyricism and dynamism of Kandinsky's Abstractions, but there is a sense that the shapes are floating, thus creating a 'fourth dimension', a popular hypothesis at this time. Malevich even named one of his pictures from this exhibition *Colour Masses in the Fourth Dimension*.

Unlike European interpretations of the hypothesis involving time, Russian notions of the 'fourth dimension' were conceived as aspects of the new consciousness that provided salvation from death into the real world of the spirits. Thus we are, in a Platonic sense, currently living in a 'shadow' of our reality.

CREATED

Moscow

MEDIUM

Oil on canvas laid on board

RELATED WORKS

Kasimir Malevich, *Eight Red Triangles*, 1915

Bibliographia, 1918

After the chaos and political uncertainty of 1917, the October Revolution had the effect of bringing a more ordered and stable government to the Kremlin. In February of the following year, Russia formally surrendered to the German army thereby ending their participation in the Great War. However, this led to two further years of political uncertainty as the old monarchist White Army tried to seize back power from the newly created Red Army of the Bolsheviks. The year 1918 became a defining moment for artists, who saw it as an opportunity to apply their own revolutionary artistic skills in the continuing struggle for stability. The early enthusiasm soon dissipated as the government announced the creation of the Department of Fine Arts thus formalizing and institutionalizing the creative arts, anathema to the avant-garde. Nevertheless, artists sought out positions within the 'department' since under the 'new order' there were no longer any private patrons. Kandinsky was fortunate enough to be one of the artists selected to teach and hold a studio at the newly created *VKhUTEMAS* (State Higher and Artistic and Technical Studios), an amalgamation of two former art schools now under State control.

CREATED

Moscow

MEDIUM

Pen and Indian ink on paper

RELATED WORKS

Vladimir Tatlin, *Monument to the Third International*, 1919

Amazonka in the Mountains, 1918

The Department of Fine Arts was set up within the control of the Commission for Education and Enlightenment to enable art to be used as one of a number of methodologies for tackling illiteracy, a major problem in Russia at that time, since nearly eighty percent of the population was illiterate. This would help to explain why Kandinsky returned to a more representational motif, as a way of explaining ideas through anecdote. Kandinsky became the head of a teaching program at the subsequently formed Institute of Artistic Culture (*INKhUK*). Kandinsky's agenda encapsulated his own theory of art, namely that art should have a 'religious' relationship with society as a whole. For him the artist was on a higher spiritual plane than other men and that it was the job of the artist to communicate his 'vision'. Although essentially he saw Abstraction as the means of that communication he seemed unwilling to make the break at this stage. Other artists within the department seemed more willing to adopt a less mystical approach to Abstraction in favour of a Suprematist idiom, for example Malevich.

CREATED

Moscow

RELATED WORKS

Kasimir Malevich, *Suprematist Composition: Red Square and Black Square*, c. 1915

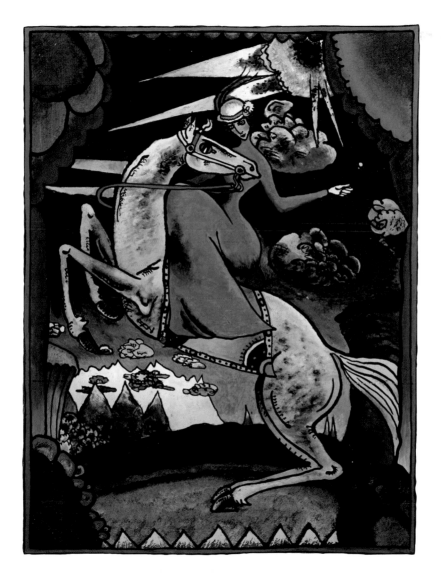

White Cloud, 1918

Although Malevich shared Kandinsky's Theosophical ideas, he sought a new language for their expression. For him Suprematism was an expression of the 'supremacy of pure invention in art'. Its simplified forms seem to have found a resonance with contemporary Bolshevik thought since it represented a distrust of the world as previously represented. Moreover it was felt that the Suprematist idiom could be articulated more easily to an illiterate audience. What Malevich and his followers sought was a 'freedom of the object from the obligations of art'.

Kandinsky began to feel more isolated as a painter within this new and burgeoning avant-garde. His reaction was to adopt a more pluralistic approach to his work that vacillated between the earlier folk-tale cum fairy-story work and the subsequent moves to complete Abstraction. The language of the painting *White Cloud* is definitely from the former, in which Kandinsky adopts very cool tones that suggest a scene from the afterlife. His extensive use of blue and its derivatives is in keeping with his ideas of the colour being 'the typical heavenly colour'.

CREATED

Moscow

RELATED WORKS

Kasimir Malevich, *White on White*, 1918

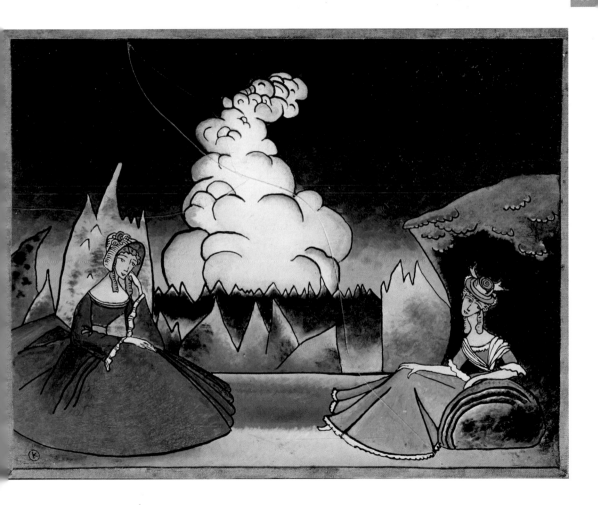

Picture with Points, 1919

While Kandinsky was living in Moscow, he came into contact with a number of the Constructivist artists. For a time he lived in the same apartment block as Aleksandr Rodchenko (1891–1956) who introduced him to other Constructivists such as Naum Gabo (1890–1977) and Antoine Pevsner (1884–1962). These artists took their lead from Vladimir Tatlin (1885–1953), who began to make 'constructions', 1914–15, but after the revolution was now in charge of the Institute of Artistic Culture, in effect Kandinsky's director.

Although it was not until Kandinsky left Russia for the Bauhaus in 1922 that he began to use Constructivist motifs, his exposure to their ideals and agenda was obviously of benefit. At this stage, however, it is equally obvious that his own aspirations towards Abstraction are still spiritual and mystical rather than Constructivist. Kandinsky, whose forms were more expressive and less geometric said, 'Just because an artist uses 'abstract' methods, it does not mean that he is an 'abstract' artist. It does not even mean he is an artist.' *Picture with Points* seems a gentle and humorous ironical rejection of Constructivism.

CREATED

Moscow

RELATED WORKS

Aleksandr Rodchenko, *Composition*, 1920

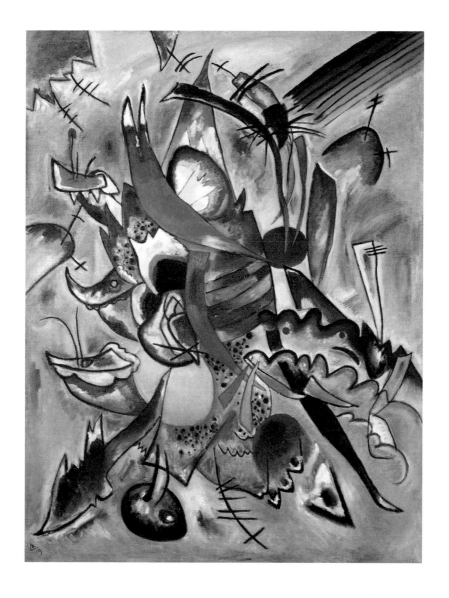

White Oval, 1919

Kandinsky had effectively severed his connections with the Constructivist and Suprematist avant-garde when using Abstract-Expressionist forms in his own paintings, for example, *White Oval*. For him, 'The meeting of the pointed angle of a triangle and a circle is not less effective than the finger of God touching Adam's finger in Michelangelo.'

Kandinsky's approach to the problem of Abstraction is rather different to the Constructivists. He began in 1919 to reassess a problem that he had, like many artists, encountered many years before – the limitations and constrictions imposed by the physical properties of a canvas, namely its rectilinear properties. In his book *Reminiscences*, which had been reprinted in 1918, he openly discloses the challenge of the white canvas as he 'learned to do battle with the canvas, to come to know it as a being resisting my wish'. The restrictions of the canvas came to be seen by Kandinsky as antithetical to the objects that we see in the physical world. This issue was to be developed in his 1926 essay, 'Point and Line to Plane'. In the meantime Kandinsky removes the limits of the 'plane' in this picture by utilizing an amorphous background form.

CREATED

Moscow

MEDIUM

Oil on canvas

RELATED WORKS

Hans Arp, *Le Passager du Transatlantique*, 1920

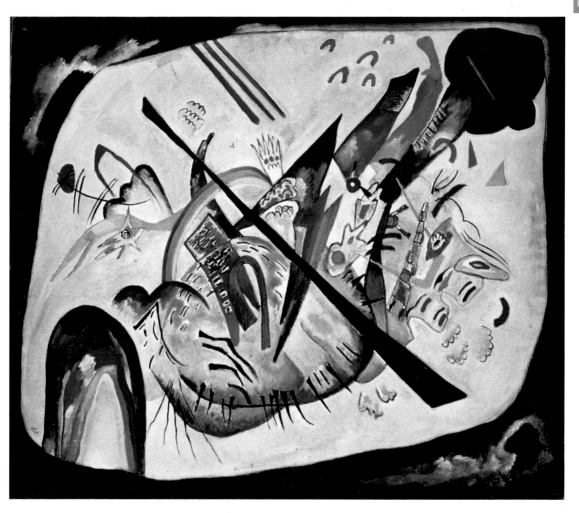

In the Grey, 1919

As Kandinsky was developing his own form of Abstraction in post-revolutionary Russia, he continued to play an active role in his post at the so-called *VKhUTEMAS*, articulating many of his theories first developed in *Concerning the Spiritual in Art*. These ideas were around the relationship of painting to that most abstract of forms, music; and to the analysis of forms and colours. Such imprecise teachings at the newly formed State-run school was anathema to its more pragmatic staff including Rodchenko, who saw Kandinsky as anti-rationalist and not in keeping with the Soviet-Russian agenda.

In the Grey seems to eschew some notions of geometric Constructivist ideas, in favour of more amorphous forms. Yet, there is also a sense of these forms 'floating' amoeba-like within the grey background, reminiscent of some of Malevich's motifs. There are also motifs from Kandinsky's past including the 'black arch' and the 'heavenly blue' patch that punctures the grey, suggestive of what the artist calls his *stimmung* ('sentiment'), a sentimental feeling (not anecdotal), that is an essential constituent of any picture, preserving it from 'coarseness'.

CREATED

Moscow

MEDIUM

Oil on canvas

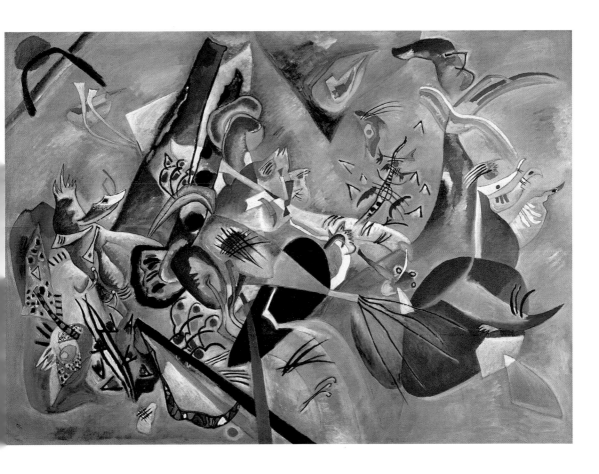

The Black Stroke, 1920

After leaving the Institute of Artistic Culture in 1920 because of the continuing animosity to his ideas, Kandinsky began working on a curriculum for the physio-psychology department of the Russian Academy of Aesthetics. This was short-lived, however, his ideas being rejected as too vague and insufficiently pragmatic. By contrast the Constructivist El Lissitzky (1890–1941) had also begun writing his ideas in a much more pragmatic way that found a resonance with the authorities. More importantly his graphics, such as *Beat the Whites with the Red Wedge*, were politically orientated and found favour with the Bolsheviks.

Kandinsky remained apolitical in his art. In his paintings he continued to explore the 'battle with the canvas' in which his forms were not limited by the canvas's rectangular shape. *The Black Stroke* serves as exemplary to this as the artist places his 'forms' in a diagonal pattern that specifically denies its existence. From 1919 Kandinsky used a number of non-geometric but abstract forms and specific colours to highlight his move towards total Abstraction, giving them specific titles that highlighted this move. Examples are *Red Spot*, *Blue Segment* and *White Line*.

CREATED

Moscow

MEDIUM

Oil on canvas

RELATED WORKS

El Lissitsky, *Beat the Whites with the Red Wedge*, 1919

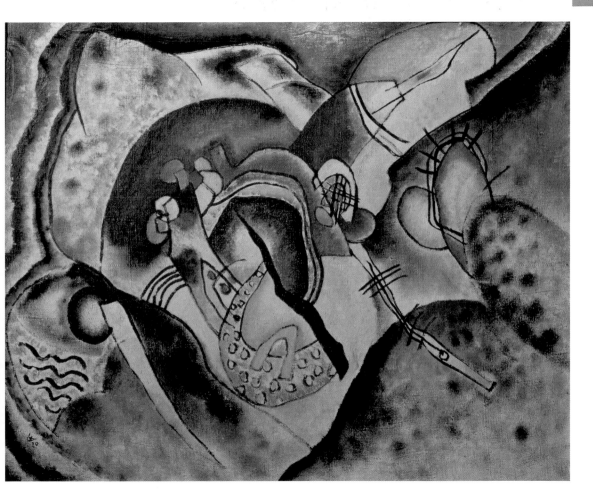

Kandinsky

Towards Abstraction

Kleine Welten III ('Small Worlds III'), 1922

In December 1921 Kandinsky and his wife arrived in Berlin, he a virtual artistic outcast of Russia, his proposal for the reorganization of the *INKhUK* (Institute for Artistic Culture) having been rejected.

On his arrival Kandinsky discovered a city that was suffering, like the rest of Germany, from rampant inflation. He was hoping to collect his share of the monies realized for the sale of his paintings left at the Sturm Gallery, but the little money that the work had made was now worthless because of the devaluation of the currency. Kandinsky had left most of his wartime paintings in Moscow and he was unable to collect most of the prewar work from his house in Murnau because of a dispute with his former companion Gabriele Münter. This dispute was not resolved until 1926, and in effect Kandinsky was virtually broke.

Fortunately Kandinsky was offered a teaching post at the relatively new Bauhaus School in Weimar, which he accepted, moving there in June 1922. One of the first works he undertook after his arrival was a set of graphic prints including these four colour lithographs, called *Small Worlds*.

CREATED

Weimar

MEDIUM

Lithograph in colours

RELATED WORKS

Gerhard Marcks, *The Owl*, 1921

Vasily Kandinsky *Born* 1866 Moscow, Russia

Died 1944

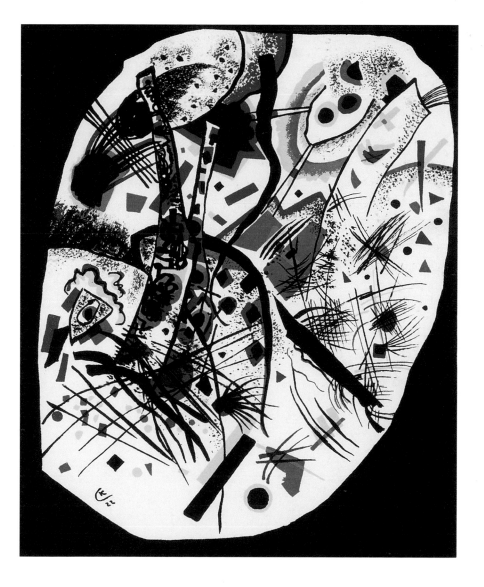

Grave Forme ('Engraved Shapes'), 1922

Kandinsky's appointment at the Bauhaus was as the Master of Form in the wall-painting workshop and as a teacher, with Paul Klee (1879–1940), who had been at the school since 1920 on the basic design course. All students were required to attend the basic course, not dissimilar to the guild system, in which students progressed to journeymen before becoming Masters.

Kandinsky and Klee were not appointed to teach painting, since the Bauhaus was not an academy but a design school. What Kandinsky taught was a sense and a theory of form and colour that would enable students to apply certain principles to design problems. The students were also expected to be proficient in the craft workshops that would enable them to synthesize both elements in a design, in essence to create a *gestamtkunstwerk* (total work of art). This was the aim of the Bauhaus's director, Walter Gropius (1883–1969) who stated, 'The Bauhaus strives to gather all artistic creation into unity.'

During his early years at Weimar, Kandinsky developed ideas from his earlier writings, providing material for the students, such as *Course in Colour, and Seminar*, which was later incorporated into the *Bauhaus-Buch*.

CREATED

Weimar

MEDIUM

Pen and ink and watercolour on paper

RELATED WORKS

Paul Klee, *Architecture of Planes*, 1923

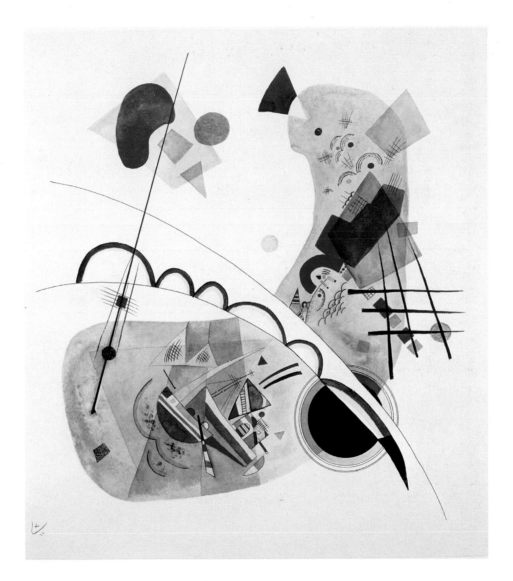

White Zig-Zags, 1922

For Kandinsky, the early years at the Bauhaus were marked by a reassessment and reworking of his theories first espoused in *Concerning the Spiritual in Art*. In the interim he had begun to assimilate some of the ideas from the Constructivists and to a lesser extent was also prepared to engage in some of the artistic debates of the time. In 1922 he attended a symposium called 'A New Naturalism'. The backdrop for this was a new wave of artistic effort called the *Neue Sachlichkeit* ('New Objectivity'), a form of political social realism that had become popular in Germany in the 1920s. Prewar Expressionism still had currency, although it was on the wane, and German Dada dominated the avant-garde. What they shared in common was the eschewal of naturalism and Abstraction.

Kandinsky's contribution to the symposium was to suggest that all these ideas were in a state of flux because of recent events, but that eventually Abstraction through naturalism would, once the 'content of the period' was resolved, be dominant. For Kandinsky they were 'two paths to the same goal'.

CREATED

Weimar

MEDIUM

Oil on canvas

RELATED WORKS

Otto Dix, *Lady*, 1922

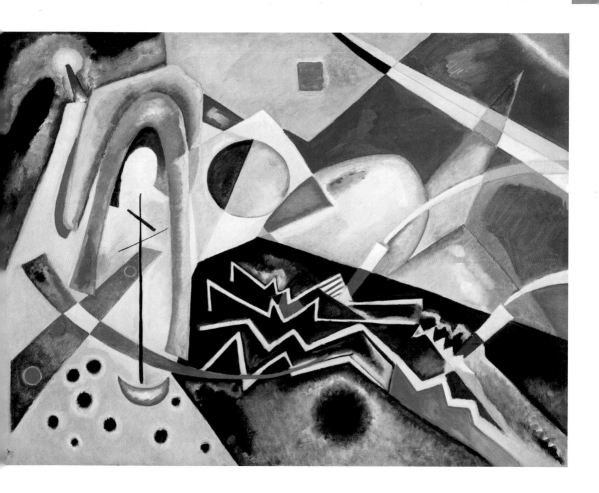

Schweres Zwischen Leichtem ('Between Heaviness and Lightness'), 1924

In addition to his teaching requirements at the Bauhaus, Kandinsky also lectured elsewhere in Germany and in Vienna during 1924, in order to supplement his income. Inflation was still a serious problem in the republic of Weimar as it was in the rest of Germany. In fact Weimar, once the home of Johann Wolfgang von Goethe (1749–1832) and Friedrich Nietzsche (1844–1900), and capital of culture in Germany, was now no more than a small provincial town. Luckily there was a collector in the town called Otto Ralfs (1892–1955), who set up a 'Kandinsky society' to acquire works for its members. Each of them contributed to a pool of money that enabled them to buy a watercolour from the artist at the end of the year at a favourable price. Kandinsky was only too willing to oblige since the opportunities for sales were few and far between.

During his years at the Bauhaus, Kandinsky executed many hundreds of watercolours and drawings that he used in his pedagogical theories. *Schweres Zwischen Leichtem* is probably one such work and exemplifies Kandinsky's move towards Abstraction in which recognizable motifs are absent.

CREATED

Weimar

MEDIUM

Watercolour, pen and coloured inks on paper, laid down on board

RELATED WORKS

Paul Klee, *Young Lady's Adventure*, 1922

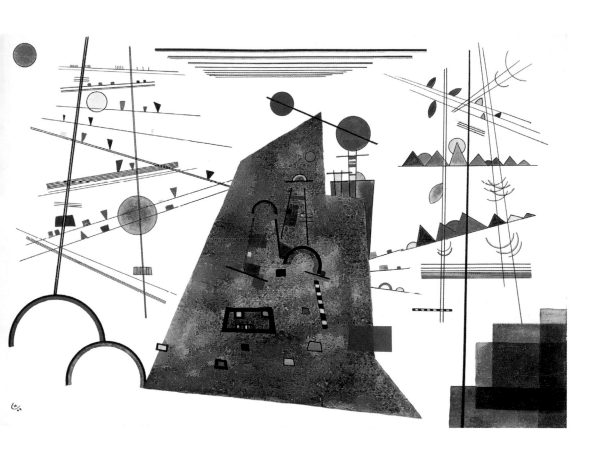

Swinging, 1925

The title of the work is suggestive of an engagement with the modern world of the mid 1920s, the so-called 'jazz age'. However, Kandinsky eschewed all notions of materialism in the modern world in favour of a spiritual salvation. His move to total Abstraction that was devoid of references to the outside world was one designed to overcome this problem. During the 1920s Kandinsky continued to develop his theories concerning form, and in 1925 published his famous essay 'Point and Line to Plane' as part of his pedagogical theories for the Bauhaus. In this work Kandinsky articulated his theories about drawing and painting to be used in graphic design. The 'point' is the starting place for a line containing a certain inherent quality, the fusion of silence and a discourse, a productive interaction between the artist and the 'plane' (sheet of paper or canvas). From the moment the pen or brush moves, it initiates a tension that sets up the work. According to Kandinsky, the lack of this tension leads to the failure of the work of art, whether it is painting, sculpture or music.

CREATED

Weimar

MEDIUM

Oil on board

RELATED WORKS

Paul Klee, *Pedagogic Sketchbook*, 1925

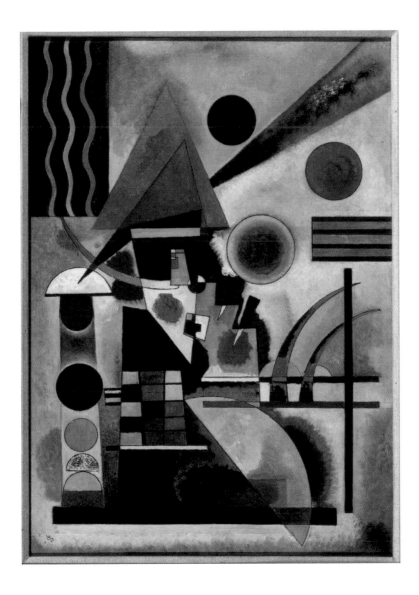

One Spot (Red on Brown), 1922

From about 1923, the dominant 'spot', a derivative of the circle, makes an increasing appearance in Kandinsky's paintings. In 1923 Johannes Itten, the Master of Form at the Bauhaus and an artist empathetic to Expressionism, was replaced by the Constructivist artist László Moholy-Nagy (1895–1946). As a result more geometric elements entered Kandinsky's artistic language, such as the circle and triangle. The circle, that most perfect form, became a focal point in his paintings. Often, as in *One Spot (Red on Brown)*, the circle is distorted, alluding to a cosmic symbol, in this case a sun complete with a hazy watery edge.

Although Kandinsky is moving towards a Constructivist language, it is often not without references to spirituality either in form, colour or both. For Kandinsky there is a balance to strike between the analytical and theoretical aspects of paintings and the purely intuitive, as demonstrated in this work. The intuitive circle is balanced by the graphic image of the ship, in keeping with the more geometric aspirations of the Bauhaus.

CREATED

Weimar

MEDIUM

Oil on canvas

RELATED WORKS

László Moholy-Nagy, *Composition*, 1921

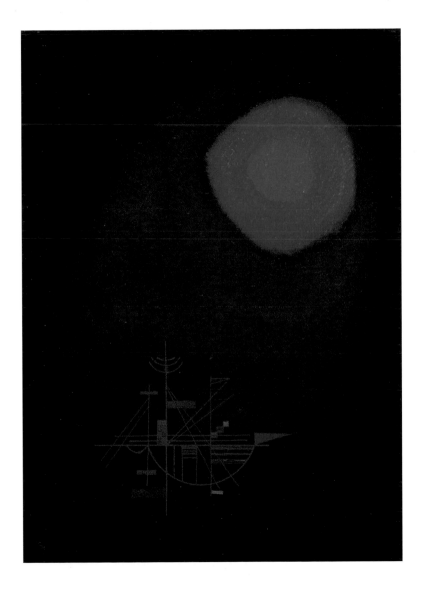

Black Triangle, 1925

The 'Weimar years' at the Bauhaus had been ones of great experimentation for Kandinsky, seeking to synthesize the two elements of his spiritual thinking and pragmatic pedagogical considerations. He was in essence a subjective painter working from an 'inner necessity' trying to teach an objective 'science of art' course. On the face of it, it would seem that Kandinsky had taken on board the many criticisms heaped upon him in Russia prior to his time in Weimar, but that would be to ignore the efforts he had already made to synthesize these elements before arriving at the Bauhaus. For example, it would be ignoring the many practical considerations in his *Concerning the Spiritual in Art*, in which he carefully articulates his colour theories using diagrams. And, as Gillian Naylor has pointed out, it would also be disregarding his 1919 essay 'Little Articles on Big Questions', in which he specifically referred to single-dimensional geometrical shapes as 'forms belonging to the first sphere of graphic language'.

In many ways *Black Triangle* is a synthesis of both the spiritual and the Constructive aspects of painting.

CREATED

Weimar

MEDIUM

Oil on canvas

RELATED WORKS

Paul Klee, *The Sublime Aspect*, 1923

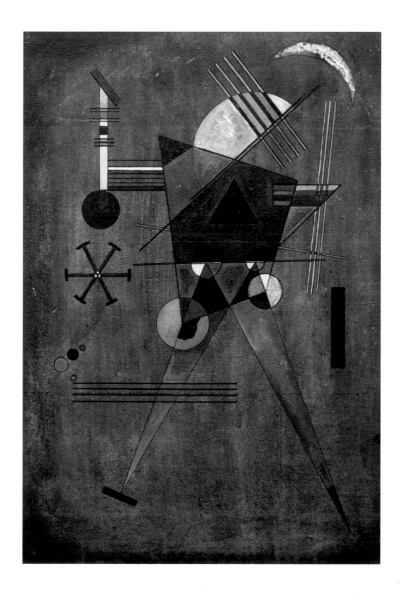

In a Light Oval, 1925

The development of the oval shape was an important consideration for Kandinsky in his 'battle of the canvas', freeing him from the tyranny of the rectangle. It was also a break from the perfection of the circle. However, as Kandinsky wrote in *Concerning the Spiritual in Art*, the yellow of the oval is intense, and 'hurts the eye in time as a prolonged and shrill trumpet-note the ear, and the gazer turns away to seek relief in the blue or green'.

During 1925 Kandinsky produced a number of 'oval' paintings, some of which were reminiscent of portraiture, being oval themselves. In fact there is an intimacy in these works as suggested in a complementary contemporary work *Intimate Communication*. The painting *In a Light Oval* is also an intimate work that is reminiscent of Kandinsky's Russian homeland, in the use of red and black 'Cossack sword' motifs.

The dynamism within the oval, accentuated by the yellow, is tempered by the perfect circle and specifically regimented forms of the rectangle in the top left-hand corner, thus creating an ideal tension for this work of art.

CREATED

Weimar

MEDIUM

Oil on card

RELATED WORKS

Paul Klee, *Magic Garden*, 1926

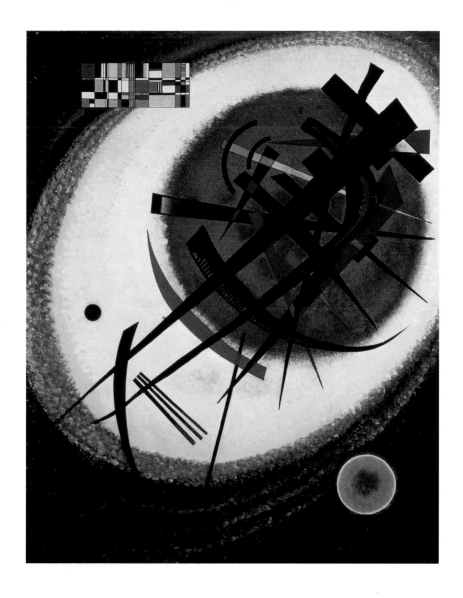

Sign, 1926

The continual pressure from the conservative nationalists in the town of Weimar, who considered the Bauhaus too cosmopolitan, led to the school moving to Dessau in June 1925. Kandinsky did not escape these often vociferous attacks on its personnel, since, like Maholy-Nagy and Klee, he was a foreign national benefiting from local taxpayers' money.

The Bauhaus was welcomed by a more open-minded society in what was ostensibly an industrial town. The move to Dessau was therefore a liberating experience for Kandinsky for this reason, but also because Gropius gave him and Klee more artistic freedom. Both artists were given the opportunity to teach painting, as well as their normal duties at the Bauhaus. They were also accommodated close to the complex, each being given one half of a large house that also contained studios. This facilitated a closer working relationship between Klee and Kandinsky that resulted in the most prodigious and prolific output for Kandinsky since his days in Munich. After moving into his house in July 1926, Kandinsky remarked, 'In a few short days we have become different people.'

CREATED

Dessau

MEDIUM

Oil on cardboard

RELATED WORKS

Paul Klee, *Italian City*, 1928

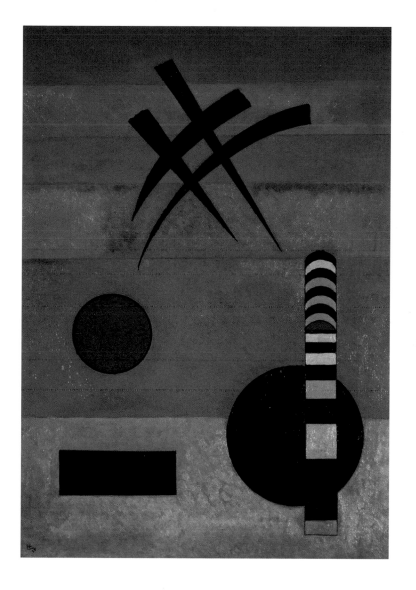

Accent en Rose
('Accent in Pink'), 1926

From 1926 until 1932, Kandinsky's output was even more prolific than it had been in Munich. The beginning of that period was marked by the artist's sixtieth birthday. Kandinsky organized a touring exhibition of his work in several German cities including Berlin and Dresden. The Bauhaus too recognized the artist's achievements, dedicating the first issue of its periodical *Bauhaus* to him and his work.

Accent en Rose is a work from this initial period that continues Kandinsky's fascination with the circle, and its almost limitless visual potential. For him they have endless tensions as they interact with other shapes. In this work it is the juxtaposition of the square that does not quite penetrate its form. The viewer is drawn to the pink circle, which is floating above the rhomboidal plane; itself floating and yet contained within the galaxy of smaller circles surrounding and touching it.

According to Kandinsky, when red is used in a painting it should be precisely defined in terms of its shade and clearly delineated from the other colours, producing both a subjective and an objective synthesis.

CREATED

Dessau

MEDIUM

Oil on canvas

RELATED WORKS

Joost Schmidt, Cover for the Bauhaus magazine *Offset*, 1926

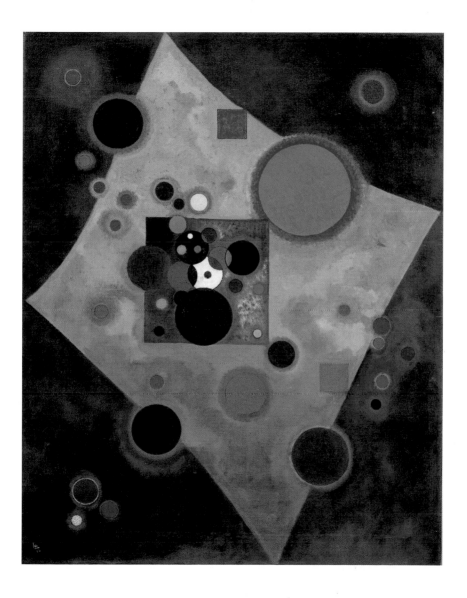

Zeichen mit Begleitung ('Sign with Accompaniment'), 1927

In his essay 'Point and Line to Plane', Kandinsky refers to the lyricism of a straight line and how that can be compromised by the addition of other lines joining and intersecting it, setting up a 'drama'. When two lines are joined it sets up a force. These forces may act alternately to produce angular lines, or simultaneously to produce curved lines. Both are present in *Zeichen mit Begleitung*, a 'constructed' work from 1926, in which the straight and curved lines are 'floated' above the constructional grid and seem to resemble abstracted motifs from Kandinsky's past, the Cossack lance and sword. These forms are connected to the background by yet another of Kandinsky's favourite motifs from this period, a cross, in this case, an inverted Cross of Lorraine.

The background is a motif from the influence of the *De Stijl* artists, particularly Theo van Doesburg who visited the Bauhaus at Weimar during 1920–21, whose aesthetic was largely disseminated and well known to Kandinsky. Its concern was with rectangular forms and the use of predominantly primary colours.

CREATED

Dessau

MEDIUM

Oil on canvas

RELATED WORKS

J. J. P. Oud, Design for *Café de Unie*, 1925

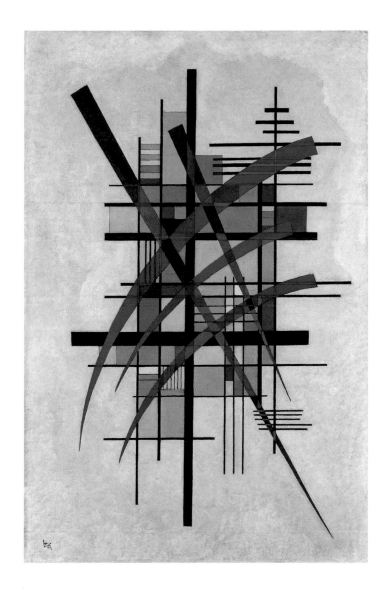

Launelinie ('Mood Lines'), 1927

Although it is possible to see this work in terms of its cosmic allusions and their spiritual connotations, the circles are more derivative of Paul Klee's own experiments, at this time, with transparent colour theory and its effect on interlocking shapes. These were in turn based on Goethe's experiments of the late eighteenth century that culminated in his *Theory of Colour* in 1810.

Klee was also a musician and believed, like Kandinsky, in the relationship between colour and music and in their power to transcend the material world. For Klee that relationship was exemplified in the music of Wolfgang Amadeus Mozart (1756–91) and Johann Sebastian Bach (1685–1750), and his own paintings such as *Fugue in Red*.

For Kandinsky, his inspirations were Igor Stravinsky (1882–1971) in his early period and Arnold Schönberg (1874–1951), with whom he had collaborated on *Der Blaue Reiter* ('The Blue Rider'). Schönberg, also a devotee of Mozart and Bach, sought to develop a musical language of simplified forms, famously stating that he wanted to 'create a novel in a single gesture'. Kandinsky spent the summer of 1927 with Schönberg, their moves towards more simplified forms finding empathy.

CREATED

Dessau

MEDIUM

Watercolour, gouache and Indian ink on paper

RELATED WORKS

Paul Klee, *Fugue in Red*, 1921

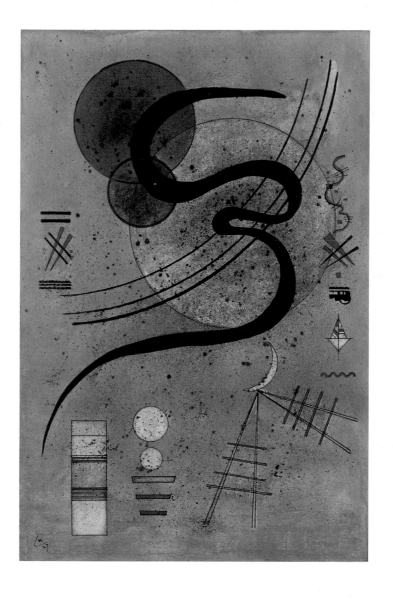

Bow and Arrow, 1927

The theory of colour as expounded in Kandinsky's *Concerning the Spiritual in Art* may be misleading, since it suggests that, for example, blue is to the circle as yellow is to the triangle. The misunderstanding is as a result of seeing Kandinsky's theory as a compositional ploy. In fact Kandinsky is referring to the 'correspondences' of colour and form, as Baudelaire wrote, 'with power to expand into infinity that sing the ecstasy of the soul and senses'. In other words it is the very opposite of a formulaic approach in that having established the 'building blocks' of form and colour, it is then for the artist to explore the subversion of those preconceived notions. Kandinsky does, however, provide some clues suggesting that generally speaking the sharper forms are more suited to yellow than blue.

In *Bow and Arrow* Kandinsky uses interlocking forms of triangles and rectangles predominantly in red and yellow, specifically anchored at the base of the overall composition (the bow) by the white triangle. The artist has used a 'heavenly' blue circle as the counterpoint to the subversion, without which the tension would not take place.

CREATED

Dessau

MEDIUM

Oil on canvas

RELATED WORKS

László Moholy-Nagy, *AXL II*, 1927

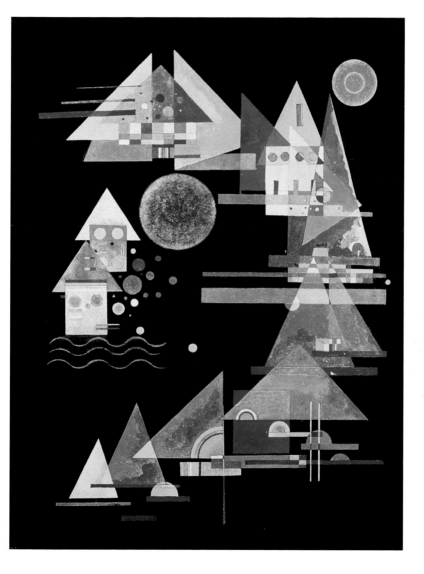

Composition No. 302, 1927

A preoccupation for Kandinsky was 'synthesis', whether in his own painting or as a *gestamtkunstwerk* with other art forms. In 1928 he was successful in staging Modest Mussorgsky's (1839–81) *Pictures at an Exhibition* in Dessau.

Although Mussorgsky composed this work in 1874, it was virtually unheard of in concert halls until Maurice Ravel's (1875–1937) version was orchestrated in 1922. It was originally conceived by Mussorgsky as a tribute to his friend the artist Viktor Hartmann (1834–73), who had died aged only 39. A mutual friend Vladimir Stasov (1824–1906) had organized an exhibition of Hartmann's work at the academy in St Petersburg. He commissioned Mussorgsky to compose a suite for piano to accompany the exhibition. After the exhibition, it was virtually unheard of again until Ravel revived the work as an orchestral suite.

Kandinsky must have been excited by this anecdote seeing it as a musical interpretation of visual art, an ideal *gestamtkunstwerk*, ripe for reassessment and synthesis. Kandinsky created a series of stage designs as pictorial counterpoints to Mussorgsky's music in which he interprets the music without ever having seen the original paintings by Hartmann.

CREATED

Dessau

MEDIUM

Watercolour, pen and ink on paper

RELATED WORKS

Paul Klee, *Pastorale (Rhythms)*, 1927

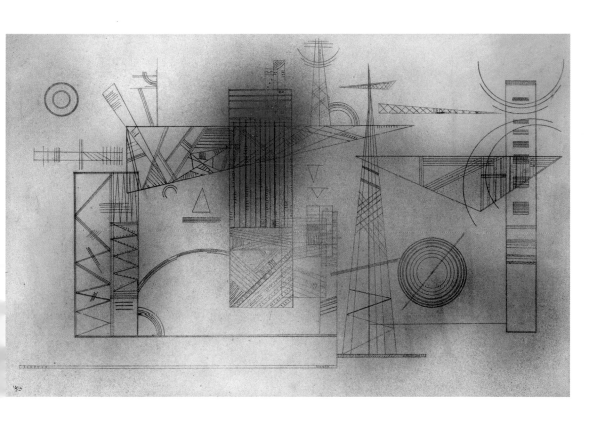

Aufsteig ('Ascending'), 1929

In many ways this work deals with the tensions between the purely formalist geometric considerations of a painting and the intuition of the line. The work is also whimsical and already anticipates the humour in Kandinsky's work during his final years at Dessau that he carried over into his late paintings. In 'Point and Line to Plane' Kandinsky refers to the relationship of straight, zig-zag and curved lines, 'corresponding' to each other as birth, youth and maturity. These are purely formalistic values. The painting also has recognizable motifs that have been abstracted. The zig-zag lines appear to be a mountain range. At the top of one of its peaks is an allusion to 'the window on the world'. The main 'character' resembles a cat, complete with triangular ears and whiskers. The secondary motif appears to be a bird perched on a wire with a nest-building stick in its beak. The title *Aufsteig* or 'ascending' suggests a hierarchy of the hunter and its prey, emphasized by the colours of red and blue.

CREATED

Dessau

MEDIUM

Watercolour, pen and black ink on paper laid down on board

RELATED WORKS

Marianne Brandt and Hin (Hinrich) Briedendieck, Kandem table lamp, 1928

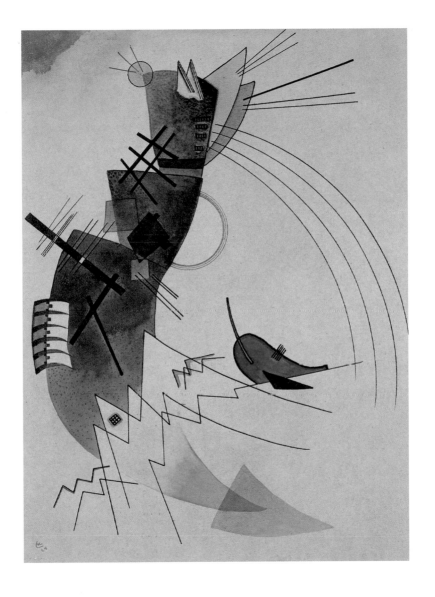

Weiss-Weiss ('White-White'), 1929

The question of formalism or functionalism came to dominate the Bauhaus under the directorship of Hannes Meyer (1889–1954) following the resignation of Walter Gropius in 1928. Meyer felt that there was too much 'art' and not enough pragmatic application to industrial design. He was a Communist and more considerate of the provision of good housing than individual aspirations within the Bauhaus. Meyer was also highly critical of the emphasis on, and preoccupation with, form.

Immediately prior to Gropius's resignation a number of key staff including Moholy-Nagy and Marcel Breuer (1902–81) also resigned, aware of the fallout that was to occur with Meyer's appointment as director of the Bauhaus. One of the Masters, Oskar Schlemmer (1888–1943), wrote at the time, 'The Bauhaus will reorient itself in the direction of architecture, industrial production and the intellectual aspect of technology. The painters are merely tolerated as a necessary evil now'.

Clearly this presented a problem for Klee and Kandinsky. It is unclear why Kandinsky decided to stay, but it marks the beginning of a period in which Kandinsky seemed to withdraw more and more from Bauhaus activities in favour of pursuing his own painting.

CREATED

Dessau

MEDIUM

Oil on board

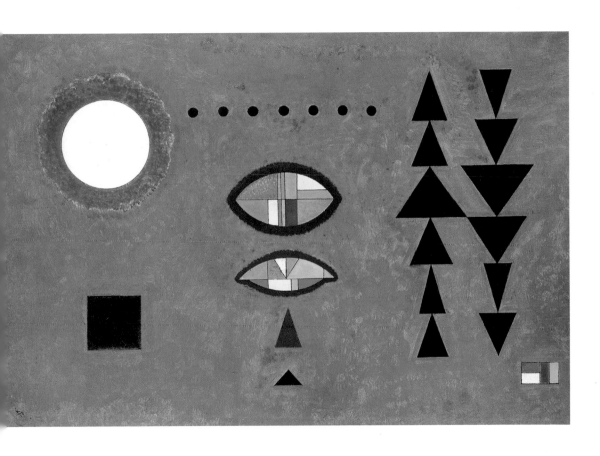

Upwards, 1929

As with the contemporary work *Aufsteig*, Kandinsky is again playing whimsically with geometric forms in this work. In this year he was to write, 'I do not choose form consciously, it chooses itself in me.' The work consists of a semicircle finely but precariously balanced on the tip of a triangle. It is counterbalanced by a narrow rectangular strip and smaller orange segment, which, although smaller in area, between them seem to balance the semicircle perfectly. To achieve this perfect balance Kandinsky uses a careful blend of colours that increases the apparent density of the smaller segment. The fact that it overhangs the semicircle both checks and extends its vertical progress; hence the title. A horizontal line that further bisects the semicircle draws our attention to its central axis, and its tension with the vertical that maintains the balance. By this Kandinsky achieves both a tension and a synthesis in the work.

There is also a sense of a human face in this work, the 'heavenly' blue circle and aura depicting the eye and the narrow red rectangle representing a mouth, reminiscent of an earlier Paul Klee work.

CREATED

Dessau

MEDIUM

Oil on cardboard

RELATED WORKS

Paul Klee, *Senecio*, 1922

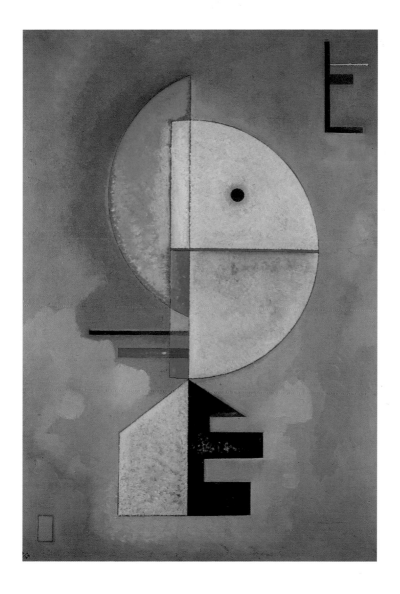

Variierte Rechtecke ('Varied Rectangles'), 1929

Variierte Rechtecke is again redolent of the *De Stijl* aesthetic in its use of a grid-like pattern of different primary-coloured rectangles. There is also a sense of the 'architectonic' values sought at the Bauhaus, particularly by its new incumbent Hannes Meyer. From the bottom of the picture, Kandinsky suggests a road leading to the heart of a 'town', bypassing the entrance to a tunnel. There are a number of 'architectonic' motifs in the picture, such as the triangular roofs and the grid patterns of a modern window system similar to those at the Bauhaus building,

The horizontal line at the top of the picture appears to represent a horizon, the setting or rising sun appearing in the top right-hand corner, and next to it is a graphically stylized tree. The three lines at the top left are a compositional ruse to balance the arrow at the bottom right, which draws our attention to the side elevation of a building perched on the edge of a hill or cliff face, and the descent down its steep escarpment. Clearly the 'town' is at high altitude.

CREATED

Dessau

MEDIUM

Watercolour and Indian ink

RELATED WORKS

Gerrit Rietveld, Design for the *Weiner Werkbundsiedlung*, Vienna, 1930–32

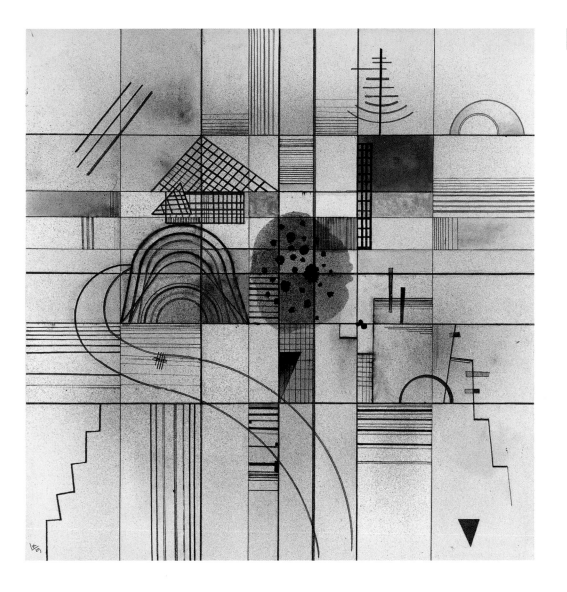

Dicht ('Dense'), 1929

The year 1929 was one of mixed blessings for the world and for Kandinsky. In May the International Exposition opened in Barcelona and probably the most controversial exhibit there was the German Pavilion designed by Ludwig Mies van der Rohe (1886–1969), who in the following year was to accept the appointment as director of the Bauhaus. The controversial pavilion was an 'architectonic' Modernist villa, which served as the venue for the official opening ceremony by the King of Spain. Kandinsky's *Dicht*, with its emphasis on the various national flags, is suggestive of the processional route towards the *Palau Nacional* from the pavilion.

In October the Wall Street Crash occurred sending financial shock waves around the world and plunging it into the Great Depression. There were obvious implications for the Bauhaus, but more especially Germany, already beset by rioting in Berlin due to the high levels of unemployment.

On a more positive note, The Museum of Modern Art opened its doors in New York, and included some early works of Kandinsky, including *Improvisation* from 1915. The director, Alfred H. Barr (1902–81), referred to Kandinsky's paintings as 'pure abstractions'.

CREATED

Dessau

MEDIUM

Oil on board

RELATED WORKS

Ludwig Mies van der Rohe, Barcelona chair, 1929

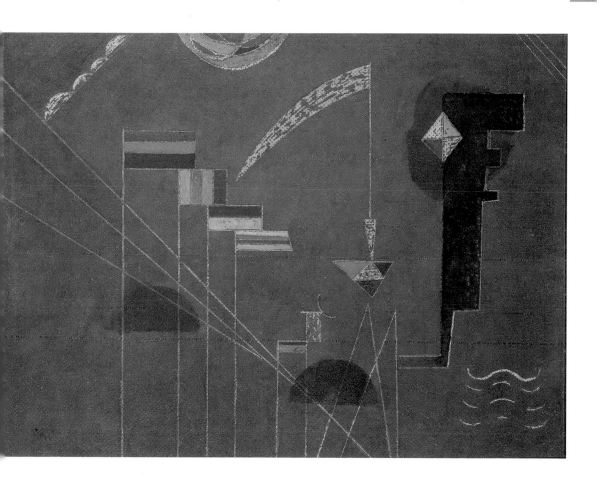

Gelb Rosa ('Yellow Rose'), 1929

Although Hannes Meyer seemed to encourage painting classes he had not really grasped the correlation between art and design. For him architecture and design was a 'biological and not an aesthetic process', that is not an individualistic but a collective discipline. The resistance to Gropius's original concept of the unity of art and industry by Hannes caused one of the Bauhaus's most loyal masters, Oskar Schlemme,r to resign in 1929. With an increasing emphasis on functionalism at the Bauhaus during 1929, Kandinsky and Klee were becoming more isolated from the school in terms of their input, since there was less emphasis on using innovative theories to solve design problems. The problem for Klee and Kandinsky was that their 'synthesis' was not easily fathomable.

This isolation from the mainstream at the Bauhaus led Kandinsky to revert more and more to his painting. In 1929 he held his first one-person exhibition in Paris at the *Galerie Zack*, where he showed a number of watercolours and drawings. This was to provide him with a foothold into the established art market in Paris that would serve him well later.

CREATED

Dessau

MEDIUM

Watercolour, pen and black ink on paper

RELATED WORKS

Paul Klee, *Saint A in B*, 1929

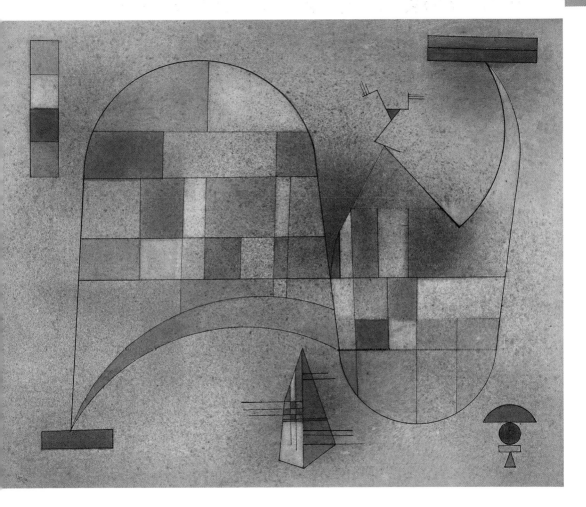

Léger, 1930

The reverberations of the Wall Street Crash were being felt in the European art market of 1930. One of the key players in that market was the French Cubist Fernand Léger (1881–1955) who, in that year, wrote an essay called 'Deus ex Machina' in which he reassessed the 'machine aesthetic' as part of the Modernist discourse. Until that time Léger and other artists had used the machine as a motif for visualizing the modern world, but now he felt that too much emphasis had been placed on this that now produced a 'sterile mechanolatry' (machine-worship). He wrote, 'I believe that we've reached the upper limit here. It will end; we'll become interested in other things. There are microbes, fish, astronomy etc. ...'.

Léger clearly had one careful eye on his potentially dwindling client base, and felt that possibly, since many of his patrons were industrialists, that a move towards a more 'natural' motif might be more expedient.

For Kandinsky, who had never embraced the 'machine aesthetic', this was sweet music. *Léger* is possibly Kandinsky's homage to this other great artist.

CREATED

Dessau

MEDIUM

Oil on card

RELATED WORKS

Fernand Léger, *La Baigneuse*, 1931

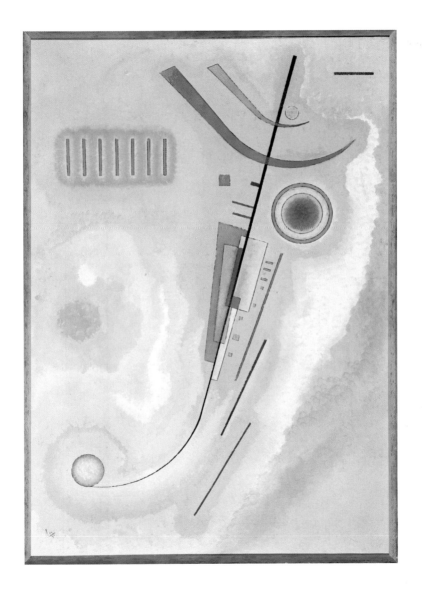

Flach-Tief ('Flat Depression'), 1930

In this Constructivist work, Kandinsky adopts very precise geometric forms. Kandinsky had always considered the circle to be the perfect geometric shape, but in this work he has varied the size, sectional elements and the position of them, to create an unidentifiable spatial structure that is emphasized by the black infinitesimal background. Although possibly alluding to a cosmic scene, Kandinsky does not allow the viewer to become complacent and self satisfied with too easy a resolution. Some of the circles are 'suspended' from 'hooks' on string, while others have the 'hooks' but no method of attachment. Some of the circles, for example the one at the bottom right, could be identified as astronomical bodies half in shade; others, for instance the central segmented 'body', could not possibly be. The circle just to its right suggests Saturn with its 'rings', and yet to its left is another circle with vertical stripes that seems to defy this logic. It is clear in this work that Kandinsky is playing with forms to tease the viewer.

CREATED

Dessau

MEDIUM

Oil on board

RELATED WORKS

L-zslÛ Maholy-Nagy, *Light-Space Modulator*, 1930

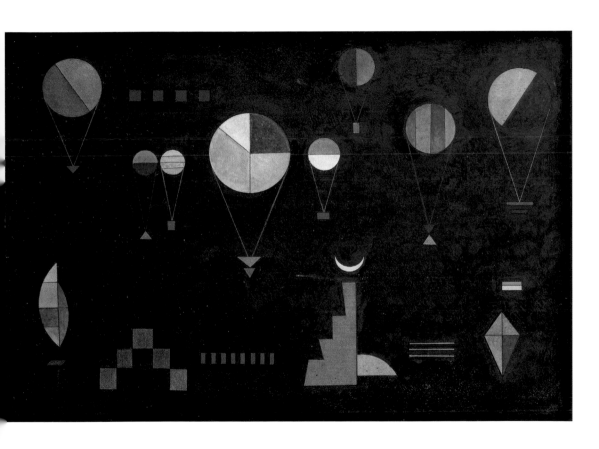

Zwei Schwarze Streifen ('Two Black Lines'), 1930

In more traditional paintings, particularly history painting, the viewer is often directed to the central message of the picture by the title. In *Zwei Schwarze Streifen* one can clearly see the lines in question, but Kandinsky uses it as a compositional ruse, acting as a foil to the central motif that makes the viewer question his judgment since we are continually drawn to its centrality. The central figures suggest one of Oskar Schlemmer's mechanical 'Triadic' ballets, performed at the Bauhaus, 1926–27. Schlemmer's figures acted as metaphor, the idealized perfect human being devoid of modern materialism.

Kandinsky's picture plane is divided between a lighter area to the left, suggesting a performing area or stage, and a darker magenta area to the right, suggesting the wings. The turquoise line, or curtain, acts as a delineation of the two areas. If there were no performance the whole picture plane would be magenta. However, Kandinsky has now applied a pale blue wash over the magenta ground on the left-hand side to show that the floodlit performance is under way.

CREATED

Dessau

MEDIUM

Oil on panel

RELATED WORKS

Oskar Schlemmer, *Triadic Ballet*, 1926–27

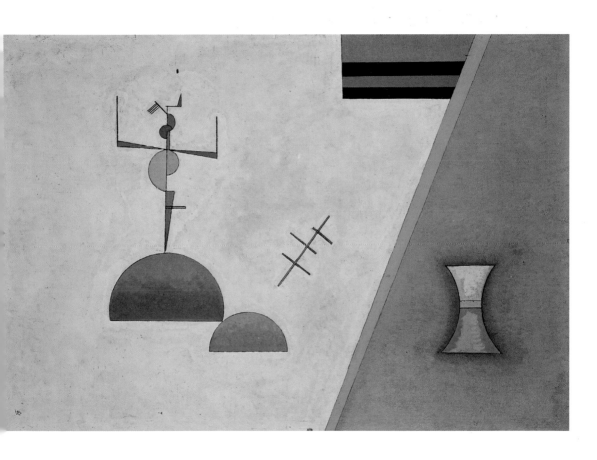

Mehr Oder Weniger ('More or Less'), 1930

In 1930 Kandinsky travelled to Paris, submitting work for the *Circle et Carré* ('Circle and Square') exhibition at the *Galerie 23*. The artist and critic Michel Seuphor (1901–99) and another artist Joaquin Torres-Garcia (1874–1949) founded this short-lived group that had abstract aspirations. Although not well known as artists, they succeeded in bringing together a number of key avant-garde artists for this exhibition such as Hans Arp (1886–1966), Le Corbusier (1887–1965), Fernand Léger (1881–1955), Piet Mondrian (1872–1944), Amédée Ozenfant (1886–1966), and Kandinsky, as well as his fellow Russian, the Constructivist sculptor Antoine Pevsner (1884–1962).

Although Kandinsky knew Arp from his Munich days, the renewed contact at this exhibition may have brought him into contact with the Surrealist group also based in Paris. The *Circle et Carré* group was essentially set up to counter the prevailing dominance of the Surrealist group by providing the journal and exhibition as a forum for the Abstractionists. Arp had a foot in both camps.

The title of this work, *Mehr Oder Weniger*, which means 'more or less', suggests the ambiguity and humour present in much of the Dada and Surrealist work of the late 1920s.

CREATED

Dessau

MEDIUM

Gouache on paper laid down on card

RELATED WORKS

Hans Arp, *Configuration with Two Dangerous Points*, 1930

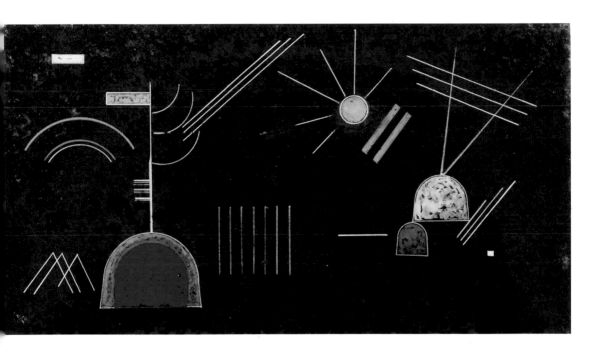

Composition, 1930

Hannes Meyer reached the end of his career at the Bauhaus in the early part of 1930. He had become too much of a political liability, his Marxist ideas at odds with the growth of right-wing extremism in Germany at this time. Meyer had founded a group of Communist students, who in the 1930 Dessau Carnival had sung Bolshevik songs in public. This flagrant act in combination with his other Marxist activities ensured his forced removal from the school. Kandinsky was implicated in the plot. Meyer was replaced by the more conservative 'International style' architect Ludwig Mies van der Rohe (1886–1969), who squashed all political activity at the Bauhaus, but continued Meyer's more functionalist approach to design.

Under Mies van der Rohe, Kandinsky had even fewer teaching commitments, thus providing him with more opportunities to paint. In *Composition* Kandinsky uses the geometric 'functionalist' form of a triangle to depict what is probably an abstracted sailing boat circumnavigating a marker buoy complete with flag. Such geometry is balanced by the ethereal effect of the suggested clouds and sky in the background.

CREATED

Dessau

MEDIUM

Watercolour, pencil and ink on paper

RELATED WORKS

Georgia O'Keefe, *Red Barn in a Wheatfield*, 1928

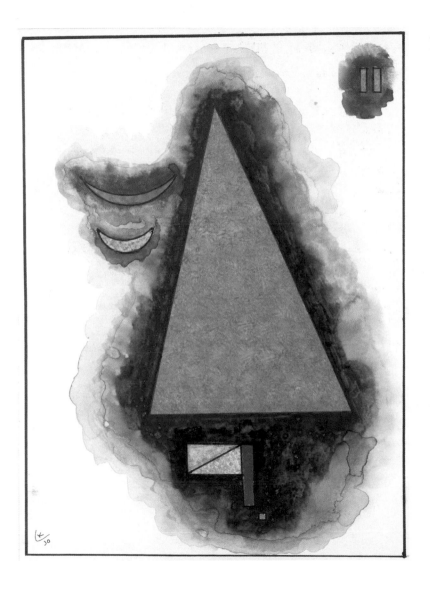

Dünn Gebogen ('Thin Flex'), 1930

For Kandinsky, the year 1930 ended on a low note. During September the Nazi party had made significant political inroads during the general election, securing 107 seats in the Reichstag. This increased their holding from 12 at the beginning of the campaign, a clear indication of the substantial swing to the right in Germany. By October, Nazi activists had begun the pogrom of smashing the windows of Jewish shopkeepers that was to reach its climax in 1938 in the so-called *Kristallnacht* ('crystal night'). Such activity also had its effect on Jewish, Communist and non-German artists. In Weimar, Kandinsky's paintings were forcibly removed from the town's museum on the advice of the art critic and Nazi polemicist Paul Schulze-Naumberg, advocating that his work was 'degenerate'.

The notion of *Entartung* (Degeneration) was conceived in 1892 by a German writer Max Nordau (1849–1923), who suggested that modern artists were suffering from diseased brains, resulting in a lack of discipline in their work. Nordau was particularly critical of the Symbolists. These theories were used by Schulze-Naumberg in his book *Art and Race* to justify a methodology for ridding art of its degeneracy on the grounds of racial impurity.

CREATED

Dessau

MEDIUM

Gouache on paper

RELATED WORKS

Albert Janesch, *Water Sport*, 1936

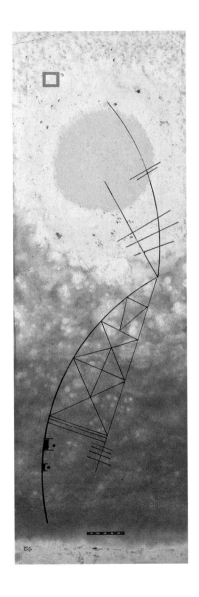

Dünn Mid Heckig ('Heckig Narrowly Avoided'), 1931

In *Dünn Mid Heckig* we see evidence of Kandinsky beginning to lighten his palette in terms of colour and forms. Gone is the black or dark background to be replaced with delicate ethereal washes that nonetheless denote his preferred 'heavenly' blue. The colour, no longer used by Kandinsky in an Expressionist way, now serves only as a background to the forms. The forms too are much lighter, relying on line rather than more solid forms, which give a vaporous transparency to the work as a whole.

There are no longer any recognizable motifs in the work beyond the dominant circle and the triangles that seem to have emanated from it. The circle appears as a 'mother' spaceship or Sputnik, the lines of trajectory from its hub suggesting that it has given 'birth' to the triangles. The form in the top-left corner vaguely resembles the rearranged components of a human face. Is this possibly God presiding over the birth of the universe? This fascination with the universe had common currency at this time, with the discovery of the planet Pluto in 1930.

CREATED

Dessau

MEDIUM

Watercolour on paper

RELATED WORKS

Joan Miró, *The Birth of the World*, 1925

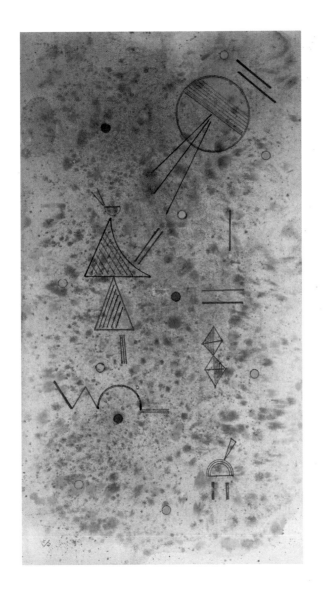

Zeichenreihen ('Drawing Threads'), 1931

Courtesy of Kunstmuseum, Basel, Switzerland/Bridgeman Art Library/© ADAGP, Paris and DACS, London 2006

In perhaps one of his most personal pieces of work from this period, Kandinsky provides the viewer with a series of geometric and organic forms in miniature, presented as though they have been collected and set on to shelves in a display cabinet. It is personal in the selection both of forms and of colours used for the motifs, which reflect his own theories and represent token aspects of his career as an artist. The circle, that most perfect form, dominates, perfectly balanced on the 'heavenly' blue triangle and juxtaposed with its complementary opposite. The square, that icon of the Suprematist ideology, is missing, a possible snub for the Russian post-revolutionary avant-garde. Kandinsky includes Egyptian hieroglyphs, a symbol of his admiration for an art seen in a modern perspective that should 'be judged as an expression of the eternal artistry'. The red, yellow and blue motif in the top right, and its complementary below on the third row, suggest figures and *mise en scène* from Oskar Schlemmer's 'Triadic' ballet.

 Zeichenreihen also contains the elements of Kandinsky's graphic work, an essential part of the Bauhaus ethos, reflecting the previous decade of his life spent there.

CREATED

Dessau

MEDIUM

Oil on canvas

RELATED WORKS

René Magritte, *The Key of Dreams*, 1930

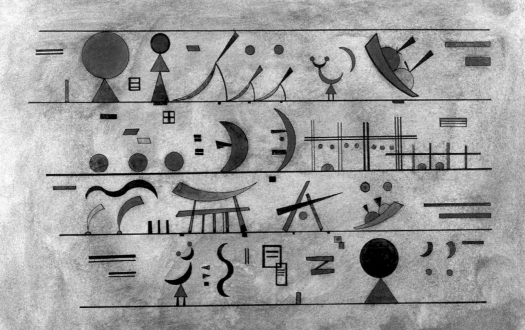

Red Across, 1931

Courtesy of Private Collection/Bridgeman Art Library/© ADAGP, Paris and DACS, London 2006

In his book *The Language of the Eye*, Paul Overy discusses Kandinsky's use of three kinds of colour in a painting, 'surface', 'film' and 'volume'. This is based on the premise of Kandinsky's extraordinary sensitivity to colour. 'Surface' colour is the raw material straight from the tube used by an artist to depict a solid object. 'Film' colour is usually transparent, akin to a rainbow, spongy in texture and devoid of a surface; while 'volume' colours are slightly more translucent than transparent and are used to give 'volume' to a shape held within or by the vaporous 'film' colour. Because of his very precise awareness of space and spatial elements at this time, Kandinsky was able to manipulate these ideas to give new expressions to his forms with the use of colour.

Red Across serves to exemplify this idea. The two outer red bands are 'surface' colour used to demarcate the central motif. Kandinsky uses pink as the 'film' colour for the central ground as a background to the main motif, which is depicted using a variety of 'volume' colours, some of which appear more translucent than others.

CREATED

Dessau

MEDIUM

Oil and tempera on cardboard

RELATED WORKS

Paul Klee, *Sunset*, 1930

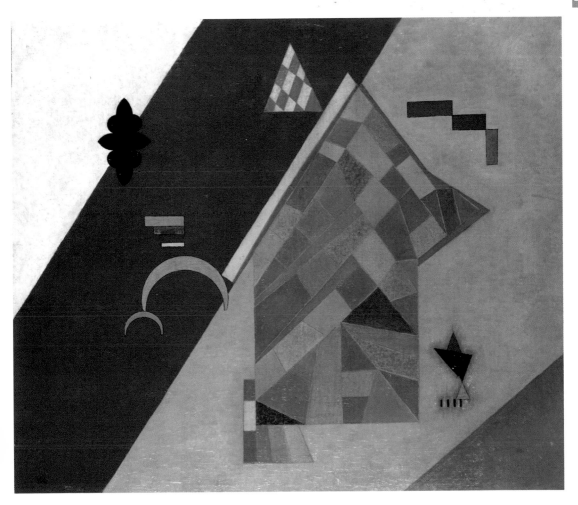

Starr ('Rigid'), 1931

The arrival of Ludwig Mies van der Rohe at the Bauhaus in the summer of 1930 further undermined the teaching of both Paul Klee and Kandinsky. Although he was less scornful of the role of the artist in stressing formal qualities than his predecessor Meyer, he continued to cut back their teaching in favour of more architectural training. The furniture, metal and mural-painting workshops were condensed into one 'interior design' unit.

All of this was too much to bear for Klee who accepted a post at the State Academy at Düsseldorf, a painting rather than a design school. Kandinsky, whose teaching had been further marginalized as well, stayed on but in his reduced role was able to spend more time painting and writing. As a tribute to Klee's achievements at the school, Kandinsky wrote an essay called 'Farewell to Paul Klee' for the Bauhaus magazine. The essay was a personal reminiscence, recounting their friendship since *Der Blaue Reiter* days. Although Klee began working at the academy, he was unable to find suitable accommodation and until 1933 commuted to Düsseldorf from his home in Dessau, thereby maintaining contact with Kandinsky.

CREATED

Dessau

MEDIUM

Watercolour and oil on paper

RELATED WORKS

Paul Klee, *Danger of Lightning*, 1931

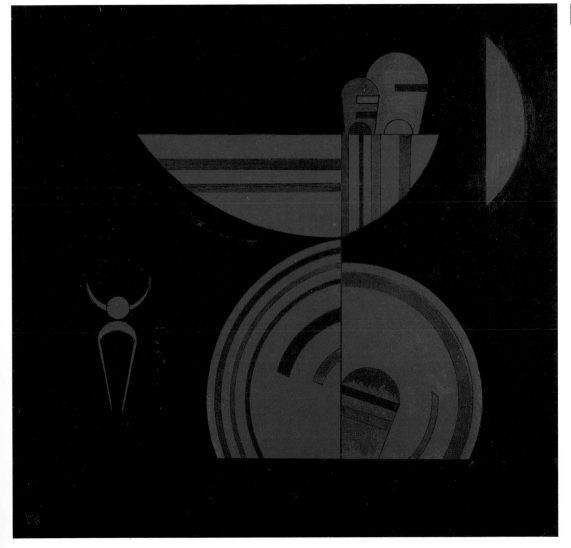

Blurred, 1932

Although Kandinsky's teaching duties had been severely diminished by this time, he still commanded the respect of many of the students. There is also evidence to show that even in 1931 students were still absorbing his theories of colour and form as laid out in his original, 'Course in Colour, and Seminar', as incorporated into the *Bauhaus-Buch*. Furthermore, Kandinsky always acknowledged the value of student interaction as a method for his own development as a painter saying, 'a man who has not had such an experience is a bad teacher and no artist at all'.

Blurred continues to show the considerable influence of Klee's ethereal qualities. As in many of Kandinsky's paintings of the late Dessau period, they are lighter and even whimsical in mood. As suggested by the title, they are a far cry from the Constructivist works and demonstrate a shift towards the more intuitive aspects of his work. Nevertheless, despite this shift, and despite gaining German citizenship for himself and his wife Nina, it is likely that the bigoted Nazis would have seen Kandinsky as a Bolshevik.

CREATED

Dessau

MEDIUM

Watercolour on paper

RELATED WORKS

Paul Klee, *To the Brim*, 1930

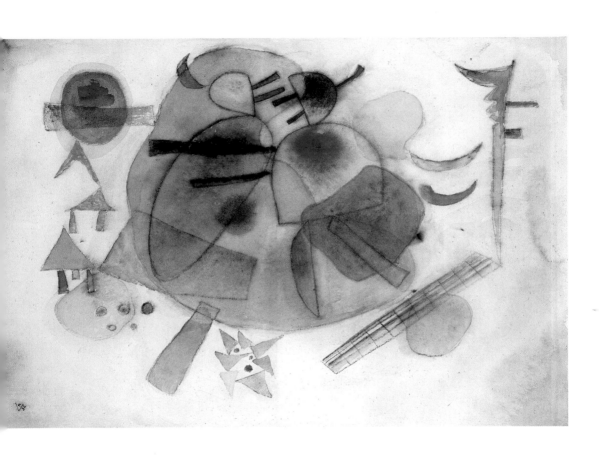

Nach Rechts – Nach Links ('To the Right – To the Left'), 1932

Courtesy of Christie's Images Ltd/© ADAGP, Paris and DACS, London 2006

The constructed forms in this work are a rare departure for Kandinsky, who had been returning to a more mystical methodology in his painting. The title, however, gives us a clue. 'To the Right – To the Left' is a sardonic political comment reflecting his mood and that of others within the Bauhaus. Up until 1930, the Communists had dominated politics in Germany. Between 1930 and 1933 there was a considerable swing to the right with the Nationalist Socialist party eventually dominating the political arena after Hitler's machinations to become Reich Chancellor. At the Bauhaus in this period, Hannes Meyer had managed to make enemies of both the 'left' and the 'right', damage that was irreparable even for the conservative Mies van der Rohe. In this prophetical painting, the figure's arm seems to indicate a preference for the 'left', but the overwhelming force of the picture's composition suggests that the 'right' will dominate and swamp it.

The composition is reminiscent of Kandinsky's 1928 work for the stage sets on Mussorgsky's *Pictures at an Exhibition*.

CREATED

Dessau

MEDIUM

Oil on canvas

RELATED WORKS

El Lissitzky, *Proun*, 1922

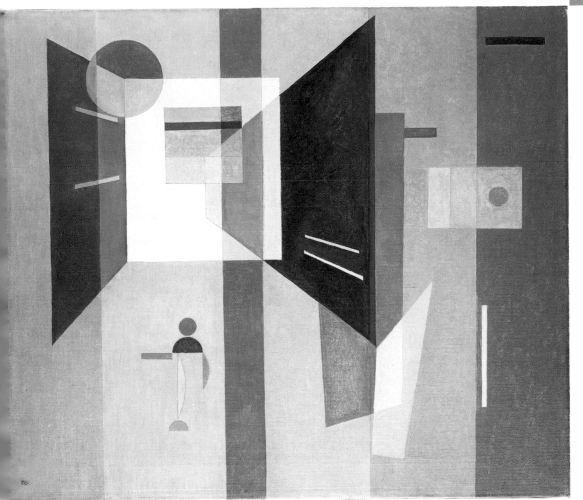

Grüne Spitze ('Green Points'), 1932

By 1932 Germany was on the brink of collapse, unable to continue with its war reparation payments, despite them being downsized, and with an unemployment figure of five million. The burgeoning Nazi party under its leader Adolf Hitler had been involved in hand-to-hand fighting, on the streets and in the Reichstag itself, with the Communists who still held the balance of power.

Even at the Bauhaus in 1931 there had been near rioting after the departure of Hannes Meyer by left-wing students critical of Mies van der Rohe's reputation as a bourgeois architect. The subsequent expulsion of the students involved did little to quell the criticisms from outside of the school by extreme right-wing political activists who by 1932 had gained control of the Dessau city parliament. Almost immediately the local government grant was withdrawn and the staff contracts terminated. Kandinsky along with all the staff left hurriedly in September 1932. Within days of vacating the premises, Nazi storm troopers moved into the building and destroyed files, smashed windows and threw fitments and equipment out on to the street.

CREATED

Dessau

MEDIUM

Gouache on paper laid down on board

RELATED WORKS

Hubert Lanzinger, *The Flag Bearer*, 1933

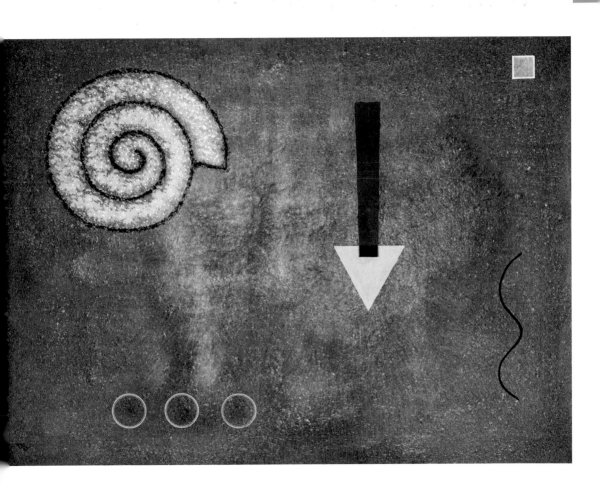

Two and One, 1933

In *Two and One*, Kandinsky appears to be using the painting as metaphor. In *Concerning the Spiritual in Art* Kandinsky refers to violet as the 'sad and ailing' colour worn by old women in mourning. 'In music it is an English horn or the deep notes of wood instruments (e.g. a bassoon).' This 'sad and ailing' colour subsumes the more 'heavenly' blue of the ground in this work, as metaphor for Kandinsky's own mood at this time. The dark violet brooding area seems to correspond with a map of Germany, the darker circles suggesting the places of most political and military activity, Berlin and the Upper Rhineland. The Rhineland had acted as a demilitarized buffer zone after the First World War and was at this time controversially occupied by the French. Berlin, the capital of Germany was the home of the Reichstag, and after January 1933 the home of Adolf Hitler, its new Chancellor.

Berlin was also the new, if short-lived, home of the Bauhaus, which moved there after its eviction from Dessau in 1932.

CREATED

Berlin

MEDIUM

Watercolour on paper

RELATED WORKS

Salvador Dali, *Soft Construction with Boiled Beans*, 1936

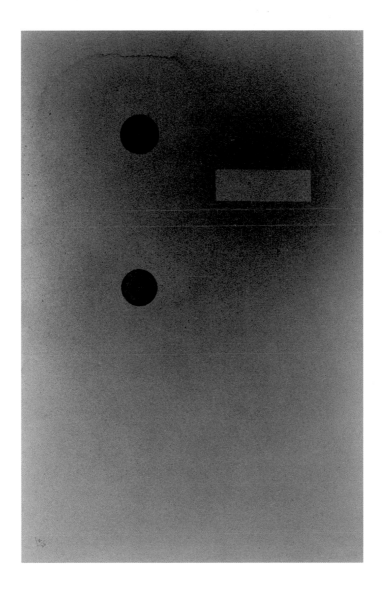

Closed Circles, 1933

On the brink of civil war in Germany, the President Paul von Hindenburg was forced to accept Adolf Hitler as Chancellor. The swing to the right was born out of a desire for order and stability by the middle classes, who controlled the factories and industrial infrastructure that was constantly under threat by the Communists. The role model for this State control of factories was Russia, who had under Bolshevik rule effectively suppressed all bourgeois enterprise.

Although the Bauhaus was not a private enterprise, it was seen as too cosmopolitan in its tastes and influence, harbouring un-German artistic values like those expressed in France, Holland and Russia. Its teachers, coming as they did from the four corners of Europe and Russia, were considered inappropriate tutors for German students. The Bauhaus was also considered Modernist in its aesthetic, which automatically linked it to Communism through its Constructivism. By the summer of 1933 the writing was on the wall.

Closed Circles is possibly a metaphor expressing Kandinsky's limited options when the Nazis finally closed down the Bauhaus in 1933.

CREATED

Dessau

MEDIUM

Oil on canvas

RELATED WORKS

Piet Mondrian, *Composition with Red, Blue and Yellow*, 1930

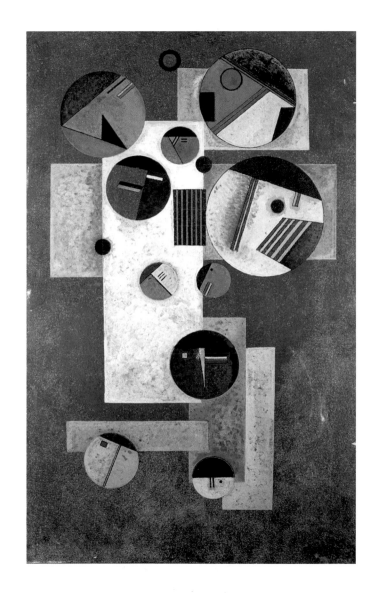

Kandinsky

Late Style

Striped, 1934

Although Kandinsky arrived in Paris in the autumn of 1933, he did not begin painting again until February of the following year, almost certainly traumatized by his enforced exile from Germany, his adopted country for almost all of his working life. At this time Paris was also torn by political unrest. Although this was not as severe as in Germany, there were still right-wing groups trying to oust the present Socialist government, which led to rioting on Paris's streets in February 1934.

In Paris, Kandinsky maintained his contacts with artists, some like him living in exile such as László Moholy-Nagy, and others such as Piet Mondrian living there to be at the centre of the European avant-garde.

In Striped, Kandinsky utilizes a Constructivist base of black and white that clearly shows a debt to Mondrian's use of black intersecting lines on a white background. The work also shows the influence of Joan Miró's biomorphic forms. Miró belonged to the *Abstraction-Création* group that Kandinsky associated with prior to his arrival in Paris, an association he was keen to continue.

CREATED

Paris

MEDIUM

Oil on Canvas

RELATED WORKS

Piet Mondrian, *Composition 1*, 1935

Vasily Kandinsky *Born* 1866 Moscow, Russia

Died 1944

Réciproque ('Reciprocal'), 1935

After settling down in Paris, Kandinsky realized that Abstraction was not as popular as it had been elsewhere, particularly in early post-revolutionary Russia and Germany. In Paris the emphasis was more on figurative painting, especially Surrealism. The doyen of the movement, the self-promoting 'pope' was André Breton, whose polemical style had ensured that Surrealism was the avant-garde. Additionally he had recruited many of the Dadaists from the avant-garde and more recently recruited another egotistical polemicist, Salvador Dali (1904–89), to the cause. The Surrealists had produced a manifesto and were also politically active, ensuring that they remained in the forefront of the avant-garde.

As a counter to these developments, a group of abstract artists formed *Abstraction-Création* to provide a forum for international debate and an exchange of ideas, as well as providing exhibiting opportunities in Paris and elsewhere.

Réciproque is one of these works from that period that combines Constructivist elements with biomorphic forms. This vocabulary found a resonance with other artists within the group such as Hans Arp, who used these 'forms' not just in painting, but also in his sculpture.

CREATED

Paris

MEDIUM

Gouache with pen and black ink and pencil on paper

RELATED WORKS

Hans Arp, *Sculpture to be Lost in the Forest*, 1932

Taches: Verte et Rose ('Spots: Green and Pink'), 1935

The early to mid 1930s were difficult years financially for all artists, not just in Paris. Paris had, however, known some very fruitful years during the 1920s, and the resulting fallout from the Wall Street Crash probably hit the city's art market harder than most.

After settling in Paris and beginning work Kandinsky's output was substantial, and he continued to work right up until his death ten years later. Between 1934, when he was already sixty-seven years old, and 1941, when he was beginning to slow down, he produced more than two hundred watercolours alone. In a Europe that was still reeling from the effects of Depression and economic turmoil, he was aware that watercolours, considerably less expensive than oil paintings, were more likely to succeed at selling. To Kandinsky his watercolours had almost as much *gravitas* as the oils. There was, as in *Taches: Verte et Rose*, a sense of immediacy about them which under certain conditions was ideal for achieving a degree of spontaneity. The properties of watercolour would allow a 'spot' to attain an unrehearsed and often unrepeatable character of its own, particularly when painted wet on wet.

CREATED

Paris

MEDIUM

Watercolour, pen brush and Indian ink on paper, laid down on board

RELATED WORKS

J. M. W. Turner, *Boats at Sea*, 1835

Brown with Supplement, 1935

Since abstract art was slightly alien to the sensibilities of a Parisian audience, the publisher of the contemporary art journal *Cahiers d'Art*, Christian Zervos, commissioned Kandinsky to write an article, which he called 'Reflections on Abstract Art'. He was asked quite specifically to explain and justify abstract art as an alternative to objective art. In typically robust style, Kandinsky turned the commission on its head and asked figurative painters to justify why their art is the only legitimate one. According to Kandinsky all artists, if they are true artists, rely on intuition, the reasoning being secondary. This was to some extent anathema to the French who were by and large Rationalists. Even Cubism had needed to be explained to a sceptical audience. Guillaume Apollinaire's (1880–1918) lyrical but ethereal writing had been inadequate and so it fell to others including Albert Gleizes (1881–1953) and Jean Metzinger (1883–1956) to write the first authoritative essays on the subject in 1911 called 'Du Cubism'.

In *Brown with Supplement*, Kandinsky plays with *gestalt* ('form') psychology. The viewer is left unsure as to whether the ground is yellow and the 'shield-like' forms are floating above it, or whether in fact they are the ground.

CREATED

Paris

MEDIUM

Oil on cardboard

RELATED WORKS

Hans Arp, *Constellation According to the Laws of Chance*, 1930

Composition IX, 1936

Kandinsky considered his 'Compositions' to be the most resolved of all his paintings, beginning with the first of them that he painted in Munich. This, his penultimate 'Composition', is perhaps the most striking and the most resolved of all, a perfect synthesis of intuition and construction, a union of the artist's head and heart. The broad bands of luscious exotic colours are separated by the black band that seems to blend amorphously with the other bands at the top of the picture, providing a structured and well-balanced ground for the other forms. The three bands of blue and black that cross it provide a Theosophical tension, redolent of Piet Mondrian's paintings that depict the competing forces of the material and spiritual worlds. Although most of the forms are amorphous, they are regulated and balanced by the recognizable geometrical shapes of the circle and rectangle. As he said in his essay 'Two Currents', written in 1935, 'A work's structure is not dictated by fragments of nature but by the totality of natural laws governing the cosmos.'

CREATED

Paris

MEDIUM

Oil on canvas

RELATED WORKS

Piet Mondrian, *Composition with Two Lines*, 1931

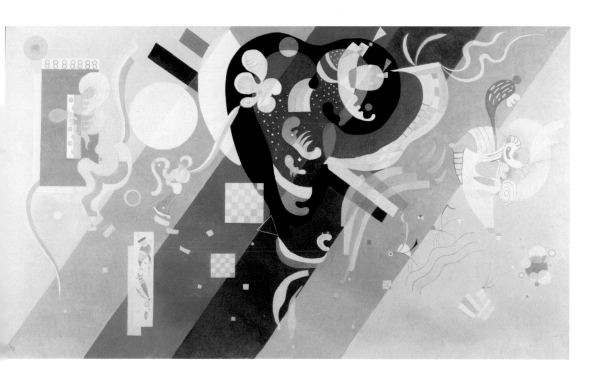

Red Knot, 1936

The painting *Red Knot* introduces a new compositional structure used by Kandinsky in his work of this period, the bipartite division of its component parts. In this work we see two quite distinct and very different biomorphic organic forms, the one on the left resembling a sea horse, while the one on the right seems inanimate, possibly embryonic. A red line delineates the two forms, possibly a fishing line that has become knotted around some reeds. The figure on the right is oblivious to this event, perhaps underpinning the notion that it is embryonic, while the left-hand figure is clearly traumatized.

As in so many of Kandinsky's paintings the composition relies for effect on the use of colour, in this case an unusual use of magenta and intense pink creating a highly decorative work that is redolent of Henri Matisse (1869–1954). The 'forms' are given a spatial awareness by the clever use of red on and around them, which is repeated in the 'line' and 'knot', thus making the viewer aware of the spatial elements of the composition.

CREATED

Paris

MEDIUM

Oil on canvas

RELATED WORKS

Henri Matisse, *The Red Studio*, 1911

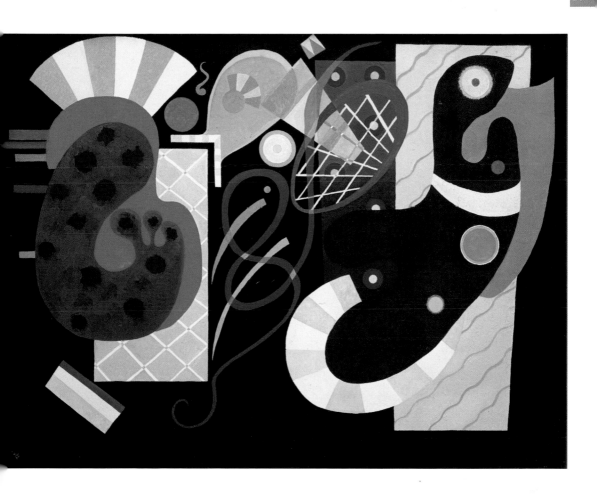

Accompanied Centre, 1937

In another essay that Kandinsky wrote in 1937 called 'Approach to Art', he stated that his aim was to 'create the pure pictorial fairytale out of the material reality of the pictorial means', rather than merely creating 'fantastic objects'. In *Accompanied Centre* Kandinsky does just that. In the centre is a rampant fish, its open mouth suggesting an ebullient scenario in which it is the king of the sea. Immediately below it is what looks like an octopus or squid. The creatures appear to have escaped the many lures and hooks in the water waiting to trap them.

The fish could be seen as metaphor for Kandinsky being 'out of water' in a city that did not really understand his work. Apart from exiles living in Paris there were probably only two French artists who had any appreciation of his work, Fernand Léger and Robert Delaunay. Neither artist belonged to *Abstraction-Création*, which had by 1937 disbanded anyway, but were kindred spirits of the avant-garde, having met each other on a number of occasions, particularly as joint exhibitors of modern art in Paris, such as the *Circle et Carré* ('Circle and Square') exhibition, in 1930.

CREATED

Paris

MEDIUM

Oil on canvas

RELATED WORKS

Fernand Léger, *Adam and Eve*, 1935–39

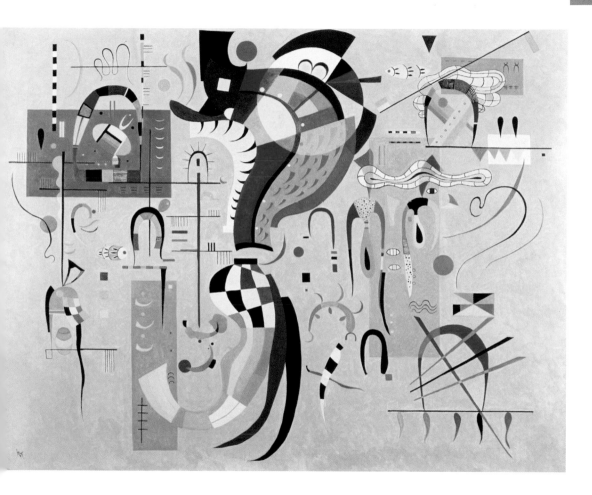

De L'Un à L'Autre
('From One to Another'), 1937

In 1935 Kandinsky had spent the summer at Cannes and many of his later works depict strange aquatic forms that are 'freed from irrelevant noises'. His aquatic world is silent, as any human being who has swum underwater can testify, but his is deeper than humans can endure, a secret world of life forms not known to man. His strange colours suggest the Indian subcontinent, perhaps the Indian Ocean with creatures that are not 'fantastic' in themselves but create a 'pure pictorial fairytale'. As he said in his essay 'Approach to Art', 'who can tell, perhaps our (abstract) forms are natural forms, though they are never objects of daily use'.

The fact that Kandinsky elected to title this work in French shows his determination to fit in with the Parisian avant-garde. In Germany things had taken a turn for the worse, as the Nazis declared Kandinsky's art 'degenerate'. In their infamous exhibition *Entartete Kunst* ('Degenerate Art') held in Kandinsky's adopted city of Munich, his work was displayed with many other avant-garde artists to be mocked in line with Nazi propaganda concerning 'appropriate' art.

CREATED

Paris

MEDIUM

Tempera on panel

RELATED WORKS

Pablo Picasso, *Guernica*, 1937

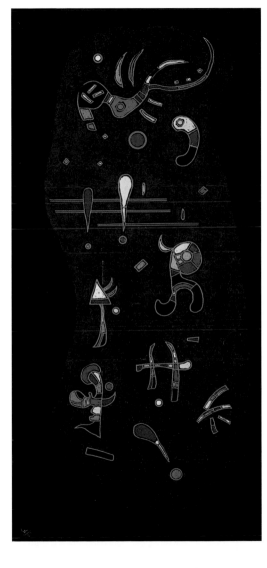

Capricious Forms, 1937

The whimsical title of this work suggests that Kandinsky is finally moving away from 'constructed' geometric shapes in favour of biomorphic and anthropomorphic forms. In fact Kandinsky made very few forays into pure geometry during his final years in Paris, becoming more interested, for example, in natural history and fossilized forms. In *Capricious Forms* he also reverted to a motif used during his Munich years, the dragon. Often portrayed, sometimes whimsically, in combat with its slayer Saint George, in this outing it appears as a more fossilized form, captured as it were in its original state of aggression, but now inert. However, Kandinsky was opposed to solipsism and firmly believed that even inanimate objects had an inner vitality. In this work, although the 'objects' appear to be fossilized they also have vitality. Kandinsky came to realize that painting a motif from nature might capture its appearance but in so doing robbed it of its vitality. He stated, 'The aims of nature and art are essentially, organically, and by universal law different from each other — and equally great and equally strong.'

CREATED

Paris

MEDIUM

Oil on canvas

RELATED WORKS

Joan Miró, *Still Life with Old Shoe*, 1937

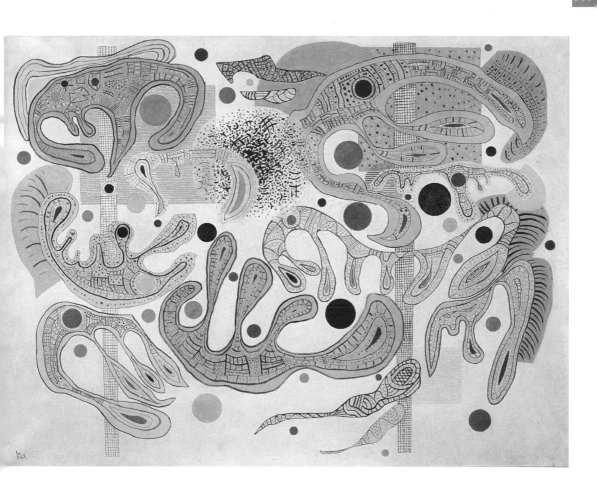

Grilles et Autres ('Bars and Others'), 1937

In his late work Kandinsky has all but moved away from Constructivism as a compositional ploy, but this work demonstrates that he was still prepared to use some of its motifs. The title of the work draws our attention to the fact that he is willing to use them in conjunction with his preferred motif at this time, the biomorphic. The 'grids' act as a structural ploy to hold the biomorphic forms together, since in this work Kandinsky has chosen to avoid using the whole 'plane' of the canvas's potential. In a typical ploy by Kandinsky he defies convention, by ignoring the tyranny of the picture plane's limitations. In its composition, *Grilles et Autres* suggests the influence of Fernand Léger, one of the few artists with whom Kandinsky was able to build a rapport in Paris.

During the 1930s, Léger had been playing with a number of organic forms that he used in his later work to 'soften' his 'machine' aesthetic; in *Grilles et Autres* Kandinsky uses a machine aesthetic to hold the organic forms together.

CREATED

Paris

MEDIUM

Oil on canvas

RELATED WORKS

Fernand Léger, *Holly Leaves*, 1930

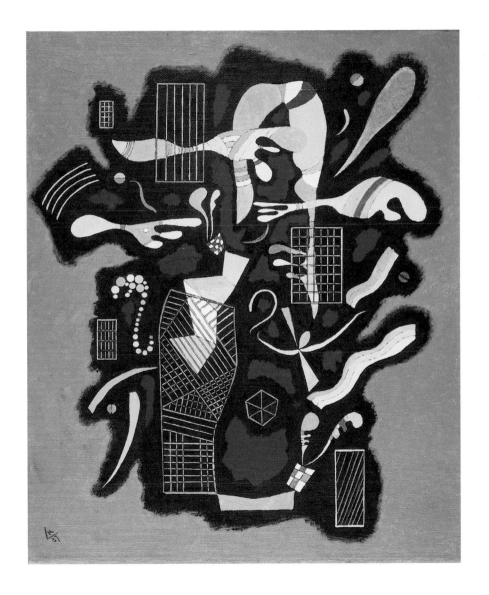

Coups Divers ('Various Knocks'), 1938

In 1938 Kandinsky wrote an essay called 'Abstract and Concrete' in which he expressed his preference for the term 'concrete' rather than 'abstract' to describe his work. The term was originally used by the Dutch *De Stijl* artist, Theo van Doesburg, to describe a particular kind of non-figurative painting. He also applied the term to sculpture.

According to van Doesburg, as articulated in his manifesto *The Basis of Concrete Art*, 'The painting should be constructed entirely from purely plastic elements, that is to say planes and colours.' Since Kandinsky has used lyricism in *Coups Divers*, anathema to van Doesburg, it seems at odds with his writing on the subject. However, van Doesburg died within a year of writing the original article, and other artists such as Kandinsky adopted the term to describe works that were purely cerebral, and not abstracted from nature.

The term 'concrete' art was also taken up by Kandinsky's long-time friend Hans Arp, who was also living in Paris at this time, and who adapted the term to accommodate his sculptural work from the mid 1930s on.

CREATED

Paris

MEDIUM

Gouache on black paper

RELATED WORKS

Hans Arp, *Human Concretions on Oval Bowl*, 1935

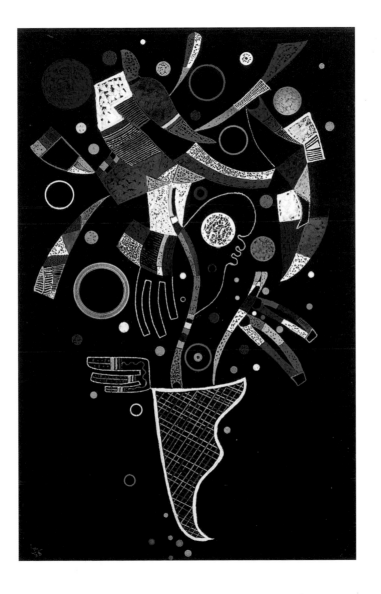

Three Triangles, 1938

According to Kandinsky in his *Concerning the Spiritual in Art*, 'the life of the spirit may be fairly represented in diagram as a large acute-angled triangle'. Using the triangle as metaphor, Kandinsky goes on to explain that if the triangle is occupied by artists and then divided into segments, often there is the spirit of a genius in the smallest segment, misunderstood and often abused by the greater number of artists occupying the larger segment. By artists, Kandinsky is also referring to musicians, since he uses Beethoven as his exemplar of the misunderstood genius. Kandinsky suggests that there are periods in history in which the 'arts' have no 'noble champion', corresponding with a lack of spiritual vitality that inevitably, to use the metaphor, allows artists to fall from the small segment into the larger one. In *Three Triangles* Kandinsky suggests that this is a period in a state of flux. He places the triangles in the centre of an 'organic' but meaningless world. It may be that Kandinsky places himself in this spiritual world, aware of his own inevitable mortality.

CREATED

Paris

MEDIUM

Oil on canvas

RELATED WORKS

Joan Miró, *The Birth of the World*, 1925

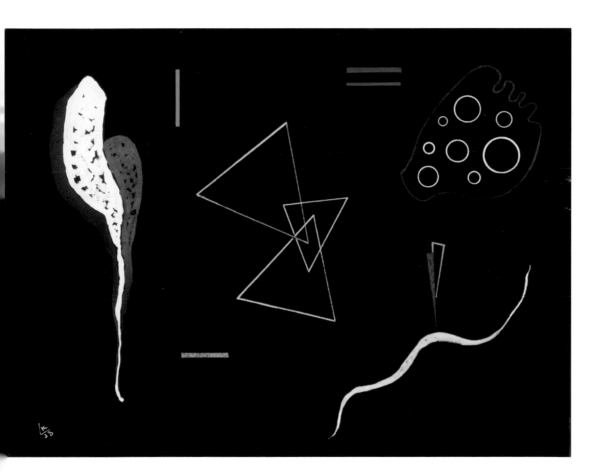

Deux Côtés ('Two Sides'), 1938

Stylistically, at least at first glance, Kandinsky's prewar pictures of the late 1930s bear a striking resemblance to those of his friend Joan Miró. He had been introduced to Miró at the *Abstraction-Création* exhibition in 1934, their friendship kindled by their presence in Paris as exiled artists. Yet that is where the similarity ends. Miró had, in 1920, chosen Paris as his avant-garde centre, in much the same way as Kandinsky had selected Munich 20 years before that.

Miró had, until the civil war in Spain broke out in 1936, always spent his winters in Paris and the summers in Catalonia. Miró became a political artist in this period producing posters that reflect his anger at the Franco regime, and appealing for help to the Republican cause. Despite similar upheavals in his home country, Kandinsky remained totally apolitical. After the civil war ended, Miró spent long periods of time in Catalonia. Kandinsky, by contrast, never returned home after 1922.

Although both he and Kandinsky were interested in cerebral abstraction, Miró's work was stimulated by Surrealism's experiments with the unconscious, whereas Kandinsky's were purely spiritual.

CREATED

Paris

MEDIUM

Tempera on black paper, laid down on card

RELATED WORKS

Joan Miró, *Aidez l'Espagne*, 1937

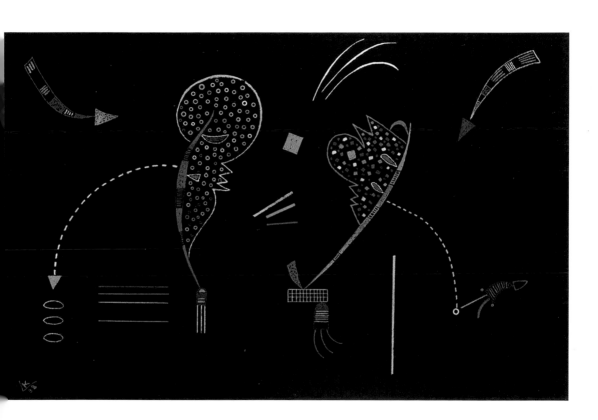

Der Rote Kreis ('Red Circle'), 1939

In his book *Kandinsky – The Language of the Eye*, Paul Overy suggests that *Der Rote Kreis* 'is almost like a journey through the insides of one's own body'. Although one can clearly approximate some of the forms to alimentary tracts, what Overy means in this analogy is that unlike the pictures of Kandinsky's Bauhaus period, which are charged with a 'structural' life, his late works, such as *Der Rote Kreis*, are charged with the 'energy' of life. What he is suggesting is that the Paris works are imbued with their own life force of 'living' organisms. 'Organic' ladders make the links between the forms, rather than the Constructivist laddered motifs Kandinsky had used in his earlier career.

The presence of the huge red circle suggests the provider of that life force, either as the nucleus of a cell from which all life forms are made, or as the ever-present sun, its sustainer. The fact that it is red may also suggest sunset, reflecting the autumn years of Kandinsky's life, a time to reflect, but also one in which he produced some of his most scintillating and evocative paintings of his long career.

CREATED

Paris

MEDIUM

Oil on canvas

RELATED WORKS

Joan Miró, *Constellation, the Morning Star*, 1940

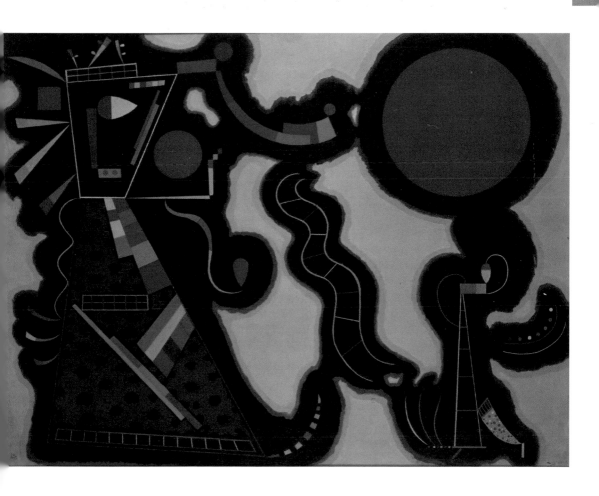

Lignes ('Lines'), 1939

The simple title of this work suggests that Kandinsky has momentarily returned to a motif that preoccupied him at the Dessau Bauhaus — the line. In selecting a black ground, Kandinsky is drawing our attention away from the colour, which is now secondary, to the purely formal elements of line. The straight line's direction has a temperature: as a horizontal line it is cold and flat, as a vertical it is warm, and as a diagonal is luke-warm. The straight line is lyrical and where it meets another a drama unfolds, as depicted in the 'box within a box' in the top left of the picture plane. The form in the upper middle of the picture plane delineates its two halves in a 'luke-warm' diagonal gesture, its inanimate shape suggesting that it is merely a compositional ruse for the two diagonally opposed forms either side of it. The other form is comprised of two curved lines, their convergence at the base of the form suggesting its dominance to the form. As if to underpin the idea of a correspondence between the two 'main' forms, Kandinsky adds a distinct comma.

CREATED

Paris

MEDIUM

Gouache on black paper laid down on board

RELATED WORKS

Naum Gabo, *Construction in Space with Crystalline Centre*, 1938

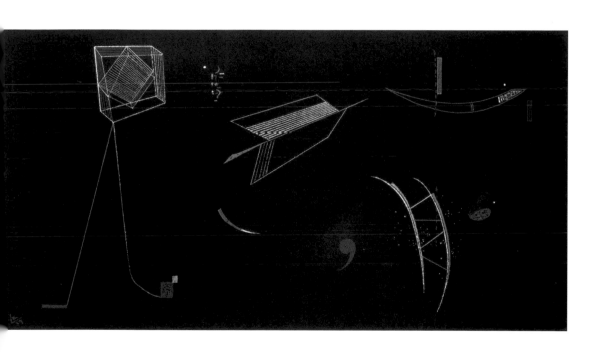

L'Entourage Blanc
('The White Entourage'), 1939

On judging Kandinsky's work at this time, or indeed at any time in his career, his calm paintings, often with witty aphoristic titles, seem to belie the traumas that were besetting Europe during the first half of the twentieth century. Unlike so many of his artistic contemporaries, Kandinsky remained apolitical. Like them he believed that materialism was to blame for so much of the world's ills, but unlike most of them found the solution in the spiritual world rather than in adopting an antagonistic and vengeful retort in his painting.

L'Entourage Blanc is one such work in which we see a central organic 'character' wrapped in a fragile fine membrane, perhaps a metaphor for his own precarious existence in Paris. Western Europe was now once again on the brink of war. Hitler had invaded much of Eastern Europe, his enterprise ceaselessly marching on, annexing every country to which he felt he had a legitimate claim. *L'Entourage Blanc* suggests perhaps that Kandinsky surrounds himself with others who share his exile, gathering together for the last time.

CREATED

Paris

MEDIUM

Gouache on paper

RELATED WORKS

Paul Nash, *Monster Field*, 1939

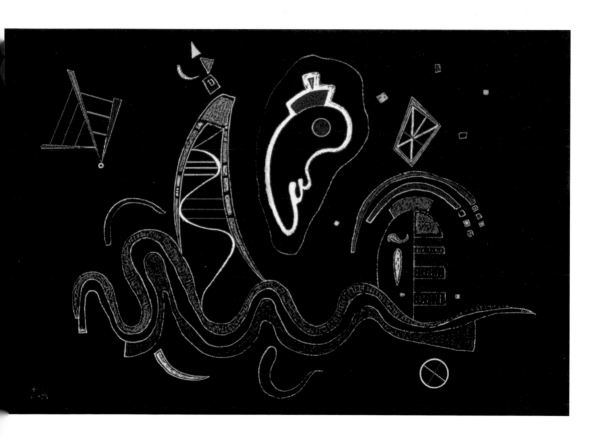

Composition X, 1939

Courtesy of Kunstsammlung Nordrhein-Westfalen, Dusseldorf, Germany, Peter Willi/Bridgeman Art Library/© ADAGP, Paris and DACS, London 2006

This is Kandinsky's last great work in the series of 'Compositions', his grand gestures. It is without doubt his *pièce de résistance*, the culmination of the total synthesis of colour, organic and geometric forms. The colours are exceptional and drawn from both European and non-European traditions. As with most of these 'Compositions' it is well ordered and yet appears totally intuitive without a recognizable motif, except for the 'perfect' circle, which in this work does not dominate through its colour, but rather through the lack of it against a sea of vital and colourful forms. It appears to be a celebration of Kandinsky's achievements in both his artistic oeuvre and as a citizen of the French Republic, which he and his wife Nina attained in 1939.

Despite these achievements Kandinsky was to remain a virtual prisoner when Germany became France's occupying force in the following year, and he would become *persona non grata*. Until then Kandinsky and all other French citizens had to mark time, the de-militarized zone along the Rhine now occupied by German forces.

CREATED

Paris

MEDIUM

Oil on canvas

RELATED WORKS

Robert Delaunay, *Circular Forms*, 1930

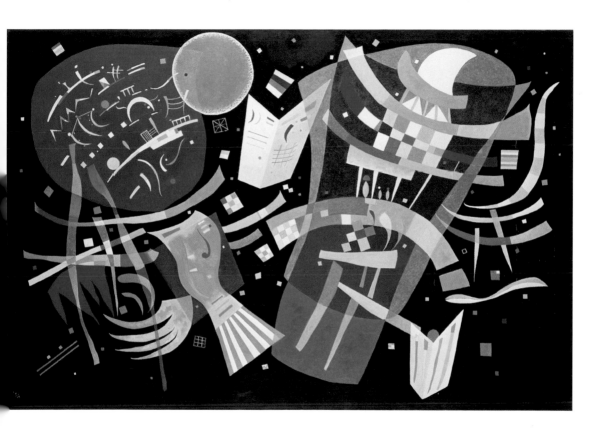

Untitled, 1940

Kandinsky's exile in Paris was complete when the German army marched into the city in June 1940. Prior to that, the Germans had advanced into Belgium and Holland and occupied them before pushing further west into France. The British expeditionary force, the last military force to resist the onslaught, had been pushed back as far as Dunkirk and forced to retreat across the English Channel, leaving the way clear for an unhindered German march to Paris. France had capitulated, its new leader Marshal Pétain, declaring an independent State of France in the south, leaving the German forces to retain control of the strategically more important north.

Apart from the Occupation itself, Pétain was further humiliated by being made to sign the armistice in the same railway carriage in which the Treaty of Versailles had been signed, in 1918. The Third Republic of France was at an end, its slogan 'Liberty, Equality, Fraternity' replaced by 'Work, Family, Fatherland'.

As a French citizen now, Kandinsky must have felt that history was repeating itself, banished as he was from Germany at the beginning of the Great War.

CREATED

Paris

MEDIUM

Gouache on paper laid down on board

RELATED WORKS

Joan Miró, *Ciphers and Constellations*, 1941

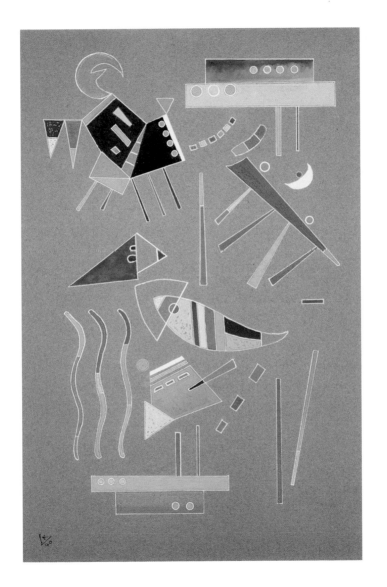

Composition, 1940

In an unusual move by Kandinsky, this particular work takes on the mantle of 'Composition', normally reserved for his most resolved works in terms of colour, line and composition, and always executed in oil. In this version of *Composition*, although the forms are quite complex, the artist has used a limited palette of gouache, normally a very vibrant medium, to express colour, suggesting that the work is perhaps ironic. Alternatively, due to the German presence in Paris and its subsequent privations to the French public, Kandinsky may not have had as much access to materials as he required.

These privations stem from the revenge sought by Germany against the French nation for the heavy burden they had suffered under the terms of the Treaty of Versailles. In retaliation the humiliation of France was complete when Germany demanded millions of francs to pay for the Occupation.

It is estimated that nearly two million people left Paris in 1940, ostensibly to escape both the tyranny and the privations. Of the mainstream avant-garde artists, only Kandinsky and Picasso remained in Paris.

CREATED

Paris

MEDIUM

Gouache on paper

RELATED WORKS

Pablo Picasso, *Café at Royan*, 1940

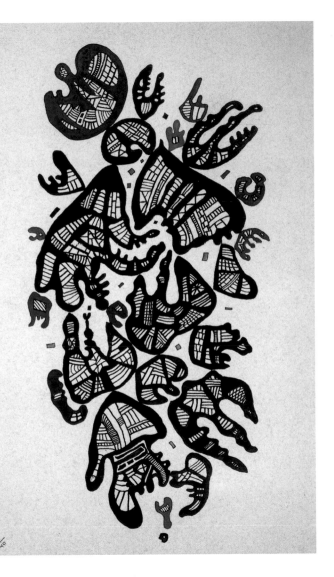

Blue Sky, 1940

For two months of 1940, Kandinsky was away from Paris in the Pyrenees. He enjoyed the mountain scenery here as he had the foothills of the Alps at Murnau. The fresh blue sky away from the city must have been something of an inspiration for him in his painting, as it had been 30 years before. The difference in the later work is that the sky is a paler blue, as used in a number of works of this period. The muted colour in *Blue Sky*, however, may have had more to do with the imminent death of his long-time friend Paul Klee.

Like Kandinsky, Klee had been forced into exile when the Nazis came to power in Germany, opting for Berne in Switzerland, his home town. Like Kandinsky he had found the transition and exile painful, as reflected in his subsequent work. He had also suffered the ignominy of having his work seized and exhibited as part of the Nazi *Entartete Kunst*.

Klee's famous painting *Death and Fire* is considered by some to be his personal requiem.

CREATED

Paris

MEDIUM

Oil on canvas

RELATED WORKS

Paul Klee, *Death and Fire*, 1940

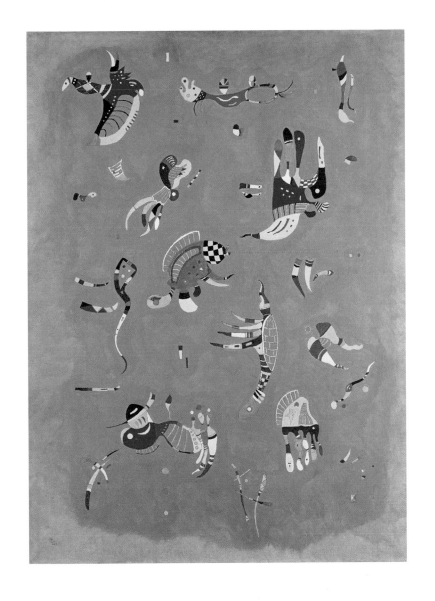

Untitled, 1940

Kandinsky painted a number of late works simply titled *Untitled*. This ploy, relatively new in 1940, came to be used more and more extensively for abstracted works. Since in the majority of cases, particularly for Constructivist art, it was unnecessary to refer to either historical reference or anecdote, titles were not required. This trend was most noticeable in the United States in the immediate postwar period, for artists such as Jackson Pollock (1912–56) and Mark Rothko (1903–70), the Abstract-Expressionists. Their inheritance came, at least in part, from the number of Surrealist artists that left Paris for New York at this time. They were successful in setting up a 'Surrealist school' in the city that included such luminaries as Salvador 'Avida Dollars' Dali (1904–89), Max Ernst (1891–1976) and Yves Tanguy (1900–55). Additionally, artists from other 'schools' in Paris also came, including Marc Chagall (1887–1985), Fernand Léger (1881–1955) and Piet Mondrian (1872–1944).

Although *Untitled* appears to have no recognizable motifs except for the geometric and organic forms, the blue circle 'floating' in a vaporous rectangle bears a striking similarity to Étienne-Louis Boullée's (1728–99) *Monument to Newton*, an eighteenth-century architectural proposal that was never realized.

CREATED

Paris

MEDIUM

Gouache on paper

RELATED WORKS

Étienne-Louis Boullée, *Monument to Newton*, 1780s

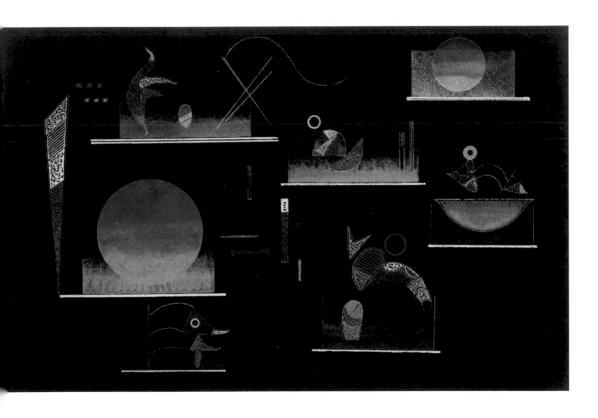

Study for L'Ensemble, 1940

One of the most successful abstract artists to make the transition between Paris and the United States was Alexander Calder (1898–1976). American by birth, he studied engineering before studying art and then moved to Paris in 1926. He stayed for seven years and during that time was an active participant in the *Abstraction-Création* exhibitions that Kandinsky had participated in. While he was in Paris, Calder developed a form of abstract sculpture that came to be known as 'mobiles'. Calder hit on this idea after watching acrobats and high-wire acts at the circus, their abstracted forms now becoming his odd shaped pieces of metal suspended from wires, moved by the constant changes in air movement that gives the work a 'kinetic' energy.

Kandinsky must have come across these attenuated abstract forms of Calder's during his visits to Paris before settling there. Kandinsky's painting *Ensemble*, for which this is a sketch, also seems to be depicting the high-wire acts of a circus in its central panel. The largest panel to its left is possibly a ringmaster's whip, the panel on the right containing a clown.

CREATED

Paris

MEDIUM

Gouache on black paper

RELATED WORKS

Alexander Calder, *Constellation*, 1941

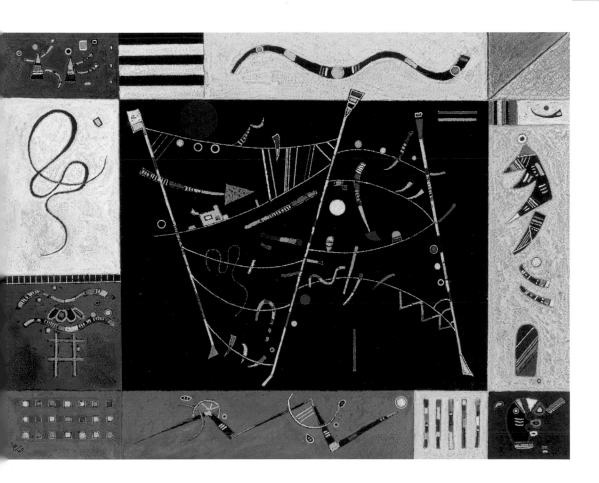

Grau mit Schwarz ('Grey with Black'), 1940

The American art market was very important for Kandinsky, particularly from the late Bauhaus period on when his client base was evaporating. He had already established links with the United States in 1924 through a regrouping of *Der Blaue Reiter* ('The Blue Rider') group of Kandinsky and Klee with two new members to replace Franz Marc and Auguste Macke. The new group now called The Blue Four, included Kandinsky's friend from the Munich days, Alexei Jawlensky, and his new Bauhaus colleague Lyonel Feininger (1871–1956). Galka Scheyer (1889–1945), a former pupil of Jawlensky who sought to educate the wider public about their work, organized the group.

In 1924 Scheyer travelled to New York to show the work and was offered an exhibition the following year at the Charles Daniel Gallery. After moving to California, Scheyer was successful in organizing other exhibitions. Apart from shows in Los Angeles and San Francisco, she also managed to arrange exhibitions in Mexico City and twice in Seattle in 1926 and 1936. It was this exposure that created a market for Kandinsky's work in the United States and his inclusion in the Museum of Modern Art's (MoMA's) 'Cubism and Abstract Art' exhibition in 1936.

CREATED

Paris

MEDIUM

Watercolour in Spritztechnik on black paper laid down on card

RELATED WORKS

Lyonel Feininger, *Mid-Ocean*, 1937

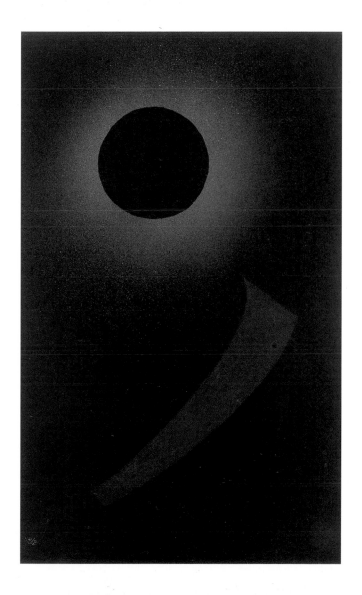

Composition, 1941

Although not numbered as in the series, this *Composition* most definitely belongs to the other 10 sharing the title. Like the others it is painted on canvas, but unlike them this version has a black background enabling the red and the pink forms to radiate from the picture's surface. The use of a black background in this work seems to reflect Kandinsky's mood, itself a reflection of the prevailing mood in Paris in 1941.

In May, the French city police rounded up one thousand Jews and handed them over to the Nazis under the terms of the Occupation. In October, in two separate incidents, two hundred French civilians were executed by the Nazis in reprisal for the death of two German officers.

For Kandinsky these terrors were made worse by the German army's attack on Russia, formerly breaking the agreement between Hitler and Stalin. By October they were boasting that Moscow was in sight, film footage of Hitler outside its gates almost certainly reaching the people of Paris, whose cinemas were carefully censored to show Nazi propaganda.

CREATED

Paris

MEDIUM

Oil on canvas

RELATED WORKS

Pablo Picasso, *Seated Woman (Dora Maar)*, 1941

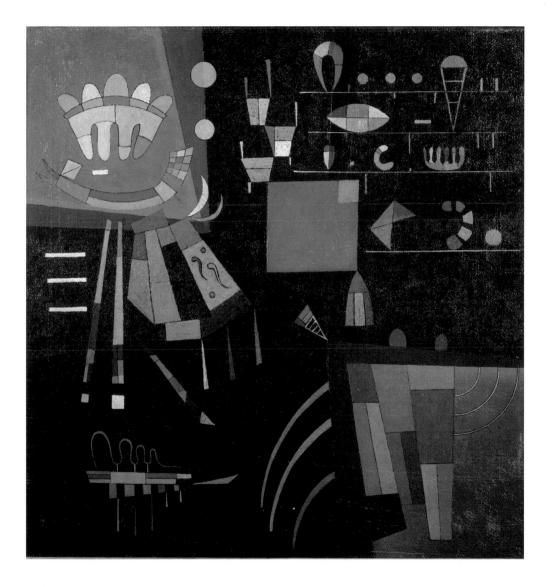

Trois Étoiles ('Three Stars'), 1942

In some of these late works, Kandinsky seems to have two preoccupations, the number three and strange nondescript forms that still contain a hint of an animal, yet without resembling one. In *Trois Étoiles* Kandinsky combines both of these traits. The title shows that the artist is playing with the viewer by drawing our attention to the stylized graphic 'stars' rather than the main forms. The forms themselves suggest strange mythical beings from another world, their only link to earthly creatures is the presence of tusks or horns. The lower figure seems to suggest an army tank, complete with caterpillar tracks, which is displaying its horns rather as a rhino would, waiting to charge its foe.

The German army had relied heavily on its Panzer tank divisions to strike a blow on two Fronts, the North Africa campaign and the Eastern Front in Russia. It was to be well into 1943 before the tide had turned regarding the latter, but in 1942, the British forces at El Alamein had routed Rommel's Afrika Corps. The tide was beginning to turn against Germany.

CREATED

Paris

MEDIUM

Oil on board

RELATED WORKS

Joan Miró, *Women, Birds, Stars*, 1942

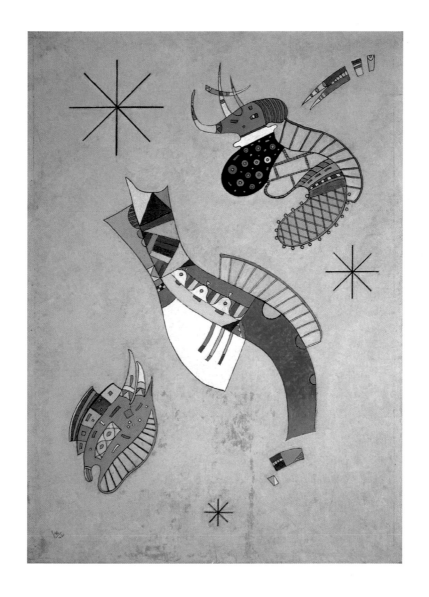

The Three Ovals, 1942

When Kandinsky came to paint *The Three Ovals* he was 76 years old, and yet the work is as vibrant and exciting as one painted by an artist half his age. The pink plane is as bold as anything he had ever painted before, a foil to the three oval shapes in the other half of the picture. Although the pink area only occupies about one third of the picture's plane, so dominant is the colour that it appears to balance the other two thirds perfectly. This pink plane appears to contain the cross section of an old sailing ship, its hull at the base and the yardarms extending to the left from the mast. At the top of the mast appears to be an oversized flag.

The oval shapes referred to in the title appear to be irregular, perhaps human heads firmly rooted to a rigid horizontal line by the easel-like structures supporting them. This is one of the last works Kandinsky painted on canvas, his supplies having dried up due to the privations in Paris at the time.

CREATED

Paris

MEDIUM

Oil on canvas

RELATED WORKS

Ben Nicholson, *1942 (Two Forms)*, 1942

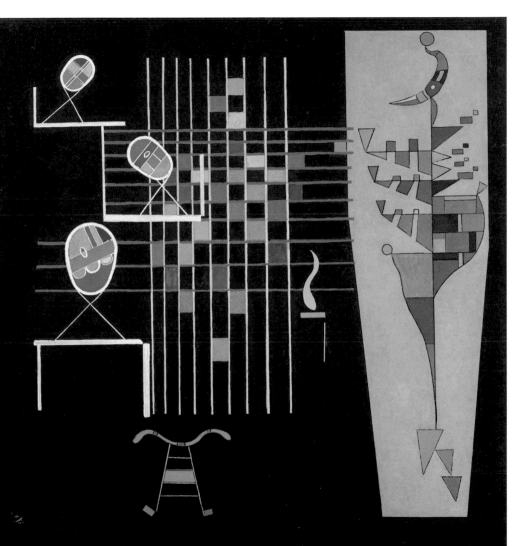

Sept ('Seven'), 1943

Courtesy of Christie's Images Ltd/© ADAGP, Paris and DACS, London 2006

During the Paris years, Kandinsky moved further and further away from mere protoplasmic organic forms to almost recognizable animal life. *Sept* is just such an example, the picture plane compartmentalizing the different species. There appear to be rodent-like creatures with long bushy tails, snakes and possibly aquatic life, and in the bottom-right compartment a highly stylized bird. These mythical creatures, part animate and part fossilized, populate many of Kandinsky's later works. Their arrangement in this work seems to imply that they are imprisoned, the strong colourful delineation suggesting their claustrophobia.

Such claustrophobia is possibly a reflection of Kandinsky's own fate at this time. He rarely left his apartment for fear of arrest as an alien. In August of 1942, for example, more than five thousand Jews were rounded up, a symptom of the Nazis' aspiration for the 'final solution'. Although Kandinsky was not Jewish and was now a French citizen, he would almost certainly still have been arrested because of his former links with Bolshevism. The Gestapo was particularly ruthless in weeding out enemy aliens, or anyone connected to the Resistance movement.

CREATED

Paris

MEDIUM

Oil on cardboard

RELATED WORKS

René Magritte, *Le Mal du Pays*, 1941

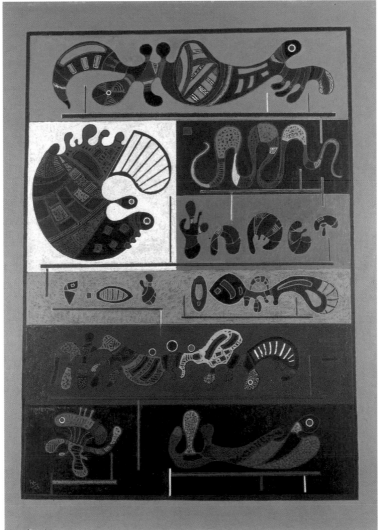

Drei Säulen ('Three Columns'), 1943

When interviewed by the Museum of Modern Art in New York concerning the acquisition of his work, the Armenian-American artist Arshile Gorky (1904–48) stated that he had once been a pupil of Kandinsky's. Although that was not true, and we know Gorky told many other lies to further his career, there can be little doubt that Kandinsky's painting influenced Gorky, much as it had done many other artists with abstract-painting aspirations. Despite the fact that this was tantamount to fraud, the lie contained a veiled compliment to Kandinsky, a mark of the esteem in which he was held.

Gorky had arrived in New York in the 1920s, a cosmopolitan city full of immigrants including white Russians. Although Armenian, he adopted the name Gorky pretending to be a cousin of the Russian writer Maksim Gor'ky. What he had not realized was that the writer's name was in fact a *nom de plume*. Nevertheless after attempting a number of styles of painting (Gorky was an unashamed copyist) he settled on the new idiom of Abstraction that had, at least in the United States, not yet been exploited as a genre.

CREATED

Paris

MEDIUM

Oil on board

RELATED WORKS

Arshile Gorky, *The City*, 1935

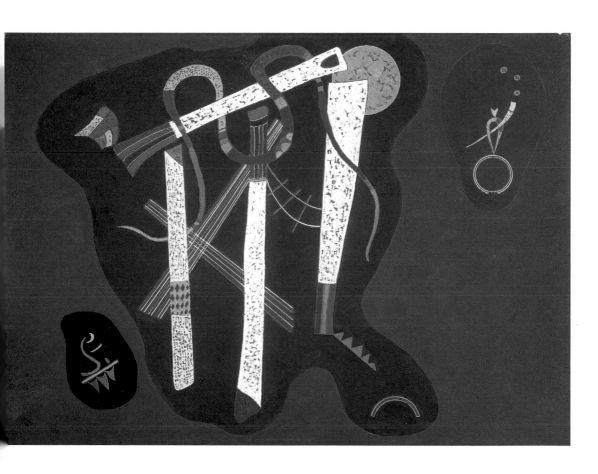

Division Unite, 1943

The last full year that Kandinsky worked as an artist was 1943, and yet his zest for painting remained as undiminished as ever. This whimsical painting, which plays with tensions of line and colour, is a wonderful testament to this. In the penultimate year of his life, Kandinsky was still as prodigious as ever despite the handicap of only having cardboard to paint on and having now to mix his own paints, due to the privations in Paris.

In March 1944, Kandinsky was taken ill, and until his death in December of the same year, painted very few pictures. He did, however, manage to put together one last exhibition during his lifetime, at the *Galerie l'Esquisse* in Paris. Kandinsky did at least live long enough to see the tide turn against the Germans, and them finally being driven out of Russia, and he was also able to witness the liberation of Paris in August. With only a handful of people present at his funeral, including his wife Nina, Kandinsky was buried in a simple grave at Neuilly-sur-Seine, near Paris, his home for the final 11 years of his incredible life.

CREATED

Paris

MEDIUM

Oil on board

RELATED WORKS

Joan Miró, *Painting*, 1943

Kandinsky

Techniques

Die Nacht ('The Night'), 1903

The technique of woodcut provided Kandinsky with one of his first inspirations for producing art, since it had both symbolic and stylized forms. Originally one of the earliest European forms of printing, as used in the twelfth century, woodcut printmaking has, over successive centuries, been employed for more delicate artworks by artists such as Albrecht Dürer (1471–1528). Woodcuts enjoyed a great revival at the end of the nineteenth century by exponents of the Arts and Crafts Movement, but it was at the turn of the century that they came into their own in the Art Nouveau style.

The technique requires the fine carving of a design on to seasoned timber. The 'relief' is then coated with ink and placed under pressure on to the paper. Because of this pressure, the 'relief' lines cannot be too fine, thus the woodcut often uses broad lines in its design. The inspiration for many of Kandinsky's early woodcut prints came from the paintings of van Gogh with his heavy use of impasto. Die Nacht is a woodcut printed in colours, and so a number of these blocks were used successively, each carrying its own colour.

CREATED

Munich

MEDIUM

Woodcut printed in colours

RELATED WORKS

Albrecht Dürer, Four Horsemen of the Apocalyse, 1498

Vasily Kandinsky Born 1866 Moscow, Russia

Died 1944

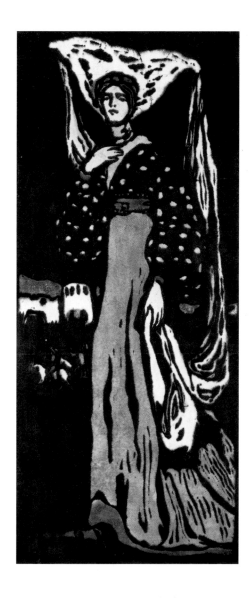

Saengerin ('Singers'), 1903

This Art Nouveau portrait of a singer and pianist is typical of both the style of the period and one of Kandinsky's preoccupations, music. In the following year to this work, the artist produced a series of woodcuts which he called 'Xylographs', another term used historically for woodcuts, but which also reflected Kandinsky's musical interests not least because of the similarity with the word xylophone.

The design is typical of Art Nouveau in the use of the 'whiplash' lines for the singer's dress, and in the highly decorative aspects of the composition. Kandinsky printed a number of copies of this image using one colour, usually either black or sepia depending on the final effect he sought. Each print would then be hand coloured by the artist, again according to the required finish.

The revival of woodcuts was probably more pronounced in Germany than elsewhere in Europe in the early years of the twentieth century, with artists such as Ernst Ludwig Kirchner (1880–1938) and the *Die Brücke* ('The Bridge') group of artists the biggest exponents. It was used by them, as Vincent van Gogh had used paint, in a very expressive manner.

CREATED

Munich

MEDIUM

Woodcut with hand colouring

RELATED WORKS

Ernst Ludwig Kirchner, *Portrait of Ludwig Schames*, 1917

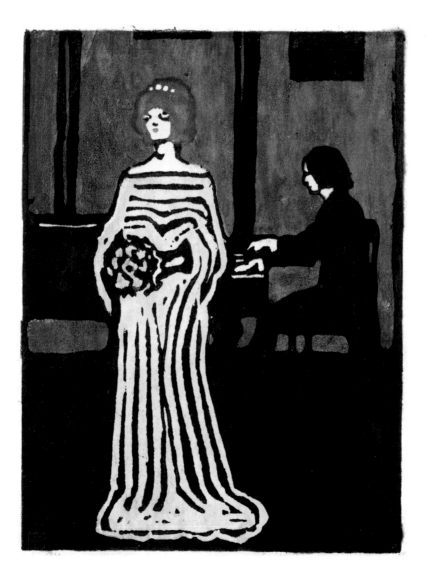

Der Spiegel ('The Mirror'), 1907

Although *Der Spiegel* is well known as a current affairs journal, it did not come into existence until after the Second World War, leaving this print with its original meaning of 'the mirror'. Mirrors and other reflective surfaces were used in many Symbolist works of the late nineteenth and early twentieth century, denoting many human traits such as vanity, lust and pride.

The linocut relief uses the same process as woodcut relief but since there is no grain to contend with, the linocut image can be much finer. The material was a standard grade flooring material composed of oxidized linseed oil mixed with ground cork. Using sharp gouges, the image is then carved into the material, which may then be glued on to a wooden block for rigidity. The printing inks can be water or oil based, depending on the type of surface being printed. Unlike woodcut blocks, which are absorbent, little of the ink actually seeps into the lino, meaning that much less pressure is required at the printing stage. Several 'blocks' would have been necessary for the work, one for each colour.

CREATED

Munich

MEDIUM

Linocut in colours

RELATED WORKS

William Nicholson, *Queen Victoria*, 1897

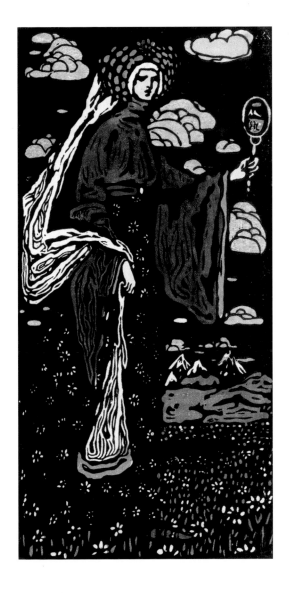

Kleine Welten VII
('Small Worlds VII'), 1922

Shortly after arriving at the Bauhaus in 1922, Kandinsky was commissioned by Propylaen Publishing to produce a set of graphic prints. In a few short weeks he had produced 12 images called 'Small Worlds' comprising four coloured lithographs, four etchings and woodcuts, two of which were coloured, an example of which is shown here. This was the first opportunity for Kandinsky to experiment with colours and forms since his ignominious departure from Russia. In this work he began to try out his colour theory as codified in his *Concerning the Spiritual in Art*, without the need for a specific motif beyond geometric shapes. Kandinsky suggested that yellow and blue have a colour-temperature antithesis to each other. According to him, placing yellow and blue next to each other in a circular shape sets up another antithesis, which also affects the first antithesis in terms of concentric movements. Thus in this work the dominance of the yellow on the outside with its warmer 'temperature' causes an anticlockwise 'movement' in the forms.

CREATED

Weimar

MEDIUM

Woodcut in colours on wove paper

RELATED WORKS

Max Pechstein, woodcut design for *Arbetsrat für Kunst*, 1919

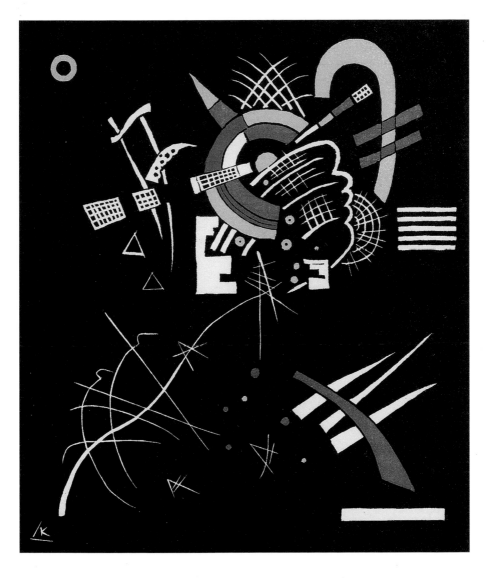

Die Schleuse ('The Sluice'), 1902

This painting of a sluice is one of the first oil paintings executed by Kandinsky. As in all of his first paintings it is from life, presumably in the countryside around his home in Munich or possibly at Kochel where he spent the summer of 1902. It was at Kochel that he began a relationship with Gabriele Münter, one of his students who accompanied him on the trip. Although he was to travel around Europe with her later, assimilating stylistic ideas for painting, in 1902 he was still only influenced by the artists he had seen in and around Munich.

The heavy layers of paint used in this work suggest that he was still influenced by members of the Munich Secession including his former teacher Franz von Stuck. Others who would have directly influenced Kandinsky would have been Max Liebermann (1847–1935) and Fritz von Uhde (1848–1911), whose dark interiors of the 1890s are so redolent of the English Newlyn School painters of the same period. It is likely that Kandinsky would also have been familiar with van Gogh's use of heavy thick impasto.

CREATED

Munich

MEDIUM

Oil on canvas

RELATED WORKS

Max Liebermann, *Bathing Boys*, 1900

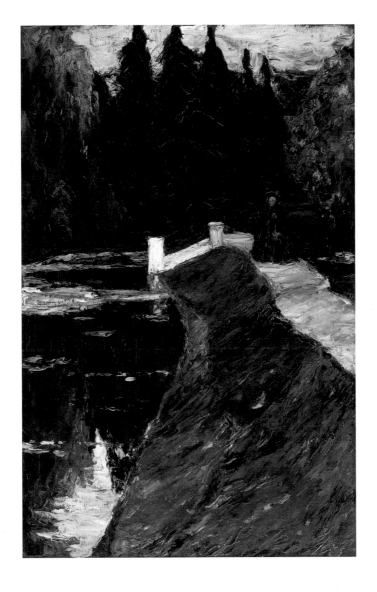

Landscape with an Apple Tree, 1906

In 1904 Kandinsky and his 'companion' Gabriele Münter began a series of trips around Europe, beginning in Holland and visiting France, Italy and Tunisia. As with most artists at the beginning of their careers, Kandinsky was seeking further inspiration for his work beyond the rather parochial and by now staid painting in Munich. In fact ironically it was the Munich Secessionists who were now the most conservative of the modern painters.

With such extensive travel, Kandinsky assimilated many styles and techniques, not to copy but to enhance his artistic vocabulary. Although Kandinsky was still using heavy brushwork in his painting, the palette had become much brighter as he began to explore colour to express form. He arrived in Paris in 1906 and showed his work at the *Salon d'Automne*, where he would also have seen the work of Maurice de Vlaminck (1876–1958). The self-taught Vlaminck used broad sweeping brushstrokes in his work in a kind of proto-Expressionism.

In this work, Kandinsky adopts Vlaminck's bright palette and painting style, and in a radical departure from not using the entire canvas, anticipates his 'battle with the canvas' of the Bauhaus period.

CREATED

Munich

MEDIUM

Oil on canvas

RELATED WORKS

Maurice de Vlaminck, *Woman and Dog*, 1906

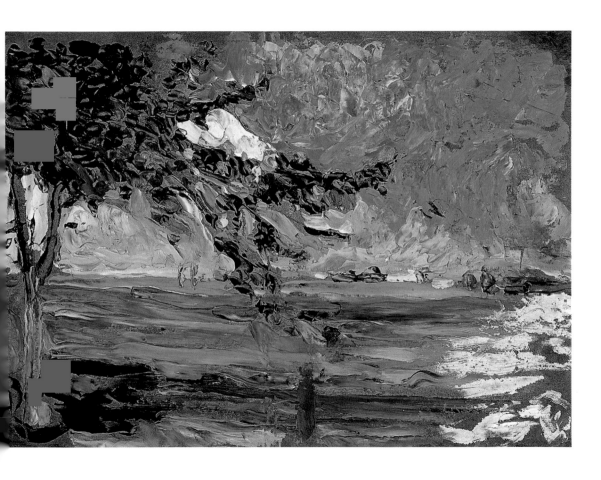

Dünaberg, 1909

Set in the Bavarian Alps, Dünaberg and Murnau are places that Kandinsky frequented both in the winter and the summer, with his companion Gabriele Münter, to paint. After his visit to Paris where he saw the work of Henri Matisse and the other Fauve artists, his own palette became much brighter, with large areas of non-natural colours used simply to express form. This phase marks the start of Kandinsky's mature period in which his work is resolved and unlike any other artist's oeuvre. His paintings of this period, where the motif originated in nature, begin to move towards Abstraction. The viewer is still able to make out the church tower and the rooftops of the little houses in the town, but little else.

Kandinsky is growing in confidence with his use of colour to define form, and as he moves towards his seminal theoretical literary masterpiece *Concerning the Spiritual in Art*, there is evidence here that he is starting his experiments in juxtaposed colours, beginning with yellow and blue each being antithetical to the other, and as such, complementary.

CREATED

Munich

MEDIUM

Oil on board

RELATED WORKS

Gabriele Münter, *Outskirts of Murnau*, 1908

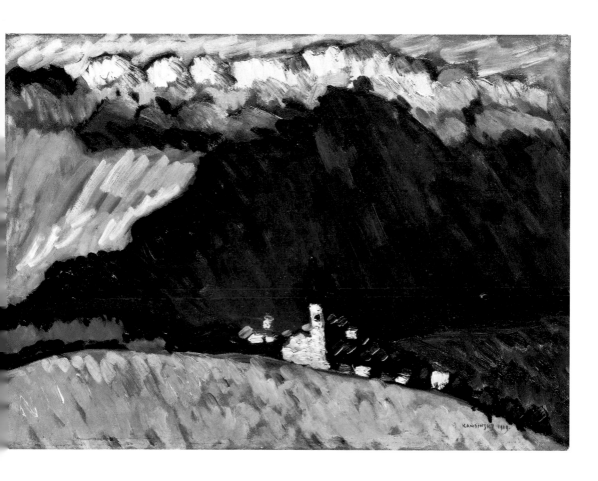

Impression No. 3 (Concert), 1911

Kandinsky began painting these 'Impressions' in 1911, following on from his previous innovations of 'Compositions' the previous year and 'Improvisations' in 1909. He had been working on his book *Concerning the Spiritual in Art*, published in 1912, at the time of these paintings and in it he refers to the reasoning behind these very abstract titles. They are all based on their analogies with 'new symphonic compositions'. Kandinsky is careful not to name the composers of these 'compositions', but states that they are after Mozart's and Beethoven's transition period, in other words from the late nineteenth or early twentieth centuries.

Kandinsky's paintings represent three different sources of inspiration: a direct 'impression' of outward nature, a largely unconscious spontaneous expression of inner character that he calls 'improvisation', and finally a 'composition', an expression of an inner feeling arrived at after a long maturing process. As a way of separating his 'impressions' from the French Impressionists he specifically makes the point that his work will be in contrast to theirs, because of his cerebral approach rather than by inspiration only.

CREATED

Munich

MEDIUM

Oil on canvas

RELATED WORKS

Claude Monet, *The Japanese Bridge*, 1900

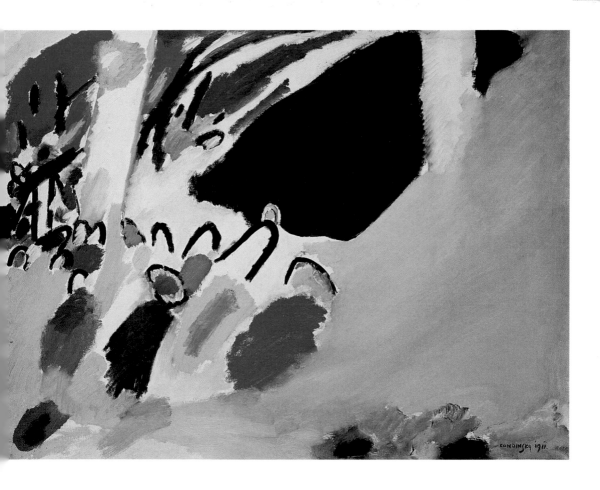

Dominant Violet, 1934

In the year that this work was painted, Kandinsky had begun work again after his move to Paris from Berlin. Although he was 68 years old at the time, Kandinsky was as keen to experiment with new forms and new techniques as he had always been. *Dominant Violet* was one of a number of works in which he experimented with new forms and new techniques, moving away from the Constructivist geometric motif of the Bauhaus period to more organic and freer shapes. Kandinsky also began to add sand to some of the painted areas and not to others so that he could delineate different planes, and highlight certain forms.

His use of sand was not unique to Western painting and had been used contemporaneously by the Surrealists in their Automatism paintings beginning in the 1920s. The most successful exponent of this technique was André Masson (1896–1987), who painted the canvas or paper with glue in a very random and haphazard manner, before sprinkling sand on to the painted surface. By this method strange shapes and forms would manifest themselves to which Masson would add further paint as required to complete the effect. It was believed by the Surrealists to be tapping into the unconscious mind.

CREATED

Paris

MEDIUM

Oil and sand on canvas

RELATED WORKS

André Masson, *Bottle of Fishes,* 1926

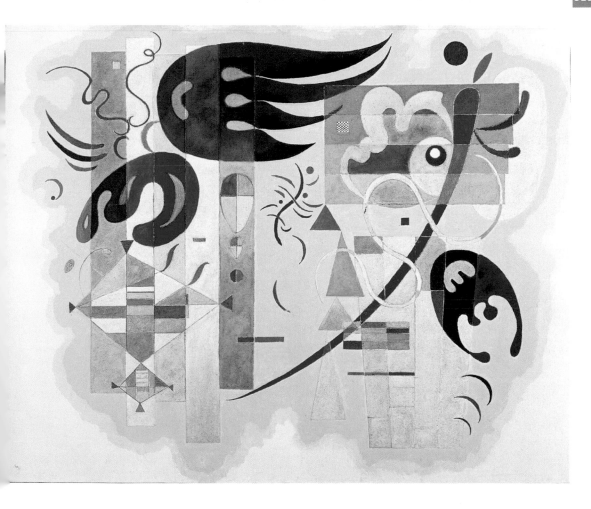

Taches Grises ('Grey Spots'), 1934

Tempera as a painting medium has been around longer than oil paint, and was used extensively by Italian artists until the early sixteenth century for panel painting, after which time oil painting (already in use for some time in northern Europe) gained favour. Kandinsky would have used egg yolk as a medium for mixing and binding the raw colour pigments, a technique explained in a treatise by Cennino Cennini (*c.* 1370–1440) a fourteenth-century Florentine artist. His treatise became lost and its rediscovery in the nineteenth century had instigated a revival of the technique. There were a number of early twentieth-century writers who also published recipes for its manufacture.

There is nothing of the versatility of oils in terms of tone and colour possibilities in tempera. The colours are limited and the use of egg as the binding medium can be problematic. However, the advantages are that being a water-based medium, it dries very rapidly leaving a fine flat emulsion-like surface that totally absorbs light so the viewer is able to enjoy the painting without any reflection.

CREATED

Paris

MEDIUM

Tempera on grey paper

RELATED WORKS

Joseph Southall, *Corporation Street, Birmingham in March 1914*, 1915–16

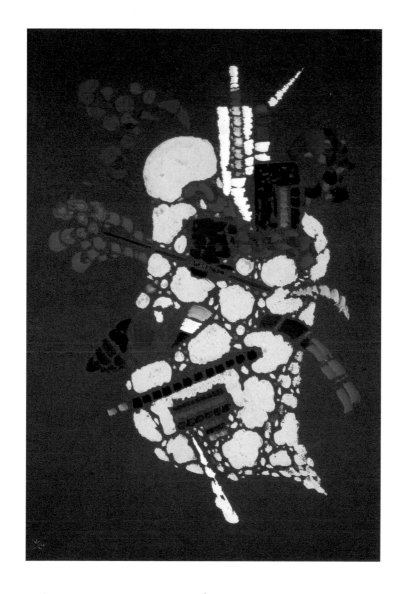

Composition with Whitened Forms, 1940

Formerly known as bodycolour, gouache has been around for at least three hundred years in its present form, although its ancestry is in egg tempera, as a water-based paint medium. It differs from the more translucent watercolour with the addition of whitening to render it opaque. This whitening may be a Chinese white (zinc oxide) paint or chalk. Gouache or bodycolour was used extensively by J. M. W. Turner (1775–1851) to enhance his watercolours in the eighteenth and nineteenth centuries.

It is possible with this late work by Kandinsky that the paint was available commercially ready-mixed in a tube, using gum arabic as the binding agent. At the time gouache was being used more and more by designers as a fast-drying, opaque medium for promotional artworks. It was also a favoured medium for a number of fine artists in the twentieth century apart from Kandinsky, for instance, Henri Matisse.

As you can see from this painting, gouache works very well as a medium against a dark or black ground. The paint already has a depth to its character, which is enhanced on this type of ground.

CREATED

Paris

MEDIUM

Gouache on black paper

RELATED WORKS

J. M. W. Turner, *A Bedroom at Petworth*, 1830

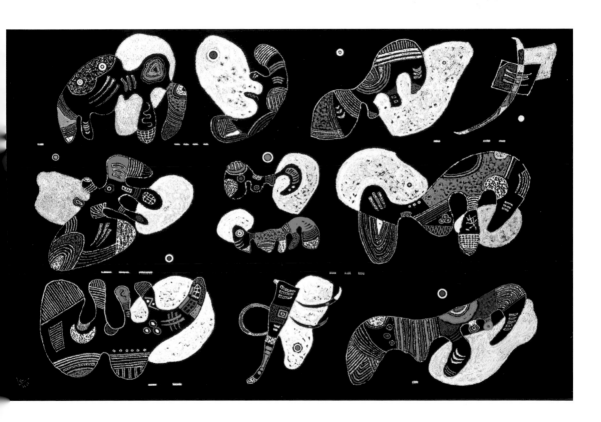

Untitled, 1923

In this work Kandinsky explored the possibilities and potential of watercolour. The fact that he does not title the work suggests that it was just an experiment, to examine the effects of watercolour, and to begin exploring the 'line' as part of a radical shift towards graphic art in line with Bauhaus orthodoxy. Unusually for Kandinsky, the white background of the paper ground dominates the picture plane. The 'white' acts 'like a deep and absolute silence full of possibilities'; the black spot in the centre is its opposite, full of nothingness, a void acting merely as a foil.

In this work Kandinsky moves away from his so-called 'cool period' with its predominance of blue forms, towards a warmer temperature, the use of vermillion a clue to the new potential. For Kandinsky, vermillion is 'a red with a feeling of sharpness, like glowing steel, which can be cooled by water'. He suggests that by quenching it with blue it becomes a 'dirty colour, scorned by painters of today'. Kandinsky's use of two 'dirty' brown forms makes this an oversight, since for him it has its 'own inner appeal'.

CREATED

Weimar

MEDIUM

Watercolour on paper

RELATED WORKS

László Moholy-Nagy, *ZIV*, 1923

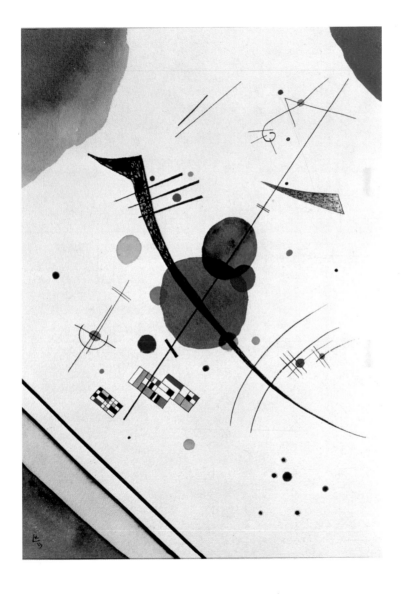

Afrika, 1916

Unlike his earlier works painted during and after his trip to Tunisia, *Afrika* contains no recognizable motifs. The work was painted four years after the publication of *Concerning the Spiritual in Art*. In its introduction Kandinsky refers to the 'observer of today' who seeks certain objectives in a work of art. These may be the imitation of nature in a realist sense, or as a 'presentment of nature according to a certain convention ('impressionist painting')' or some 'inner feeling expressed in terms of natural forms'. For Kandinsky if they are genuine works of art then they are imbued with what he calls *stimmung* ('sentiment'), which is capable of transmission to its viewer.

Kandinsky is suggesting that a painting does not have to have recognizable motifs in order for it to contain *stimmung* as the use of colour is enough. Here, the artist provides a clue to the content of the picture in its title, but it is about the mood and sensation of the place rather than discernable motifs. He is trying to stimulate those same emotions in his viewer that 'preserve the soul from coarseness'.

CREATED

Russia

MEDIUM

Watercolour, pen and ink

RELATED WORKS

Paul Klee, *Coloured Circles with Coloured Bands*, 1914

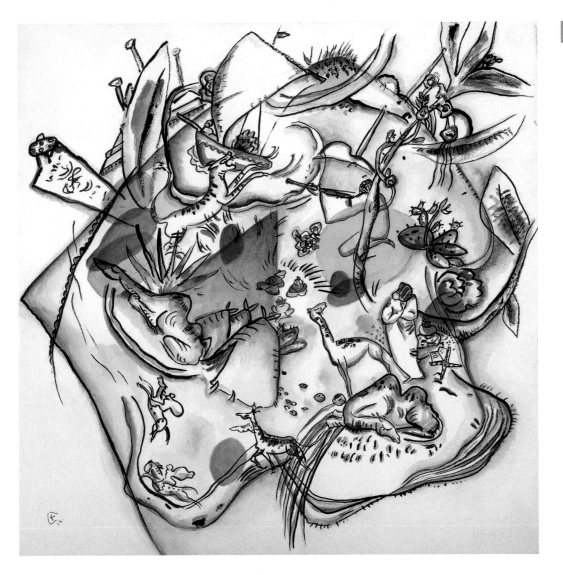

Untitled, 1912–13

Most of Kandinsky's watercolours at this time are untitled as he experimented with colour and form. The thinly applied washes are translucent allowing one colour to be overlaid on another to create a third colour. Beginning with the primary colours, he was interested in the effect of colour on people. Kandinsky recognized that it was impossible to be too objective about his colour theory since it was ultimately subjective, emanating as it did from his 'inner need' and hoping to stir similar spiritual emotions in the audience for his paintings.

Kandinsky suggests there are two different temperatures of colour, warm and cold, that corresponded approximately to yellow and blue. There is a movement between these colours and the viewer, yellow advancing toward and blue receding. To place the colours next to each other, as he has done in this work, sets up a tension for the rest of the picture plane. His use of green (a combination of blue and yellow) in other parts of the composition, 'the most restful colour that exists', serves to calm the tension.

CREATED

Munich

MEDIUM

Watercolour on paper

RELATED WORKS

Frantisek Kupka, *Amorpha, Fugue in Two Colours*, 1912

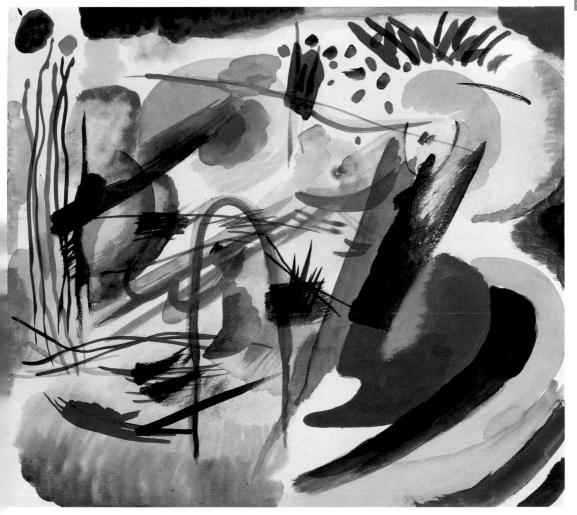

Impression V, 1911

Early in his career Kandinsky made the connection between music and painting. For him this resonance was very distinctive, a correspondence that he referred to as 'Klang'. In essence, colour is the musical instrument itself, the eyes are the fingers that play it and the soul is the combination of both. This is so for both the artist and the viewer, if the soul has the awareness in the first place.

From about 1910 Kandinsky began to title some of his works with musical themes, for instance 'compositions', 'impressions' or 'improvisations', in line with a number of contemporary musical composers such as Claude Debussy (1862–1918) and Maurice Ravel (1875–1937). This was not a whim on the part of Kandinsky but relates to his deep interest in music and his sharp focus on tonal colour in these paintings.

Kandinsky made the connection as part of his 'inner necessity' to convey 'sounds' visually. For him, red had the sound of 'trumpets, strong harsh and ringing'. He knew that the colour red when 'heard' has no boundaries, in the mind it has a limitless potential. When it is seen by a man's soul and not just his eye, 'it exercises at once a definite and indefinite impression on the soul'.

CREATED

Munich

MEDIUM

Oil on cardboard

RELATED WORKS

Giacomo Balla, *Abstract Speed and Sound*, 1913–14

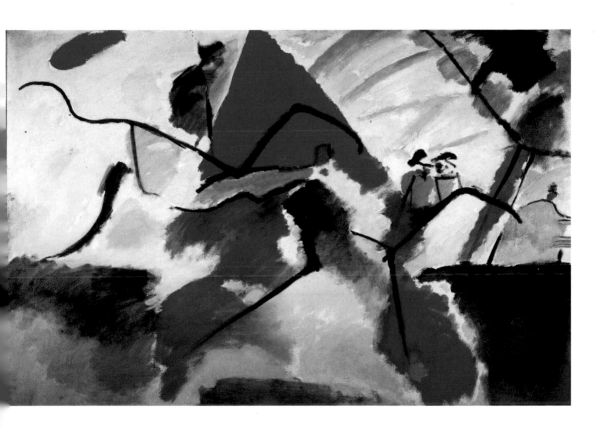

Watercolour with a Red Stain, 1911

Watercolour affords both a luminosity and translucency that oil painting cannot, which explains Kandinsky's extensive use of the medium at this time for experimenting with colour. In this work there are no recognizable or discernable forms other than those created by the colour alone. For him the more abstract the form, the clearer its appeal. He clearly felt, as he recorded in his writings, that 'the more an artist uses these abstracted forms, the deeper and more confidently will he advance into the kingdom of the abstract'. His aim was to 'dematerialize objects'.

The yellow background is an 'earthly colour' that is devoid of any profound meaning on its own, but provides a ground for the darker yellows and then the other colours to float above it in another spiritual plane. The red, always dominant and, according to Kandinsky, 'more beloved than yellow', is used in decorative objects and clothing to great effect. Yet red, the boundless colour, needs to be mixed with blue to ennoble it. The red 'stain' has been ennobled and its juxtaposition with the green makes it beautiful.

CREATED

Munich

MEDIUM

Watercolour

RELATED WORKS

Franz Marc, *Tyrol*, 1913–14

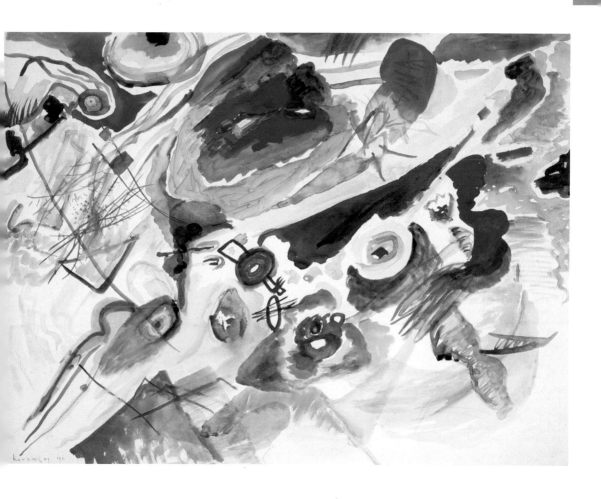

Quadrat im Kreis ('Square in a Circle'), 1928

This simple and unambiguous title refers to one of Kandinsky's preoccupations at this time, geometry, in line with the Constructivist ideologies at the Bauhaus. However, Kandinsky also uses colour that creates a special synthesis in his more mature work. His friend and closest ally at the Bauhaus, with whom he worked very closely at this time, was Paul Klee. It was Klee who encouraged him to use a spray technique in the application of watercolour paint to soften the edges of his geometric forms. This had the effect of adding another dimension to the forms and colours by increasing or decreasing the intensity of their juxtapositions and therefore the amount of dynamism experienced by the viewer. For example the yellow and blue are juxtaposed, but the blue fading into the yellow by graduation mutes the intensity of contrast. Similarly the red, although remaining as a focal point in the composition, is toned down, its colour being added to the surrounding blue circle. The red is still undiminished in intensity, still generating its aura, but contained within the 'heavenly blue' circle.

CREATED

Dessau

MEDIUM

Watercolour on paper

RELATED WORKS

Paul Klee, *Polyphonic Setting for White*, 1930

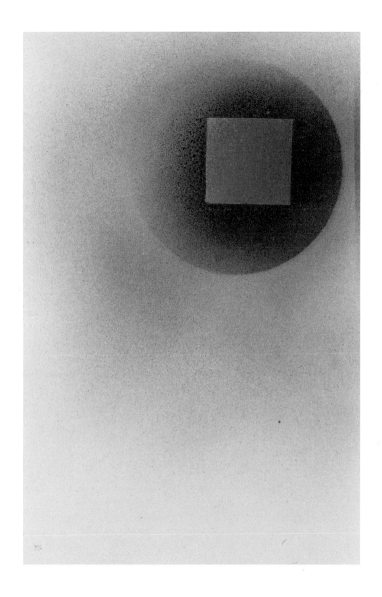

L'Ouverture ('The Overture'), 1938

When Kandinsky came to paint this picture his attitude to gouache as a painting medium had changed from his earlier usage. He now considered it equal to oil, but with different properties. Since its early use he changed the painting ground to black, which had the effect of enhancing the opacity of the paint and intensifying the ground itself. Kandinsky regarded black as 'a totally dead silence ... a motionless corpse', a profound musical pause after which 'the continuation of the melody seems the dawn of another world'. Unlike white as a ground in which, according to Kandinsky, all colours are in discord, black offered a suitable alternative since it was completely devoid of harmony in its own right and against which the 'minutest shades of other colours stand clearly forward'. The notion of colours and forms on a different plane to the ground was an important consideration for Kandinsky.

Although the properties of gouache are essentially opaque, Kandinsky would often varnish certain parts of the composition to create a semi-transparent glaze to the work, thereby effectively adding another planar element.

CREATED

Paris

MEDIUM

Gouache on black paper laid down on mount

RELATED WORKS

Joan Miró, *Composition*, 1933

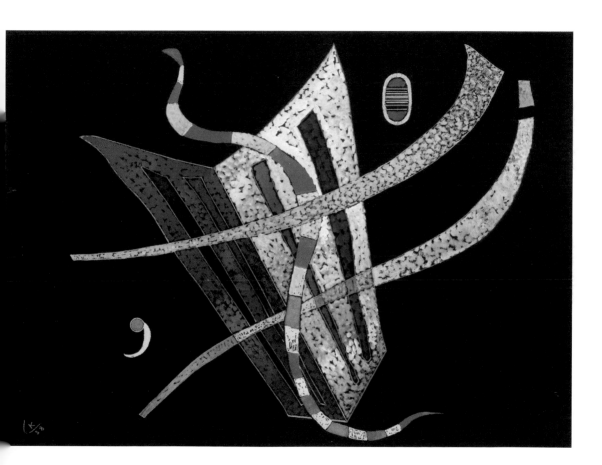

In Blue, 1925

This painting, completed before his move to the new Bauhaus building in Dessau, exemplifies the Constructivist influence on Kandinsky's work. The background to the work is black providing a ground that facilitates the 'floating' sensation of the geometric forms. The illusion is enhanced by the use of the black 'gash' in the centre of the picture plane, as though the forms have passed through it. 'Black hole' theory had a particular currency at this time and it may be that Kandinsky felt this was a suitable motif, since it too was an abstract notion and one that could not easily be visualized. The background has been given something of a cosmic ambiance by the use of blue, which the artist referred to as a heavenly colour.

The main forms are red, which have been contained by the use of a green aura, adding to the cosmic feel of the work. Green and red are antithetical colours, the hot red, almost too powerful, particularly within the perfect form of the circle, is still contained by the most restful of colours that exist, green.

CREATED

Weimar

MEDIUM

Oil on canvas

RELATED WORKS

Kasimir Malevich, *Yellow, Orange and Green*, 1914

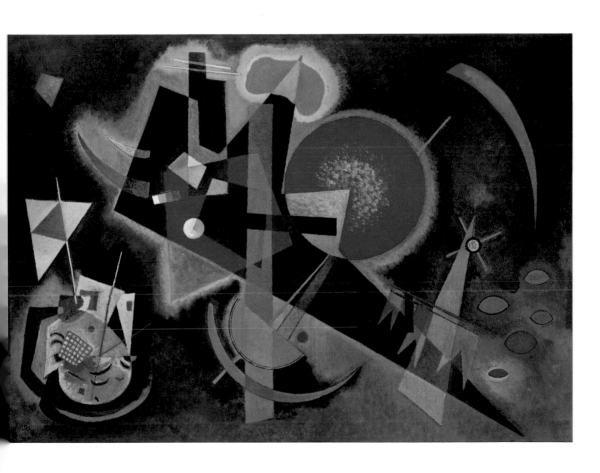

Development in Brown, 1933

In one of the last paintings undertaken during his Bauhaus period, Kandinsky's geometric forms and use of vivid colour appear to have subsided, perhaps indicative of the difficulties he was experiencing at the time. The central design, unusually in this period on a white ground, contains a number of triangles each of which is subdivided into smaller triangles and trapezoids by the use of colour. The top of the design shows a fan-like motif, another form that seems to be exclusive to Kandinsky.

The surrounding design uses a predominance of brown, a colour that Kandinsky referred to as 'unemotional and disinclined for movement'. This dour colour is enhanced here and there with additions of red, but it is a cool red to which blue has been added. By then adding the dark lines, which are almost black, the whole has a sombre tone, rather sad and ailing. The fact that Kandinsky draws our attention to the colour brown suggests that it is indeed a reflection of his 'inner necessity' at this time.

CREATED

Berlin

MEDIUM

Oil on canvas

RELATED WORKS

Paul Klee, *The Scholar*, 1933

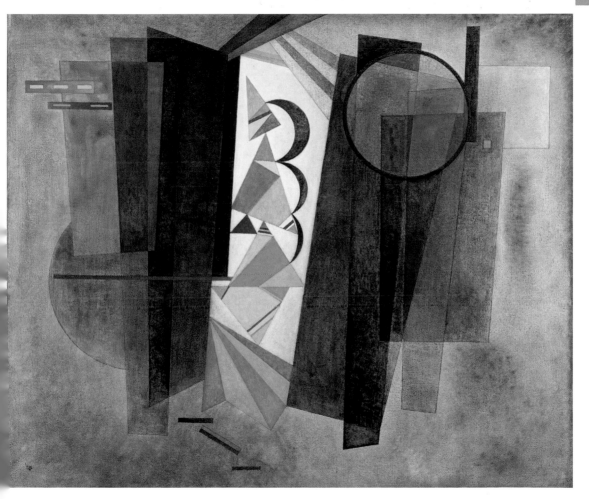

From Light into Dark, 1930

Although arrows seem to be a preoccupation in Kandinsy's work at this time, they should be considered as compositional ruses rather than forms in themselves. In this work they have been used to draw the viewer's attention to the main semicircular form and to provide a balance to it. They also help to contain the predominance of red. Typically for this period Kandinsky used a black background for the work to enhance the colours and provide another form at the top of the picture, the black circle. The extensive use of red in the work is measured with the use of different tones and shades of the colour. For example, behind the vertical arrow is an area of orange, the addition of yellow drawing it closer to the viewer. This is enhanced by the subtle addition of blue to the area to its left to make that area recede slightly.

The vaporous atmosphere of the subtle red tones is facilitated by the use of gouache for the more solid forms and the use of watercolour to build up a series of thin different colour washes over them.

CREATED

Dessau

MEDIUM

Gouache and watercolour

RELATED WORKS

Paul Klee, *To the Brim*, 1930

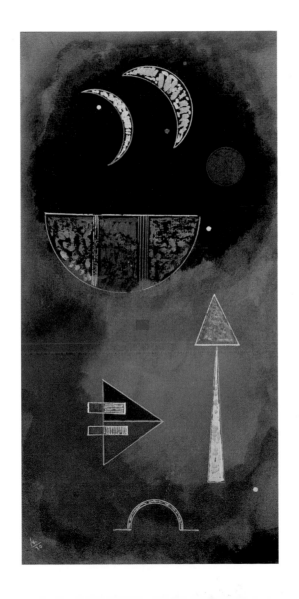

Square, 1927

At first sight this purely geometric work seems untypical of Kandinsky. It certainly has the Bauhaus ideology of Constructivist forms, but the viewer could be forgiven for thinking that it was executed by someone else, since it appears to be a mere exercise in geometry. Yet on closer examination the work is so masterful that only someone with his consummate skills could have painted it.

Square seems to show three ages of painting. The background is regular and precise rather as a Classical nineteenth-century academic painting would be. Violet and black, 'rather sad and ailing', are reminders of this past age. The middle plane represents Kandinsky's age, an expression of Abstraction, not from nature but from pure geometry for its own sake. The colours are vibrant and show all their respective antitheses, violet and orange, red and green, yellow and blue, an example of Kandinsky's extensive artistic theories. Finally the frontal plane uses the black and white antithesis to express movement to and from the viewer, its kinetic features anticipating Op Art by 40 years.

CREATED

Dessau

MEDIUM

Oil on panel

RELATED WORKS

Paul Klee, *Architecture of Planes*, 1923

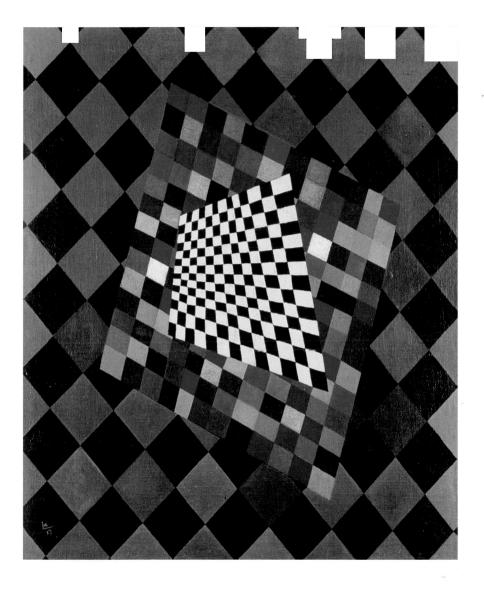

Soft Hard, 1927

Courtesy of Galerie Maeght, Paris, France, Peter Willi/Bridgeman Art Library/© ADAGP, Paris and DACS, London 2006

Kandinsky stated that 'blue is the typical heavenly colour' meaning that it is a colour that ultimately creates rest. In *Concerning the Spiritual in Art* he suggests that to make the blue darker, by adding black, creates a colour full of grief 'that is hardly human'. Conversely making the blue lighter by adding white causes it to lose its restful appeal because it becomes weaker and more distant. Kandinsky compares the variance of blues to music 'a light blue is like a flute; a darker blue a cello; a still darker a thunderous double bass; and the darkest blue of all – an organ'.

Kandinsky uses this simile to great effect in *Soft Hard*. The pale blue nondescript background provides an ambiance for the work, which creates a level of rest that is not too emotionally evocative, rather like a hazy summer's day. The form on the right is a straightforward Abstraction of a small sailing yacht, its keel immersed in the sea as denoted by the blue 'wave'. To its left is an eye, ever watchful of the changing moods of the ocean, as suggested by the variance of blue colours used.

CREATED

Dessau

MEDIUM

Oil on canvas

RELATED WORKS

Alexandra Exter, *Construction*, 1922–23

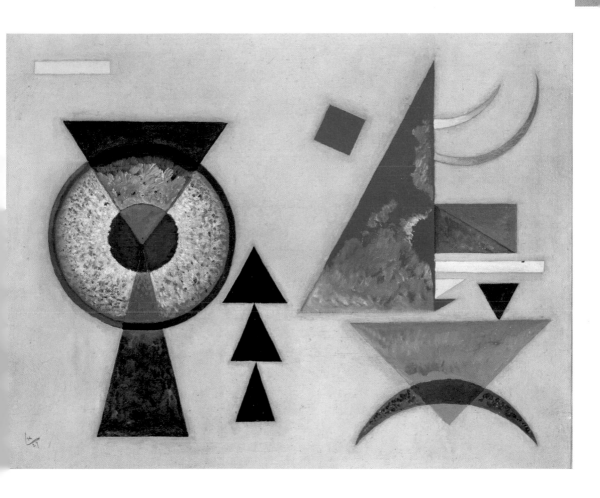

Coloured Hexagons, 1925

Courtesy of Private Collection/Bridgeman Art Library/© ADAGP, Paris and DACS, London 2006

The hexagon is one of the most easily 'constructed' geometric forms after the circle, triangle and square. Derived from the circle, its construction was formalized by the Greek mathematician Euclid in the fourth century BC. Its appeal as a constructed form is in its tessellating properties, which, unlike a circle, can fill a plane surface with no overlap. It is precisely these properties that Kandinsky seeks to undermine in *Coloured Hexagons*. In the picture there are only two hexagons and neither of them is regular. In fact none of the polygons used in the composition is regular.

Kandinsky was working at the Bauhaus at the time of this painting, and its strict regimented ethos of Constructivism under László Moholy-Nagy may have been too oppressive for him. A non-Bauhaus painter, Robert Delaunay, whose own post-Cubist works were expressions of the interplay of colour and light in irregular forms, probably influenced the subversion of this doctrine by Kandinsky. He was aware of Delaunay's work, having invited him to exhibit at *Der Blaue Reiter* exhibition in 1911. Clearly, the title suggests that Kandinsky has enjoyed teasing the viewer with this picture.

CREATED

Weimar

MEDIUM

Gouache on paper

RELATED WORKS

Robert Delaunay, *Simultaneous Windows*, 1912

Descent, 1925

The middle years of Kandinsky's time at the Bauhaus mark the high point of his embrace with Constructivism. The carefully regular forms of the triangle, square and circle and their endless possibilities became a doctrine for the Masters of Form such as László Moholy-Nagy. *Descent* is nevertheless imbued with an essence of Kandinsky's earlier theories, particularly those espoused in *Concerning the Spiritual in Art*. Kandinsky devoted an entire chapter to 'The movement of the triangle' using its derivative the pyramid as metaphor for the development of man's spiritual life. He suggests that at the top of the triangle are artists, who are able to provide that spiritual elixir. Depending on the age, the triangle is able to move forward and upward at a different pace. Sometimes, a man of rare genius (Kandinsky quotes Beethoven), who is often ridiculed because he is not understood in his lifetime, occupies the top of the triangle. At times of decadence, souls fall to the base of the triangle, unable to find this elixir, relying instead on superficial materialism. In *Descent* the artist clearly feels that man is about to descend to the depths in a new era of decadence.

CREATED

Weimar

MEDIUM

Gouache and mixed media on paper

RELATED WORKS

László Moholy-Nagy, *Composition Z VIII*, 1924

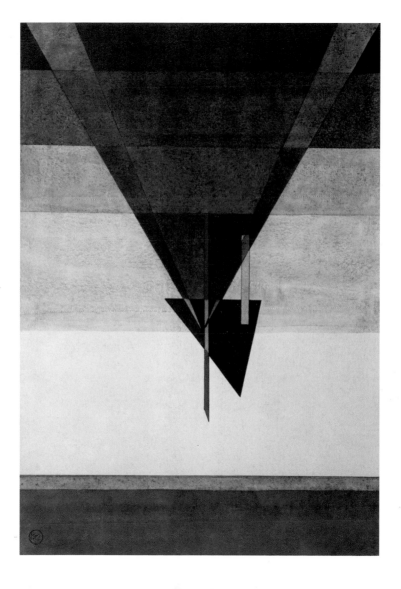

Fröhlicher Aufsteig ('Merry Ascent'), 1923

Unlike Kandinsky's earlier woodcuts, which were often coarse in terms of reproducing lines and colours, lithography opened up more possibilities for reproducing highly detailed reproductions of his work. Lithography for fine art purposes is not dissimilar to today's offset lithography in that both use the natural antipathy of grease and water to make an impression on paper. With fine art lithography, the artist creates the stone plate by actually drawing his design on to it with special grease-based ink or crayons. The design is then fixed using chemicals. Water is then applied to the stone, which is absorbed by the untreated areas of the stone and repelled by the greasy lines. Ink is then applied to the surface, adhering to the lines but repelled by the water-laden surface. The impregnated stone is placed in a press where the image is reproduced on a sheet of paper in reverse. Each colour in the process requires a separate stone plate in order to build up the whole image.

In theory the print run can be many hundreds of copies, but in practice fine-art lithographs are usually subjected to a limited run.

CREATED

Weimar

MEDIUM

Lithograph printed in colours on wove paper

RELATED WORKS

Vladimir Mayakovsky, poster against illiteracy, *Teach Your Child*, 1925

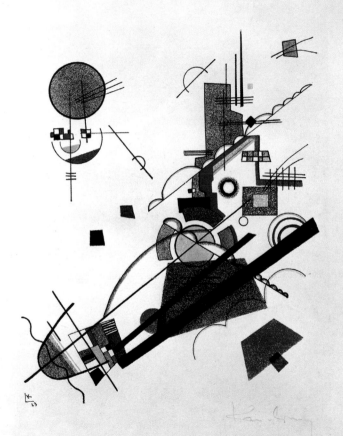

Zersetzte Spannung ('Disintegrated Tension'), 1930

Courtesy of Christie's Images Ltd/© ADAGP, Paris and DACS, London 2006

The title of this work offers the viewer a clue to its intention, marking the end of a period of turmoil at the Bauhaus. After László Moholy-Nagy's arrival, the Bauhaus was completely dominated by Constructivism. After him came the short tenure of Hannes Meyer, who eschewed notions of formalist values. He was then replaced by the even more pragmatic Ludwig Mies van der Rohe.

Much of Kandinsky's work in the mid 1920s was imbued with Constructivist motifs, but in his later work he began to use other formal values, such as colour. The broad yellow band at the top of the work adds another spatial element to the main geometric forms, the two circles. The specific use of yellow brings the whole of this plane towards the viewer, to facilitate our concentration on the two circles, which are involved in a tussle to escape the clear embryonic 'egg' in the centre of the picture. The left-hand Constructivist ideal represented by the 'red' circle remains trapped, while the right, perhaps representing Kandinsky, seeks escape using the line which he sees as 'the product of a force'.

CREATED

Dessau

MEDIUM

Oil on board

RELATED WORKS

Paul Klee, *Fire at Evening*, 1929

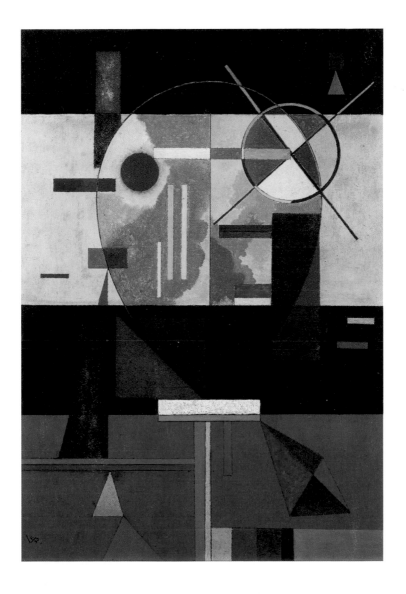

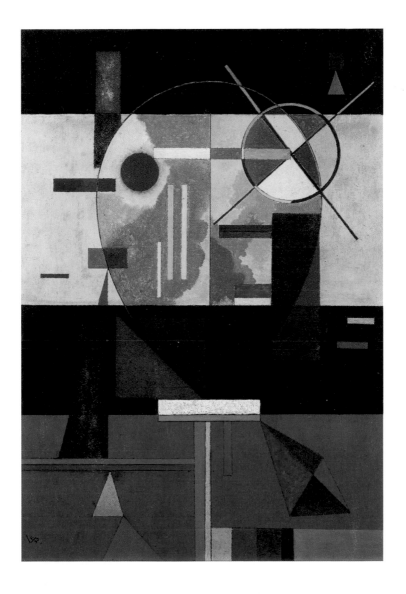

Rot in Spitzform ('Red Pointed Shape'), 1925

By drawing our attention to the red triangle, or wedge, Kandinsky is clearly drawing the viewer's attention to his knowledge of El Lissitzky's Constructivism. Lissitzky's development of Constructivist ideals was based on the pure geometric Abstractions of Kasimir Malevich, whose ideas were initially apolitical and were specifically anti-realist exercises in formal aesthetics. Building on Malevich's formalist considerations, Lissitzky developed a more pragmatic aesthetic suitable for the proletarian masses within the new Communist State that was both propagandist and pedagogical. In his *Beat the Whites with a Red Wedge* Lissitzky depicted a red triangle penetrating a white circle, on a specifically black and white ground.

Rot in Spitzform seems to be a comment on Kandinsky's own enforced exile from Russia in 1922 for not towing the Communist party artistic line. His extensive use of 'unemotional' brown shades and the neutral nondescript background suggest, in contrast to Lissitsky, his apolitical stance. As though to emphasize the point, Kandinsky depicts a black circle, which he emphasizes by using charcoal to provide both opacity and texture to the form.

CREATED

Weimar

MEDIUM

Watercolour, Indian ink and charcoal on paper, laid down on board

RELATED WORKS

El Lissitzky, *Beat the Whites with the Red Wedge*, 1919–20

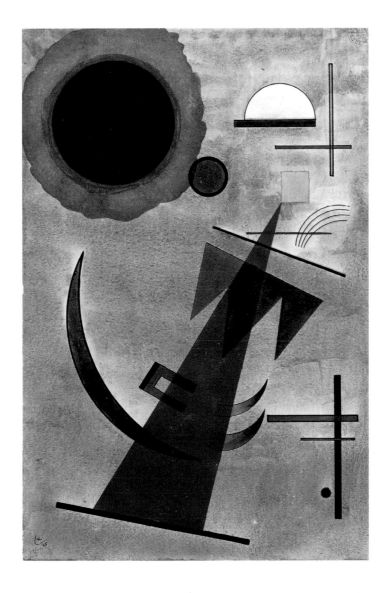

Geflecht von Oben ('On Top of the Network'), 1927

This highly developed work can be considered as one of Kandinsky's 'compositions', a synthesized work that utilizes a number of Kandinsky's preoccupations at this time. In 1926 Kandinsky published his second major theoretical work, *Point and Line to Plane*, and *Geflecht von Oben* appears to be an exercise in its practical application. He suggests that the beginning of any line is a point, which may be of varying colour, intensity and size. The line emanating from that point is a living force, which may be straight or curved. In this work Kandinsky uses only straight lines, but they vary in direction, which has an effect on their perception. There are no horizontal or vertical lines corresponding respectively to cold, dark tonality and warm luminous tones. Instead the diagonal lines that Kandinsky uses possess no tone and are reliant on their proximity to other lines and their interaction with the coloured 'points'.

Although many of the 'points' are various shades of yellow and orange, which move themselves towards the viewer by varying degrees, they are juxtaposed by blue 'points' that recede, thus creating another spatial dimension in the composition.

CREATED

Dessau

MEDIUM

Gouache, watercolour, pen and black ink on paper mounted on board

RELATED WORKS

Aleksandr Rodchenko, *Red and Yellow*, c. 1920

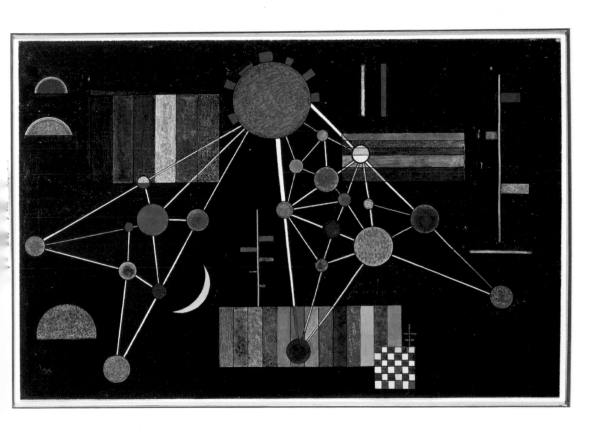

Halbkreis Oben ('Semicircle on Top'), 1928

Courtesy of Christie's Images Ltd/© ADAGP, Paris and DACS, London 2006

The background to this work has been achieved by applying an ochre wash of watercolour, providing a neutral 'earthly' colour. The addition of blue to the original yellow has subdued the intensity that would have been too aggressive, but retains enough of its power to create warmth to the overall picture plane. The patches of darker ochre are achieved by adding red to the original colour and spraying it on to the surface. This removes the blandness of the original surface and creates areas of slightly warmer tones as a background for the forms themselves.

The forms are an exercise in the use of Kandinsky's *Point and Line to Plane*, using both vertical and horizontal lines. The horizontal line corresponds to the ground on which human beings move, but which is dark and cold. The vertical line by contrast affords a warm tonality, enhanced by the warmth of the background. For this reason the viewer's empathies lie with the vertical line, which offers no support to us, but which aspires to limitless heights of achievement. It is by this route, according to Kandinsky, that man will find a spiritual wellbeing that is beyond materialism.

CREATED

Dessau

MEDIUM

Gouache, watercolour, pen and Indian ink on paper laid down on board

RELATED WORKS

El Lissitzky, *Victory over the Sun*, 1923

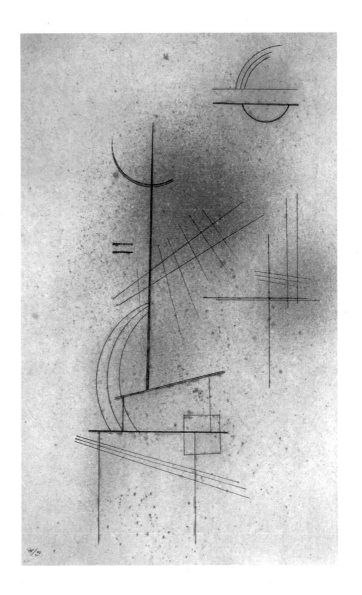

Yellow, Red, Blue, 1925

Yellow, Red, Blue is one of Kandinsky's most famous works, because it marks the beginning of his so-called 'cool romantic' period, when there was uncertainty about the future of the Bauhaus at Weimar. It is a large canvas suggesting that Kandinsky held this work to be at least on a par with his 'Compositions'.

The painting is divided into two sections, the predominantly yellow brighter area to the left and the darker blue tones occupying the right-hand side. The left seems to be occupied by a human form, its yellowness signifying its earthliness, emphasized by the number of horizontal black lines surrounding it. On the right-hand side is the 'heavenly' blue, in the form of a circle, which Kandinsky said 'can sometimes only be described as romantic'. He predicted a new period of Romanticism, which he likened to 'a piece of ice with a flame burning through it'. Kandinsky hoped that people would sense the flame and not the ice. The melding of the blue and red in this painting is clearly a metaphor for this warning.

CREATED

Weimar

MEDIUM

Oil on canvas

RELATED WORKS

Piet Mondrian, *Composition with Grey, Red, Yellow and Blue*, 1920

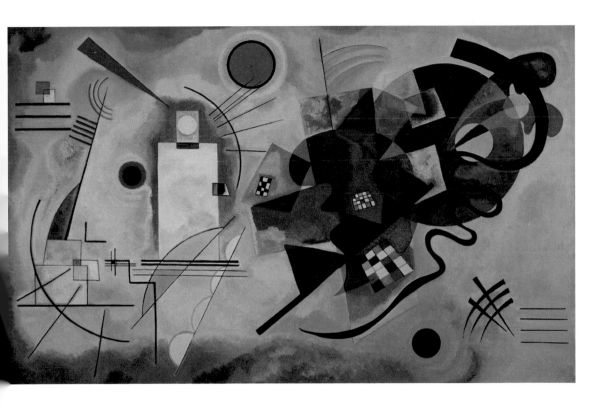

Plate III from Poids Montes ('Mounted Weights'), 1935

This enigmatic work is a kind of painting within a painting using a *trompe l'oeil* effect. The title gives the viewer a clue to help decipher the picture, which is of a 'weight' mounted on to a card possibly for framing. The strange red biomorphic shape suggests the influence of Hans Arp, whom Kandinsky had known from his Munich days and was now in touch with in Paris. However, the use of red for the motif is pure Kandinsky. For him, red, unlike the other primaries of yellow and blue can be made warmer or cooler by the addition of either of these primaries. The addition of yellow creates orange, to draw the red towards the spectator. 'Orange is like a man, convinced of his own powers. Its note is like that of an angelus, or of an old violin.' The addition of blue creates a 'cool red' in which the 'inward glow increases and the active element disappears'.

In this painting Kandinsky has reached a compromise that draws the red towards the viewer while still retaining the inward glow.

CREATED

Paris

MEDIUM

Oil on canvas

RELATED WORKS

Hans Arp, *Human Concretion*, 1935

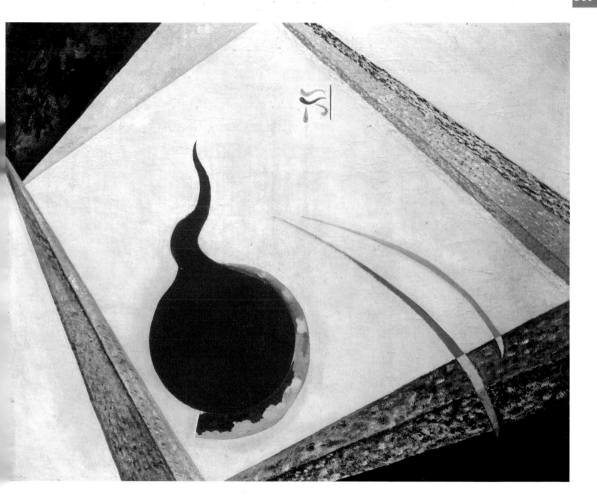

Geometric Abstraction, 1925

Geometric Abstraction is one of the rare works by Kandinsky that contains no colour. As he worked towards his text on *Point and Line to Plane*, published in the following year, this is clearly a disciplined exercise in pure geometric lines and forms using the simplest of media, pen and black ink.

This work was one of a number of 'exercises' designed to fulfil his role as a teacher of form at the Bauhaus, and at the same time use the material to explore his own theories of geometry. At the Bauhaus, particularly under its then Master of Form László Moholy-Nagy, Kandinsky was charged with teaching graphic design to its students using Constructivist principles. Kandinsky would have demonstrated that lines could be as effective as colour to convey sensations. For example, he maintained that, 'The angle formed by the angular line possesses an inner sonority, which is warm and close to yellow for an acute angle, cold and similar to blue for an obtuse angle, and similar to red for a right angle.'

CREATED

Dessau

MEDIUM

Pen and black ink on paper

RELATED WORKS

Lyonel Feininger, Cover for the Bauhaus proclamation, 1919

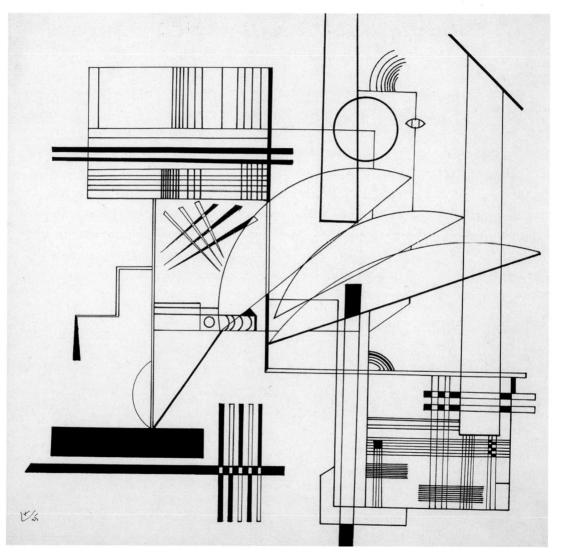

Cup with saucer, 1923

Generally little is known of Kandinsky's design capabilities, since he was first and foremost a painter. Yet like many painter-artists he had been involved in design and design reform on the periphery of his career as far back as his Munich days. He belonged to the Munich Society for Applied Art and produced a number of designs for jewellery, embroidery and book covers. He also designed some of the dresses for his then-companion Gabriele Münter . After leaving Munich and moving back to Russia he also designed some crockery for the Leningrad Porcelain Manufacture in 1919.

As a tutor at the Bauhaus, Kandinsky would have had access to the workshop facilities and been in contact with many of their ceramic designers, such as Gerhard Marcks (1889–1981) and Otto Lindig (1881–1966). However, his design seems more in keeping with those of Peter Behrens (1868–1940), an example being his design for *Bamscher* in 1901. Kandinsky has used his own colourful interpretation of a Japanese motif for this design of a *chawan* and saucer, for the traditional tea ceremony.

DESIGNED

Weimar

MEDIUM

Porcelain

RELATED WORKS

Peter Behrens, Designs for *Bamscher*, Weiden, 1901

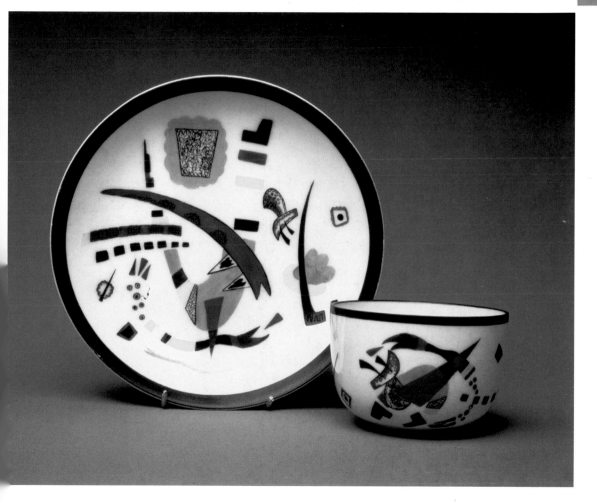

Horizontalee, 1939

Aubusson is a town in the French region of Creuse, well known for its manufacture of carpets and tapestries since the fourteenth century. Although the use of tapestries as wall hangings had been in decline since the advent of wallpaper, it was still considered a luxurious item to own a hanging as a decorative item.

Horizontalee is one of a number of designs by well-known artists, such as Salvador Dalí (1904–89), Raoul Dufy (1877–1953) and Pablo Picasso (1881–1973), who were invited to Aubusson to express their ideas in this unusual medium, wall hangings. Although not woven by the artists themselves, the designs still carry a monograph or signature woven into the design.

Kandinsky chose to express his ideas in a series of horizontal bands of colour surrounded by the 'heavenly' blue. The coloured bands represent the six colours that make up his theory of the three main antitheses, red-green, violet-orange and blue-yellow. Kandinsky brings one of his oft-used motifs into the later works; the snake, which he saw as representing eternity. The snake also represents wisdom and the power to heal.

CREATED

Aubusson

MEDIUM

Hand-woven tapestry

RELATED WORKS

Pablo Picasso, *Women at their Toilette*, design for a tapestry

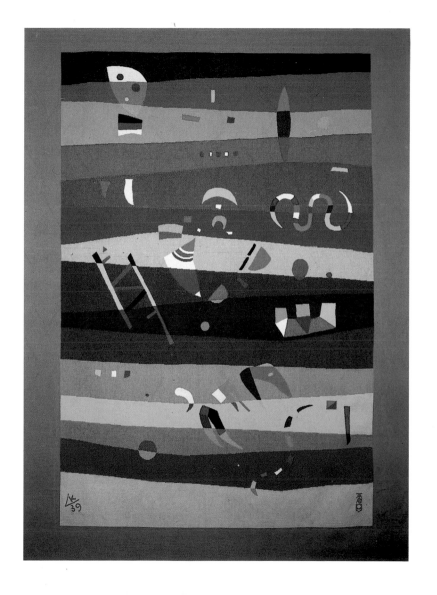

Untitled, 1920

This work was untitled because it was intended as a design for an embroidered motif, to be used on a dress that was being designed by one of Russia's top designers of the day Nadejda Lamanova (1861–1941). According to Kandinsky's widow Nina, the dress was for her.

Lamanova was, like Kandinsky, caught up in the aftermath of the Russian Revolution when many of her bourgeois patrons ceased to exist. Like Kandinsky she became a professor at *INDhUK* (Institute of Artistic Culture) in Moscow, and it seems more than possible that she undertook this design as a gesture of friendship to the couple, who had been married for only three years.

Both Lamanova and Kandinsky's designs were often based on Russian folk tales, as suggested by the 'crown' motif in this work. Kandinsky also introduces an element of wit into the design by encircling the dominant red (representing the new Communist State) with a band of green, which he referred to as 'the colour of summer, the period when nature is resting from the storms of winter'. In Kandinsky's hierarchy of colours, green was the 'bourgeoisie' – self-satisfied, immovable and narrow.

CREATED

Moscow

MEDIUM

Gouache, watercolour, pen and black ink on paper

RELATED WORKS

Elsa Schiaparelli, dress and headscarf to a design by Salvador Dali, 1930

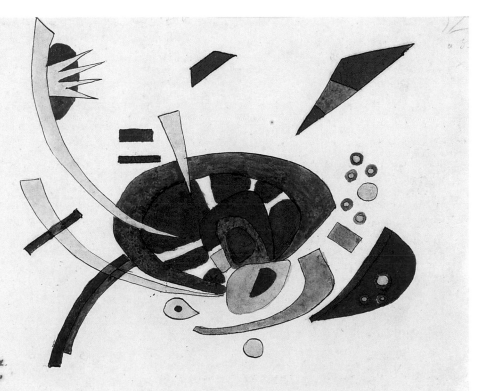

Author Biographies

Michael Robinson (author)

Michael Robinson is a freelance lecturer and writer on British art and design history. Originally an art dealer with his own provincial gallery in Sussex, he entered academic life by way of a career change, having gained a first class honours and Masters degree at Kingston University. He is currently working on his doctorate, a study of early modernist period British dealers. He continues to lecture on British and French art of the Modern period.

Elizabeth Keevill (foreword)

Elizabeth Keevill trained as a printmaker and textile designer at Camberwell School of Arts and Crafts in London and at ENSAD in Paris. She is a writer, journalist and broadcaster specializing in the arts and lectures at Kingston University.

Picture Credits: Prelims and Introductory Matter

Pages 1 & 3: *Schweres Zwischen Leichtem* ('Between Heaviness and Lightness'), Courtesy of Christie's Images Ltd/© ADAGP, Paris and DACS, London 2006

Page 4: *Composition No. 218*, Courtesy of State Russian Museum, St Petersburg, Russia/Bridgeman Art Library/© ADAGP, Paris and DACS, London 2006

Page 5 (l to r top): *Song of the Volga*, Courtesy of Musée National d'Art Moderne, Centre Pompidou, Paris, France, Lauros/Giraudon/Bridgeman Art Library/© ADAGP, Paris and DACS, London 2006; *Saint Vladimir*, Courtesy of Stadtische Galerie im Lenbachhaus, Munich, Germany, Peter Willi/Bridgeman Art Library/© ADAGP, Paris and DACS, London 2006; *Imatra*, Courtesy of Pushkin Museum, Moscow, Russia/Bridgeman Art Library/© ADAGP, Paris and DACS, London 2006

Page 5 (l to r bottom): *Women in Crinolines*, Courtesy of Tretyakov Gallery, Moscow, Russia/Bridgeman Art Library/© ADAGP, Paris and DACS, London 2006; *Amazon*, Courtesy of Tretyakov Gallery, Moscow, Russia/Bridgeman Art Library/© ADAGP, Paris and DACS, London 2006; *Zubowskaja Ploschad*, Courtesy of Christie's Images Ltd/© ADAGP, Paris and DACS, London 2006

Page 6 (l to r top): *Grave Forme* ('Engraved Shapes'), Courtesy of Staatsgalerie Moderner Kunst, Munich, Germany/Bridgeman Art Library/© ADAGP, Paris and DACS, London 2006; *Weiss-Weiss* ('White-White'), Courtesy of Christie's Images Ltd/© ADAGP, Paris and DACS, London 2006; *Red Across*, Courtesy of Private Collection/Bridgeman Art Library/© ADAGP, Paris and DACS, London 2006

Page 6 (l to r bottom): *Composition X*, Courtesy of Kunstsammlung Nordrhein-Westfalen, Dusseldorf, Germany, Peter Willi/Bridgeman Art Library/© ADAGP, Paris and DACS, London 2006; *Trois Étoiles* ('Three Stars'), Courtesy of Christie's Images Ltd/© ADAGP, Paris and DACS, London 2006; *Three Triangles*, Courtesy of Musée d'Arte Moderna di Ca' Pesaro, Venice, Italy/Bridgeman Art Library/© ADAGP, Paris and DACS, London 2006

Page 7: *Kleine Welten VII* ('Small Worlds VII'), Courtesy of Christie's Images Ltd/© ADAGP, Paris and DACS, London 2006; *Afrika*, Courtesy of Christie's Images Ltd/© ADAGP, Paris and DACS, London 2006; *Yellow, Red, Blue*, Courtesy of Musée National d'Art Moderne, Centre Pompidou, Paris, France, Peter Willi/Bridgeman Art Library/© ADAGP, Paris and DACS, London 2006

Further Reading

Becks-Malorny, U., *Kandinsky*, 2003

Burchett, K. E., *A Bibliographical History of the Study and Use of Color from Aristotle to Kandinsky*, Edwin Mellen Press, 2005

Dabrowski, M., *Kandinsky: Compositions*, Museum of Modern Art, New York, 1999

De Larminat, C. & Richard, C. (transl.), *Kandinsky: Sky Blue*, Abrams, 1990

Düchting, H., *Wassily Kandinsky 1866–1944*, Taschen, 1999

Endicott, V., *Kandinsky Watercolours: Catalogue Raisonne: 1900–1921 Vol 1*, Cornell University Press, 1993

Endicott, V., *Kandinsky Watercolours: Catalogue Raisonne: 1922–1944 Vol 2*, Cornell University Press, 1994

Flux, P., *The Life and Work of Wassily Kandinsky*, Heinemann Library, 2003

Golding, J., *Paths to the Absolute: Mondrian, Malevich, Kandinsky, Pollock, Newman, Rothko and Still*, Thames & Hudson Ltd, 2002

Hahl-Koch, J., *Kandinsky*, Thames & Hudson Ltd, 1993

Hoberg, A., *Wassily Kandinsky and Gabriele Münter*, Prestel Publishing Ltd, 2005

Jäger, C., *Wassily Kandinsky*, Taschen, 2003

Jelavich, P. & Weiss, P., *Kandinsky in Munich*, Art Data, 1982

Kandinsky, W., *Concerning the Spiritual in Art*, R A Kessinger Publishing Co., 2004

Kandinsky, W., *Point and Line to Plane*, Dover Publications, 1979

Kandinsky, W., *Sounds*, Yale University Press, 1981

Kandinsky, W. & Marc, F. (eds.), *The Blaue Reiter Almanac*, Da Capo Press, 1989

Kutschbach, D., *The Blue Rider: The Yellow Cow Sees the World in Blue*, Prestel Publishing Ltd, 1997

Lacoste, M. C., *Kandinsky*, Bonfini Press, 1979

Le Targat, F., *Kandinsky*, Rizzoli International Publications, 1990

Messer, T. M., *Wassily Kandinsky*, Harry N. Abrams, Inc., 1997

Poling, C. V., *Kandinsky: The Russian & Bauhaus Years, 1915–1933*, Guggenheim Museum Publications, 1983

Rachum, S. & Gage, J., *Masters of Colour: Derain to Kandinsky*, Thames & Hudson Ltd, 2002

Rosenbaum, J. et al, *Schoenberg, Kandinsky and the Blue Rider*, Scala, 2004

Roskill, M., *Klee, Kandinsky and the Thought of Their Time: A Critical Perspective*, University of Illinois Press, 1995

Schoenberg, A. et al, *Letters, Pictures and Documents*, Faber & Faber, 1984

Vezin, A. et al, *Kandinsky and Der Blaue Reiter*, Editions Pierre Terrail, 1994

Weiss, P., *Kandinsky in Munich: The Formative Jugendstil Years*, Princeton University Press, 1979

Whitford, F., *Kandinsky*, Hamlyn, 1968

Index by Work

General Index